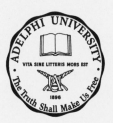

ARTHUR GIARDELLI

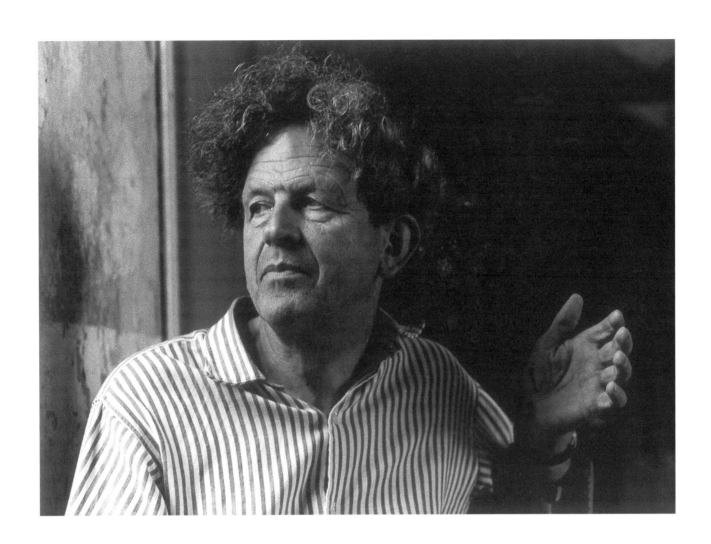

ARTHUR GIARDELLI

Paintings Constructions Relief Sculptures

CONVERSATIONS WITH DEREK SHIEL

FOREWORD BY MICHAEL TOOBY

seren

Seren is the book imprint of
Poetry Wales Press Ltd
Nolton Street, Bridgend, CF31 3BN, Wales
www.seren-books.com

ISBN 1-85411-238-4

A CIP record for this title is available from the British Library

The publisher works with the financial assistance of the Arts Council of Wales

Printed in Plantin by Hackman Print, Clydach Vale

Contents

To Bim and Marcia

Foreword

Watching the old BBC Wales film about Arthur Giardelli recently, I was particularly engaged by the scene where Giardelli goes to speak on modern art to an adult group. This scene today appears staged, stiff, dated. Yet it is somehow utterly believable and rather revealing. Here is an artist who, despite a productive studio practice and an evident need to be in and around the landscape and seashore, will nevertheless get in a car and go to an out-of-the way village hall or college to talk to the five or six dedicated sceptics who make up the local evening class. This must be a remarkable personality, not simply to pursue this activity, but, more subtly, to insist that the producer of a tv documentary includes this in a feature about his own life and work. How many artists distort the picture of their working lives to edit such activity, even when they do pursue it, whether out of necessity or commitment?

In the filmed talk, Arthur Giardelli speaks about Mondrian, prompting questions from his audience, who are respectfully doubting. They suggest to him that he should explain what they perceive as a disjuncture of language between artist and audience, about whether we know which 'way up' abstract art should be, and about the notion of 'subject'. He deals with them skilfully and with a striking confidence. To a contemporary audience, however, the Mondrian illustration also demands interrogation as to why Giardelli again felt this could connect with a public exploration of his own work.

Giardelli's work, to me, means a joy in material; in surfaces which combine an underlying organisation and structure which is a vehicle for celebration of colour and texture in the natural world. The natural world, he tells us by the way, includes things seen and experienced as well as found and depicted.

Mondrian commented in 1925, at the height of his 'abstract' period, that what he saw around him were "fragments of the particular". These fragments cohered into "a new harmony", where the plastic whole of the painting – the painting as an object as well as an image – expressed a unity of experience which is missing from the experience of only the fragment. At around the same time, T.S. Eliot, in his poetic collage *The Waste Land* conjured up an image of memories and impressions as "fragments against ruin". For many of the formative figures of the movement, unity of experience and knowledge was something to search for as one tried to make sense of the world.

I hope that in seeing a complete study of his life and work, Arthur Giardelli can imagine the future lecturer engaging the audience (in whichever village hall, evening class or museum or gallery tour it may be) as being able to gain from it something which is analogous to his most successful works – something where detail and fragment add up to a harmonious whole which expresses the underlying order of things.

The challenge to anyone writing about his work is the awareness of the subject's own passionate commitment to communicating both the joy of art, and to the need to acknowledge why learning and enquiring deeper is important to furthering that joy. His example is one that Wales will be able to look to in the future as what a model of the artist's outlook can be: rooted in his particular environment, and relating it to the complete experience of the world by addressing the grand themes of the widest artistic traditions.

Michael Tooby
Director
National Museum and Gallery of Wales, Cardiff

Introduction

The reason for my travelling to Pembroke to meet Arthur Giardelli was to discuss his friendship with David Jones, the painter and poet, whose life I was researching for a book I was in the process of co-authoring. Soon after my arrival, we seated ourselves either side of a blazing fire with a drink in our hand and began to talk, at first, on my part at least, somewhat nervously. Before long we were discussing lithographs by Zoran Music and finding we shared an admiration for the paintings of Soutine. It was, however, early next morning that I was conscious of something a little more out of the ordinary. During breakfast I made a remark which there was not time to follow up as I removed myself to another room to study a bundle of letters from Jones. At precisely eleven o'clock Arthur entered the room, referring to the remark and wanting to know what I had been on the point of saying. Such a degree of attention paid to conversation is unusual; I was impressed. In fact so animated did discussion then become between Arthur, his wife Bim and myself that I had respectfully to remind them I still had Jones's letters to annotate before catching my train.

Not long after this visit my publisher, Mick Felton, suggested I might ask Arthur if he would be interested in writing his autobiography. Arthur considered the proposal for several days and decided that since he was not really a writer he would rather devote his remaining years to his art. Nevertheless, he would be willing to participate in a book of conversations. This information he gave me by telephone and when I asked him to mention the name of a writer in Wales with whom he might like to work his answer took me completely by surprise: "I don't want a critic, I want an artist – in fact, someone like you!" Taken aback, flattered, and with a degree of embarrassment, I reported the news to Mick Felton. That is how the idea of our book originated and some months later Seren agreed to be its publisher.

Arthur at once threw himself into the project as his letters make clear: "The book, our book, is much in my thoughts... I am making jottings... I have been reading Leonardo's notebooks and remembering Plato's *Symposium* and its way of thoughtful exploration." After I sent him a copy of the conversations between Francis Bacon and David Sylvester he at once read the book and wrote back: "I think in any conversation we might have your contribution would be to state your view which would stand for something other than mine".

In view of Arthur's age – he was then in his eighty-seventh year – and work commitments I had misgivings about taking up too much of his time, but he reassured me: "The book and your visits are an inspiration... They drive me on rather than intrude on my painting... I look upon the book as an extension of my work as an artist." He explained why: "I have long valued artists' writing about painting. The artist and his inherited craft is the point of departure. We are both artists so we have the primary authority..." and he added: "Making the work of art is a lonely activity, essentially. Only someone else who has experience of that loneliness... can see what one has been up to."

Here he touched a nerve. As an artist living and working in London I had from time to time regretted that I knew no older, well established painter with whom I might talk. Such opportunities I'd had as an art student I saw as quite different since at that period I was no more than a beginner, nor did I consider the conversations I enjoyed with my peers as altogether sufficient. And although much enlivened by snatches of talk with painters such as Jack Smith, Cecil Collins or Francis Bacon I had no repeated experience of conversing with an older artist. This I felt to be a lack. Now, without being fully aware of it, here was my chance.

So, once more seating ourselves either side of a blazing fire, we began to talk but this time more formally, with a tape recorder on a chair between us. My brief, as I discovered gradually, was far from simple: I was to cover biographical, social and aesthetic aspects of Arthur's life, principally concentrating on his many years in Wales working as artist, lecturer, writer and Chairman of the 56 Group Wales. I was to discuss his friendships with British and international

artists, especially his relationship with his dealer, Eric Estorick of the Grosvenor Gallery, and detail his travels, either in association with the 56 Group Wales or with his wife as a topographical painter.

One of the themes of the book is the story of a family from humble Italian and British backgrounds. However, it was not altogether plain how humble certain family members always were. Arthur's grandfather, Vincenzo Giardelli, who had fought under Garibaldi before emigrating to England, was once seen coming out of Buckingham Palace but when questioned jokingly brushed aside any explanation. Quip's illustration of him shows a grave and dignified figure in evening dress, wearing his service medals. Among the Lutmans, the maternal side of Arthur's family, there are indications of a much less impoverished branch, whose riches have long been the subject of legal dispute. Undoubtedly the family was poor but the upward mobility brought about by its unremitting zeal is worthy of admiration. In fact, as the book makes clear, the life of Arthur Giardelli is one filled with surprise, surprisingly coherent but in unexpected ways, surprisingly varied despite seeming at times confined or repetitious. Coincidences, chance meetings, happenstance – all of these are turned to advantage because for Arthur chance invariably suggests opportunity, rather than the reverse.

In early childhood his mother was Arthur's sole parent and his time with her and his brother in the village of Abinger proved to be, in his words, idyllic. She was a countrywoman, physically strong, more than capable as both mother and school-mistress, essentially supportive in his nurturing. He remembers her reciting poems and telling him stories and, although he had small tasks to perform in the home, she was happy to allow him his freedom to explore with other children all the advantages of rural life.

With his father, however, once he returned from the War, Arthur was not left to his own devices for long. He must work, he must study, must exercise his intellect as well as his body; personal development was critical, nothing must be allowed to go to waste. One anecdote indicates how demanding of excellence his father could be:

> At Alleyn's School there was a reading prize which any boy could enter for; normally you'd aim at it when you arrived in the sixth form – but my father said, "No, we'll try it earlier". He taught me to read [Arthur was years later to realise he was dyslexic]. I had to stand at one end of the room and read aloud to him so that he could feel I had understood what I was reading and explain it as though I'd written it myself. Indeed, I made the effort to get the prize long before I actually did, in the end, win it when I too was in the sixth form.

At first Arthur was encouraged to look at art, then to attend lectures, next to develop his drawing in museums, have private lessons at home and to go to Suffolk to learn oil painting, while also still drawing and painting at school. But quite suddenly, when Arthur reached the sixth form, Mr Giardelli decided that any more encouragement would be inadvisable: his son must be prepared for the realities of adult life. Arthur puts the issue simply: "My music-master thought I should become a musician and my drawing-master thought I should become a painter. The dilemma was resolved when instead my father decided I'd better go to Oxford! 'You've got to become a school-master, then you'll earn a living,' he said."

Surprisingly Arthur responded well to this about turn, laid aside his art, knuckled down and prepared for university, finding within himself scholarly abilities he knew nothing of. He passed the necessary exams and secured grants sufficient to take him to Oxford. Our conversations describe his life at Hertford College and how he went on to become a teacher at Harvey Grammar School in Folkestone but letters from the mid and late thirties tell another part of the story. His father's decision had resolved the issue no more than temporarily: every now and then the dilemma would re-surface. He had prepared for a career he was not sure he should follow but his father, in making his mind up for his son, had imposed a restraint,

one it took Arthur many years of inner conflict to overcome. Finally in Dowlais, well away from his father's influence and having the unequivocal support of his wife, he began to make his breakthrough, due to the artists he encountered but principally because of Cedric Morris, who happened to come to stay next door. Chance in Arthur's life was never sweeter. Morris set him at last on course to become the artist he had always wanted to be, the artist his father had done so much to make him. To this day Arthur's praise of Cedric is unstinting. As late as 1969 he writes adamantly to his American friend, the painter Fairfield Porter: "I do not believe that those with a gift for painting are those who paint. Some do. Some... don't have the encouragement needed or are in an inappropriate situation. I think it nonsense to say a great gift will out. I am sure lots of them have been stifled."

The third male figure of deep significance in Arthur's life was much more complicated than Cedric Morris, a character it seemed impossible to pin down. Eric Estorick, the director of the Grosvenor Gallery, began by offering Arthur what an artist dreams of having: a gallery, a one-man exhibition from which every work was bought by the gallery, private and public commissions, a personal friendship with him and his wife and access to his private collection of twentieth century masters. But then a problem arose, which Arthur did not directly connect with himself but that was to have unforeseen consequences. In 1971 Estorick closed his impressive contemporary gallery and moved to much smaller premises in South Molton Street, not usually open to the public, in order to devote himself to the promotion of the Russian designer Erté around the globe. Studying the situation now it would appear that Arthur ought to have parted from Estorick in the early 70s. But they had become friends. Friendship is of primary importance in Arthur's life and very possibly friendship mattered to Estorick too. For all his celebrity and success he may well have been lonely, flattered by Arthur's continued attention and needful of friendship – or he required it. Estorick was proud, once described as a prince patron. Might he have considered Arthur's departure as desertion, or even betrayal? And would Arthur have found parting tolerable; for him it could have amounted to disloyalty. While the ties between them grew, Estorick's commitment to Arthur as a dealer waned, had of necessity to wane, due to his phenomenal success with Erté. Possibly Estorick fought shy of telling Arthur directly that he no longer had time to handle his work. It was easier to promise another exhibition, and one was eventually held in South Molton Street in 1987.

Arthur's relationship to Pembrokeshire also figures here. In our conversations he spells out what Pembrokeshire has come to mean for him as artist and individual, how it feels to work away from London but in the midst of Welsh artistic affairs, what it has been like to exhibit in Europe as an artist from Wales. If, as Peter Prendergast has suggested, there has been a penalty, it is one Arthur has been willing to pay rather than become the victim of a dealer, as he thought Ceri Richards had, or be outcast by the critics like Cedric Morris. From west Wales Arthur's view of London and dealers was always equivocal but the sheer dynamism of Eric Estorick's personality had mitigated his wariness.

Arthur is reticent about Eric Estorick, and is similarly so about his two wives. His love and admiration for women is immediately apparent and their loyalty and support accepted without hesitation, yet it is separate, more private, less easy to discuss, perhaps the result of guilt at the end of his first marriage. I suggest this admiration originates in his unproblematic relationship with his mother which made the marrying of Judy, and later Bim, seem part of a natural process. Each wife enabled him to fulfil himself through her organisational skills and through her own creativity, the first as musician, the second as painter. In return he helped each shape her talents; in the case of his first wife Judy I quote his words from a letter written soon after their marriage, whereas Bim has described to me his instruction and encouragement, summing it up in the phrase, "With Arthur I became myself".

While Arthur has passionately believed in educating others in the appreciation of art he is clear that his pursuit of it takes him way beyond words in making the work itself. In a letter

to me he quoted Braque: "The only thing that matters in art is that which cannot be explained". Beyond the thousands of words which comprise our conversations stand his relief sculptures, his constructions, his paintings. Arthur agrees with Francis Bacon's assertion that it takes at least seventy-five years before a work of art can be reasonably assessed. What can, however, be said is that Arthur's work places him in a unique position in Britain as a maker of reliefs. They are unlike those of anybody else and at their best stand in a European or international context.

My wish to know a master practitioner has been fulfilled: Arthur's dedication to his art deserves the greatest respect. His nature is essentially optimistic, buoyant and probing, and while each of his wives has greatly contributed to his sense of wellbeing, his own determination and will power are innate. When our work was about to begin Arthur wrote: "I would want my life to show why my art is what it is". Together we have done what we can to fulfil this aim and in conclusion we would want to reiterate the words of Constable, being "anxious that the world should be inclined to look to painters for information on painting."

ONE

Although of Italian extraction, you're a Londoner.

Yes, I was born in Stockwell but the next year we moved to Wembley and then, in 1915, my father decided to join the army. I recall that my mother gripped my hand as we followed my father, marching behind a band over Westminster Bridge on his way to fight the Germans in France. So, in a sense, I lost him almost as soon as I became aware of his existence.

Was your brother born by that time?

We were both born before the War, I in 1911 and Wilfrid two years later.

As you say, consciously you had hardly begun to get to know your father.

That is about right; I had only a remote sense of my father before then. He used to take me for walks on what was, I think, called One Tree Hill in Wembley. I remember being with him as we watched a train go along the bottom of that hill. Nothing else.

Because before long he was gone, almost without exception, until he returned at the end of the War.

He had leaves but by that time we'd moved to Abinger, in Surrey. My mother had been a school-teacher in London but soon after my father went away she accepted a post in Abinger at the village school. The headmaster was leaving for the War so she became assistant mistress under the headmaster's wife, who took over as headmistress. Together they ran the school for the rest of the duration of the War.

And you became a pupil at this school?

Yes. It was a lovely school, where we were taught gardening as well as everything else.

That was unusual, surely?

Well, the school had its own garden and my mother taught gardening amongst many other subjects such as needlework, cooking, gymnastics, or physical education as it was called. My mother was a countrywoman, brought up on an estate near Petersfield where her father was coachman and gamekeeper. She used to tell me of an occasion when as a little girl she had seen some attractive flowers just below a bank and had jumped down only to find herself knee-deep in a bed of watercress! Another story she told was of her father making the Christmas tree. They didn't dig one up; instead he made it out of bits of wood, which was apparently what you did at that time. Much later she had been brought to London by her parents and had become a school-teacher in Spitalfields, teaching mainly Jewish children. This is relevant because my parents took a great interest in Jewish people; in fact the whole family always has done.

Lutman – is that a foreign name?

It must have been originally, but where it comes from I don't know. She was christened Annie Alice Sophia.

Can you give me a sense of your life in the country; it's a time you seem never to have forgotten.

Ah, it was idyllic. We lived in one of a group of houses called The Dene, which was about a mile and a half from the school; from the house we'd walk uphill to Abinger, either by the road if the weather was poor or we'd cross the fields if it was a sunny day. My mother took us but quite often, for some reason or other, we managed to come home alone so I got to know my fellow school-children very well and entered into country life, having the joys and fears of a human being and the experiences of an animal amongst other little animals. We did go to school but we really were very intimate with the creatures too. We knew where all the birds' nests were; we could find a skylark's nest in a hayfield, we found the blue tit's nest and those of sparrows, swallows, thrushes and Jenny wrens, and climbed up to the pigeon's nest. We found snakes among the cowslips in the railway cuttings and saw red squirrels in the trees. You see, little country children are like that, they know all about country life. The other thing I remember vividly, particularly in retrospect, is that I don't think I knew anything about money until I was ten and went to Guildford Grammar School. And I only knew about

it then because my mother gave me a penny to buy a banana on my way home. Living in the country everything we needed we had to make or invent. If, for example, we wanted to play a game, we'd make our own bows and arrows, we'd carve our spinning tops or our leaping poles – a leaping pole was one we made in order to leap across the river Tillingbourne.

Was it like a stilt with a notch for your foot?

Oh, no, no. It was a pole a bit taller than we were ourselves; we'd put it in the middle and leap over. These we would cut ourselves and the sticks that we'd use we would decorate with all sorts of patterns, taking great care. Every boy had a knife and so whatever we made was what we could shape with a knife. And if we felt hungry, we'd go to the field and pull up one of the farmer's turnips or we'd climb a tree and get some hazelnuts or find chestnuts or we'd go raspberrying or blackberrying. We chewed young beech leaves and the stems of sorrel or we ate what are called pig nuts, which we dug out of the ground. Everything we did we organised as part of this little gang.

You've mentioned trees, climbing into them for particular purposes.

You'd climb trees in order to get nuts, you'd climb trees to find birds' nests, but I didn't collect birds' eggs because my mother forbade me to do so since one time I was climbing up a tree to get at a pigeon's nest and fell out of it. It sounds dangerous but the floor of the wood was covered with leaves so it did me no harm. I loved to be well up in a tree and look down on people passing underneath, who would be completely unaware that I was there watching. For as long as I could climb trees I climbed them. We used to climb trees also to swing out of them. We'd take the great bough of a beech and two or three of us would be on the end of it swinging. We also cut our names on tree bark as Orlando had in *As You Like It*.

These were a whole range of discoveries which city children such as myself would have little or no experience of. Every day was spent in exploring nature.

We would go out and get a sackful of fallen leaves for the garden or we'd get dung from the horses as they passed up and down the road, also for the garden. We'd go into the woods if the woodman was felling trees and bring home sticks – we called them faggots – for the fire. We had to dig pits in the garden in order to empty the lavatory bucket, so we knew life in its most intimate sense. My friends were the woodman's children, the shepherd's and the cowman's, and as little animals we explored one another's bodies, also in an intimate sense.

Even when really young?

From very early days. I think there was a marvellous richness from the beginning of my life.

Because you were the elder son and your father was away, did your mother rely on you particularly?

I have no awareness of that at all. All I am aware of is that she was a very, very able woman, running that school of about forty children with the other teacher and looking after her own two children at the same time. We had a dog, I remember, a wonderful dog that my father brought home when on leave on one occasion. He was ill and and had come back to England to be nursed but instead was sent to a hospital at Llantrisant in Wales. The matron in charge gave him a black retriever for us children and we would get into the kennel with it; that's another reason for my saying that I grew up like a little animal. An animal is part of nature, so that part of myself I knew before I knew anything else; I believe it's something that those who don't experience it when small can ever catch up with later.

No, it isn't. My mother found herself in much the same situation as you and even now remembers those days as the most wonderful of her life.

You know what it is to be extremely cold. You know what it's like to skate on the pond when it's got ice on it. You know when it's got enough ice; you know those who've fallen into the ice. You can paddle in the stream and you can swim in the stream. We tickled trout and caught sticklebacks.

And collected tadpoles or caught frogs?

And cut out the delicate wasps' nests.

Children as young as you were wouldn't be afraid of getting stung?

We'd know where the wasps' nests were. It was partly daring and partly fun; of course, I now realise it was cruel. We made two kinds of pipe from young ash wood, one which would whistle at different pitches and the other which made precise notes. We also made wooden clappers that we played rather like castanets, brooms, carts, propellers or later aeroplanes. And we made fire with a magnifying glass or with a pointed stick spun in a hole in a flat piece of wood.

All in all a very practical introduction to life. For you, who were to become a maker, an ideal start.

I'm sure that was the beginning of it all. I've always assumed that I had to make whatever I needed without relying on money to get it. We had no money at all.

It makes sense to mention money in this context; everything had to be provided from the abundance of nature.

That's right.

And, presumably, there were no shops to compare what you were making with what could be bought, your own bat or whistle, for example, with a typical cricket bat or penny whistle?

Oh no, we knew little or nothing of shops. We knew there was a butcher and a milkman, because we'd see the cow being milked and then we'd carry the milk back home. Another point of interest is that as soon as we were old enough we became choirboys. *There's a completely different aspect: there was teaching at school, there was the life of nature but also every week we went to two choir practices, one on Tuesday, another on Friday and then on Sunday we attended church for both the morning and evening services. So I was brought up with a knowledge of the Christian faith from my early boyhood, singing in the choir.*

Even when very small you were in the choir?

Of course. Everybody was.

Was there less mischief-making on Sundays?

Well, I'm not sure about that – you had to go to church and come home – but it wasn't mischief, it was life. We hadn't an understanding of good or evil but we knew what we weren't allowed to do at school... I remember an instance when I was seven or eight or conceivably nine. Lord Farrar owned a fine house, Abinger Hall, on the side of the North Downs in a magnificent park with woodland and fields. We sometimes used to be invited from the school to do country dancing in the park or the village teams would play cricket in the field in front of the house. In the autumn we, as little boys, often climbed up the wall of Lady Farrar's walled garden to gather apples or plums or whatever we could find, but the park we regarded as our playground. One day I was there picking up chestnuts when Lady Farrar approached with a company of ladies. Seeing us she said to me, "How would your mother like me to come into her garden and pinch her cabbages?"

Rather daunting! Were there other hierarchical aspects to the village?

Oh yes. There was a Miss Wyn Williams, she lived in the manor house and every morning at break-time she would send a couple of servants over with a cauldron of cocoa and we were all given a mug of it. Another lady each year arranged for a farm cart – they were beautiful wagons – to take us from Abinger to the sea and then bring us back again; I think it was to Worthing. I remember also a third lady whose husband was a stockbroker, who had an elegant house, garden and lawns. Every year she would invite us for a party, the high moment of it being when she took sweets and, with a grand gesture, scattered them widely across the lawn. We chased one another to pick up as many of those sweets as we possibly could. It was not long afterwards – about ten years I should imagine – that her son came to tea with me while I was a student at Oxford.

Events come full circle. You've told me that little children were taught to salute.

We were taught courtesy to our betters so we saluted members of the aristocracy. We also saluted the village nurse and our headmistress, whom we called 'Governess'. If in doubt when you met someone you didn't know, you saluted.

You've mentioned singing in the village church, but were you Anglicans?
I always have been.

Because of your grandfather being an Italian I thought you would have been Roman Catholics.
My grandfather was what he called a 'freethinker'.

But then why had your father been brought up as an Anglican?
My father was a very devout man; he became a Lay Reader, having passed the appropriate exams and gained a Lay Reader's medal, which he put on when he read the lesson. I remember him sometimes preaching from the pulpit, taking services. He met my mother, I would guess, through his attendance at church. One of his friends later was the priest in Streatham and he was also friendly with some of the men in the choir. He was extremely religious, as indeed was Mother, understanding his faith through studying it deeply; Mother used to sing solos in the choir.

What happened when your father returned from the War?
Well, when he first came back we continued to live in The Dene but soon afterwards we moved to a bigger house very close to the village school, one of a small group called Ellix Wood Cottages. Whereas The Dene consisted of twenty-six little houses, two by two, those of Ellix Wood, although somewhat similar were larger, only six cottages or three doubles, built on land adjoining the school garden. The War had destroyed my father's career; just before it he'd been in a lawyer's firm dealing in scientific law with Germany, where he would have been given articles, but on his return there was no job since this firm had gone out of business so he decided to train as a teacher instead. After studying at Birkbeck College he gained his qualification and became a schoolmaster in Bermondsey. He quickly realised he couldn't go from Abinger and back every morning and evening, although he did do that for quite a time after having tried living in lodgings during the week and hating it.

Was it easy or difficult, or wonderful, to have a father in the house again, day by day?
I remember my parents quarrelling sometimes when my father got back. It's not surprising because, naturally, my mother was all important until he returned. There was the poignant occasion when my father came home at the end of the War and my brother asked my mother, "Who's that man?" and ran off. My father used to tell me that story. My brother was frightened of him, because he could be extremely severe.

And what about you?
I don't think I was frightened of my father, not then anyway. I was frightened of him later on because his ambition for me was almost *insupportable*, as the French would say. He was ambitious himself but had not had the opportunity, so he was determined that we boys should have it.

With hindsight, do you think he'd suffered in the War? Had he ever terrible tantrums or depressions afterwards?
My father was extremely fortunate because just as he was about to be sent up to the Front the order was withdrawn. He served in the Army Service Corps – later renamed the Royal Army Service Corps – where his job was to assess the value of the wood we were taking from French forests. To the French this was extremely important whereas to the British, not being much concerned about wood, not nearly as important. He became expert in estimating the price of wood, such a specialist, in fact, that they kept him back from the Front Line. He was a small man and would almost certainly have been killed if he had gone to the Front. He spent most of his time in the army in Rouen and, when the War was over, one of the first things he did was take his little family to Rouen to show us off to those he'd known when he was a soldier. The first time I remember going to France was then, but I also understood from my parents that they had taken me there before I was one year old.

This is a remarkable story because it is obvious your father had become genuinely friendly with the local people, in spite of being a British soldier.
That's right.

He seems to have had no first-hand experience of the horror. If he'd had appalling memories, of the trenches for instance, he would hardly have wanted to go back to France so soon afterwards.

That's very likely true. I now recollect that he had lived in Paris at the end of his teens. I remember it because he told me he and his friend Arthur Niebergal – a curiously German name for the son of a baker – while working there for a time, used to throw pellets out of the window at people. Only because of that story do I recall my father having stayed in Paris. So his French was good. Later on he was to become a teacher of French in the Central School in Bermondsey.

Already, while still a small child, you were able to travel abroad and realised that your father could speak another language. This ability to communicate with others plays such a part in your subsequent life. Had your father been back long before it was agreed that you were ready for secondary school?

No, about as soon as my father came home the decision was made that I should go to Guildford Grammar School, which I absolutely loved. It was quite a long journey: I went by bicycle from Abinger to Gomshall and then had to catch a train to Guildford and after that had a walk of about a mile to the school. Every day, from the age of ten, there and back again. I used to leave my bicycle at Gomshall. When I got out of the train on my return I had, I suppose, two or three miles to ride and it would be dark by then, as I arrived back at Gomshall at about a quarter past five in the evening. When I got as far as The Dene, our previous home, on the incline up to Abinger I had to walk because there was a steep hill all the way up to Ellix Wood Cottages. On the left hand side was the wood and on the right open fields. I was terrified of this wood, which to me was dangerous and frightening, so my mother, on the dark nights of the year, would always come to meet me. I would long for her voice as I climbed uphill pushing my bicycle and then at last I'd hear it – you see the wood was all right but there were openings in it and I was very, very frightened of these black openings. Eventually I'd hear her shouting out, "Coo-ee! Coo-ee!" That must have lasted for two or three years so it was a real toughening up for a little boy.

Toughening you and developing your imagination.

Well, the toughening up was also due to the fights we used to have in the trains. One of our entertainments was to lean out of the window of our compartment – we always hoped to get an empty one – and take a piece of bread or paper or anything and throw it through the window of the next compartment trying to hit the person who was sitting in the corner! I'm not sure that I couldn't still be put in prison for it but it was part of our entertainment. We used to fight in the carriages as well so the journey home from Guildford to Gomshall was dramatic and in winter-time the journey from Gomshall up to Abinger quite a strenuous business. But I was very happy indeed at that school; I even remember clearly the name of my first form teacher, Mr Clayton. I learned my first bits of French and little bits of Latin there.

Did you have art classes?

Oh yes, I always have had. I was painting all the time.

Even at your first school?

Even in the country school we used to make little pictures and at Guildford Grammar School it was quickly recognised that I was good at drawing. I was captain of the form. It's a very curious thing that again and again I've been captain of something.

Where did this start? It's interesting to pinpoint the first occasion.

At Guildford Grammar School.

Very often about the age of twelve art becomes a subject pupils are no longer allowed time for.

Ah, it was not like that at Guildford. We had a very good teacher named Mr Collins who taught me to draw birds. He was a painter of birds in watercolour, and illustrated books; I saw his illustrations later. Having lived in Abinger I already knew about birds but he showed me how to draw them.

He was a good artist?

Yes, a professional.

That is significant because it seems that very often in your life you've been lucky enough to encounter people in the arts who actually were people of calibre.

He was one.

How did you first discover works of art?

At The Dene. I remember on the wall opposite my bed there was a reproduction of *The Light of the World* by Holman Hunt, in colour, and on another wall a Raphael Madonna, in sepia. My father tried to persuade me that the Raphael was much more important while I was trying to persuade him that *The Light of the World* was the one I liked far better! I suppose that really is my first memory of works of art so I must have been about ten years old. I took it for granted that art was what you had in the house. And one of the church windows in Abinger was designed by Rossetti, or perhaps another of the Pre-Raphaelites.

Art in home and church. Since you were living in the country and Hunt's painting depicts a cottage door with weeds growing in front of it this was a subject near to your own experience.

That could be. But it was also the colour – that's the point – it was more like a painting, I thought. I knew both of them as pictures but certainly preferred *The Light of the World*, which much later I saw in the chapel at Keble College.

Soon you were to be introduced to actual paintings rather than reproductions.

At last my father said, "We've got to go and live in London again". And so in 1923 we moved to 71 Hopton Road in Streatham, and on arrival the question was once more where should I go to school.

To come back to London must have been an enormous shock.

It was a dreadful shock which I don't think I ever really got over, partly because when I arrived at Alleyn's School in Dulwich, I suspect through my father managing to exert some sort of influence, I was immediately put into the bottom possible form, Form D.

A big jump. You, who had been captain of your class, were now starting from the bottom in a new school.

The thing I was best at was always games. I was little but because of my country upbringing I was tough and so I became captain of boxing, was in the school cricket eleven and in the school football eleven.

This, I imagine, is rare for an artist. Budding artists are usually the ones taking refuge in the art room.

I was really good at gymnastics and sport of all kinds.

And art? You began to do more at Alleyn's, didn't you?

In the lower forms everybody took art but it was in the sixth form that it was decided it would be sensible for me to become an artist. I was put into Six E, which was Six Economics; I was a moron in economics but I think I had seventeen periods a week of art – I almost lived in the art room. Our teacher had studied with Alphonse Legros at the Slade. His name was Finch and we nicknamed him 'Birdie'. When my father went to see him, because he was interested in the fact that I seemed to be good at art, he addressed him as 'Mr Bird'.

Finch was a practising artist?

Yes, he was a portrait painter.

Once again you were meeting a professional.

He *was* a professional. And by that time my father had already begun taking us to museums.

Can you recall any details of those visits? Would they be on a Sunday?

Most weekends, either on a Saturday or Sunday afternoon when my father had time off, the four of us would travel by bus or train either to the Embankment or by that wonderful tram, which used to go under the road from the Embankment right up to the British Museum, or quite close to it. Sometimes we'd take the bus from Streatham across Tooting Bec to the Tate, National Gallery or the Victoria and Albert Museum. My father was keenly aware that we had a heritage other than our English heritage and made a point of showing us great

masterpieces of the Italian School and then, as soon as I was old enough, fifteen or sixteen I suppose, he persuaded me – I didn't need much persuasion – to go to lectures at all four museums. I was still a schoolboy but we had Tuesday or Thursday afternoons off so I could play games, which I certainly did, or used to go up to the lectures at those institutions. They were wonderful lectures and I got to know one man, Charles Johnson, well enough to see him again after I came down from Oxford. He came to stay with us when we lived in Wedmore after the War.

You were maybe the youngest among those attending his lectures and must have stood out a little. I probably asked him questions. I may well have been one of the youngest and he, perhaps, was interested in the fact that I kept on reappearing.

But you did not consider this work? I imagine most children nowadays would find it irksome to visit museums weekend after weekend; and your father was encouraging you not only to look at painting and sculpture but also to go to lectures and learn more about what you were seeing.

I think in the present context it is very important to explain that it cost nothing. At that time you could get from Streatham to London for tuppence provided you caught your bus or tram before four o'clock. It cost tuppence there and tuppence back so I ran hard to catch my bus before four. Entrance to the gallery or museum was free and to attend the lectures cost nothing. The streets of our cities which we pay for in our taxes are no more important than our cultural heritage. There are countless copies of the 'Ode to a Nightingale' or of *Romeo and Juliet*; I can read them or hear them on the stage or radio or television. A copy of a Beethoven sonata does not cost much and I often have the chance to listen to it whereas a painting by Rembrandt or a piece of sculpture is unique. I have to go to London or Rome to see it since reproductions are no more than a pale reminder. The understanding of our being that we get from a work of visual art is not available in words or in the sound of music. The Davies sisters left their Cézannes, van Goghs and Monets for everyone to see freely but recently the entrance charge has become an effective barrier to studying our national heritage.

What you are pointing out is relevant because even a bus ride can be expensive today for a child. Exactly. Do you know how much it costs to go to the National Museum of Wales for a family of four? Seven pounds. They say, "You know, the children come in classes and they get taught by the experts of the museum". Suppose the child wants to take his parents there? Suppose the whole family wants to go? How often can they? Once a month? Once a year?

It becomes a crucial decision.

It is extremely important. It's putting a knife into the culture of our country.

You were especially fortunate in having another museum, the Dulwich Picture Gallery, not far from your school. Did you visit it now and then?

Oh indeed, and several paintings come to mind from that time by Rembrandt, Murillo, Reynolds or Gainsborough, and in the school hall I remember on either side of the organ large paintings were hung, very probably borrowed from the Picture Gallery as it is actually part of the same Foundation. When I won the Founders' Prize for art it was given to me in the chapel adjoining the Picture Gallery by Sir Frank Dicksee, who was then President of the Royal Academy; I can still recall the occasion. There were actually two prizes for art and I won them both in different years.

So you were the artist of the school?

There were others.

And you won another important prize before leaving.

The Collins Reading Prize. My father, being a Lay Reader, coached me rigorously and I won it. With the money I bought two books which I still have, one of drawings of Titian and the other a translation of *The Divine Comedy* since I was by then starting to learn Italian.

Your father not only encouraged your visits to museums but even went a step further.

As I grew older I began to take a greater interest in drawing. At school there was a cast of the figure of a boy pulling a thorn out of his foot, which I drew. I suppose my father then

thought it would be good if I made drawings elsewhere so he took me to the British Museum and we asked an attendant whether it would be possible for me to draw there. The man was most kind and introduced us to someone with more authority, who agreed that I could; after that periodically I drew Greek and Roman statues in the open galleries and also in the room where casts were stored. The staff even provided me with a place where I was able to keep my board.

Did you also draw in the large cast room at the Victoria and Albert Museum?

I did draw there as well but how I got permission I cannot recall. I was shy of being looked at so I hardly ever went beyond the cast rooms; they were usually empty.

And you also had private tuition.

Some time later my father asked a colleague of his, Harold Jones, from the Central School in Bermondsey, if he would give me private lessons in Streatham. Jones had studied under William Rothenstein at the Royal College of Art and become an illustrator; a copy of a book of children's poems by Walter de la Mare, illustrated by Jones, was presented to the Royal children. The other art tuition I had was from 'Birdie' Finch. I spent a week or perhaps two working in a studio he used in Aldeburgh, learning to paint in oils. That was an academic teaching whereas years afterwards under Cedric Morris I was taught something quite different, an *alla prima* technique.

What happened in terms of music after the family moved from Abinger – did you sing in a choir in Streatham?

I joined the choir at St Anselm's, the local church, and also the school choir. The school had a system of midday concerts, sometimes given by professionals and sometimes by boys; I used to sing solos. The music-master taught me the piano, I sang and, as soon as violin lessons became available, I began to study the violin and later joined the school orchestra. My brother studied the viola but the time came when he had to take an examination and, as it would have been inconvenient for him to attend rehearsals, I said I'd play viola if they let him off. I then gave up the violin, thank goodness, and took up the viola instead.

What caused you to take it up in the first place?

My father's parents had as a paying guest, a Mrs Roberts, who was socially well-connected but had come down in the world; her husband had been in India as a colonial civil servant. She played the fiddle well and gave my mother lessons, so there was a violin in the house and that was the one I learned to play on, a copy of a Diconetti. In my last year at school I tried for singing scholarships at Cambridge; I sang at Trinity and at St John's College. I even remember what I sang: a Mendelssohn, 'Isaac and Israel', one of the great tunes from *Elijah* and a piece of Bach at Trinity but neither of the Colleges gave me a scholarship.

You told me that at one time it was even suggested you might try for a scholarship to Winchester.

The proposal came from my first piano teacher in Gomshall, "Would your boy go to Winchester as a singing scholar?" The decision was no, and I'm jolly thankful it was. I would have been miserable in a public school. I've no doubt of that at all.

You've also alluded, poignantly I thought, to the fact that you felt yourself to be different at Alleyn's because you were small and because of your Italian surname.

I don't think it's surprising.

No, it isn't but, as we both know, an artist's life often begins with feeling somehow apart. It's usually quite early in life when he or she first recognises it.

I think I realised at school that I was pretty stupid because I got nought out of a hundred for maths in my first end of term exam, and nought for Latin. And I could never finish my dictation. I didn't understand at the time that it was because I was dyslexic. Only about two years ago my son Lawrence explained to me that I was dyslexic. I now realise why I hobbled up the school until I got into the Sixth Form. I was and still am a very slow reader.

But throughout your adult life you have read a great deal.

Yes, I have but I've read slowly.

What I noticed, when you were speaking of music, is that a sense of quality and of the history of music, as of art, were given to you while still very young. A sense of excellence ...

Absolutely.

Whether it was singing in the choir or whatever. For you it never became a dreary grind of lessons.

No, not at all. The music-master, Mr Smith, was an excellent singer.; I think he sang professionally. Unfortunately, by the time we did Glück's *Orpheus* at school my voice had broken but I was playing viola in the orchestra. The other person I connect with singing was my father – this is one difference between the world then and now – my father played the piano very badly, he almost taught himself, but loved playing. We would stand around the piano at home and sing folk-songs or carols or, if friends came, they would sing similar things. This doesn't happen any longer. Music has very great value in that it causes people to gather together for something higher than themselves, greater than themselves, so they lose some of their individuality and become associated socially through it. That's one of the great virtues of music.

And that is one of the great difficulties for painters – I noticed it acutely in London forty years ago – we've become so separate from one another, often so envious.

You've got to be alone to be an artist.

Yes, but you have become the chairman of a group of painters and sculptors so you've moved within a body of artists for much of your life – forty years – which is a rare thing to do in this age.

I realised that in our time artists must band together because we are an isolated body of people.

I'm wondering if you learned that from music; is it something valuable you took from one art to another?

Music and games as well. You've got to have eleven to play a game of football or cricket.

Can you say any more about this sense of difference you've already touched on? You were different because you had an Italian surname. Did other boys laugh at this?

Oh yes, and because I was small. And my father had suffered from having a parent who couldn't speak English properly. My grandfather's accent was awful. He swore by Bacchus or by the Madonna.

A curious combination!

He must have been very much a foreigner in my father's eyes as compared with the fathers of others, although my father had been at school with Charlie Chaplin's family, which must have seemed a foreign family too because of being Jewish. My uncle, by the way, was a friend of Charlie Chaplin at school in Kennington, since he was a little younger than my father.

When did you begin to get to know your Italian grandfather as a person? I'm guessing it would be after you came back to London.

It was after I had taken my Matriculation examination, which I failed. I got General Schools, as they called it, and spent most of my time in the art room. Before long my father became anxious and thought I wouldn't earn a living as an artist. I remember a phrase he used, "If you go on like this, you'll spend your life looking through a window at a brick wall". So he went to see the headmaster, Mr Henderson, and explained that he was very concerned about my future because he couldn't believe in an artistic career. He was worried about my learning economics, which I was no good at, and spending so much time on art. The headmaster – I can't imagine why – said, "Well, we'll try him in Six A". Sixth form A was the highest. I'd taken quite good General Schools in French and English but I'd failed in mathematics. Then the question was what should I take my Higher Certificate in? They suggested Italian, the idea being that I should take Higher Certificate in Italian, French and English and give up drawing. But who would teach me Italian? The music-master, a singer, knew some Italian and agreed to teach me but I soon discovered that he didn't know much so my father got a girl from the Italian Institute and I swotted away at the language with her. Then my father carted me off to my grandfather. I read my Italian to him and he corrected my accent but

he had no skill in teaching. I don't think he was particularly interested either, but I can recall what he taught me, first of all, "Vedi Napoli e poi muori!" and then, "In Italia si vive bene!" Those two phrases I remember, with his very careful corrections of pronunciation. Anyhow, I passed my Higher Certificate in these three subjects and tried for Oxford; my friends were going to Oxford or Cambridge and I wanted to do the same but next I had to be taught Latin as you needed to pass Latin to get in. Mr Henderson was a marvellous headmaster in this respect and offered private lessons from two of the masters in their spare time, so I had private lessons in Latin, passed Matriculation and got to Oxford as a Commoner, receiving scholarships and bursaries from other sources. I remember that at the Hertford College entrance examination I had to do a Latin translation and by a miracle already knew the passage to be translated. I scraped in, I think partly because the chemistry-master had been to Hertford and recommended me.

What interests me in this story is your father's concern for you. Here is a man with high standards who wants his son to do well.

And that was what frightened me about him: he was a really severe father although I'm sure he loved me very much. He himself had a very unhappy upbringing. His mother was a most difficult, greedy woman, who didn't give him the opportunities he deserved. He passed what they now call an 'eleven plus' to go to grammar school, which was a very rare occurrence at the end of the nineteenth century, and won a place at St Dunstan's College in Catford. Most of the pupils there were fee payers whereas he was a poor boy from a Board School in Kennington. If something went wrong the headmaster would ask, "Whose action was worthy of a Board School boy?" and the others would turn to look at my father. He became extremely discontented and at twelve started playing hookey and then never went back to school again. After that his mother was always trying to get him into a job that paid more. Somehow or other he got into the Patent Office, a government job with a pension, but then she found a man who would pay a bit extra, so she forced him to leave and earn more, of which she took part.

That was imprinted on you as an adolescent.

I was extremely bad at mathematics whereas he was a brilliant arithmetician, able to do quite amazing things with figures in his head. And he never realised that I had this disability of dyslexia.

On the other hand, in ways he at times suggested, he had a knack of setting you on the appropriate path for what you were later to do. Somewhere beneath this severity, almost in spite of himself, he discovered that drawing, lectures and other languages would be what would take you further. He had learnt French but, strangely, not Italian.

My grandfather read German, French and Italian, which was normal in middle Europe, but my father never learned Italian. It astonishes me that my grandfather didn't take the trouble to teach his son Italian in spite of christening him Vincenzo Ausonio Elvezio.

It looks as if your father felt a need to ground himself in England.

Indeed, whereas his father was much more interested in remaining an Italian fighting for independence, living his life principally in Soho among likeminded Italians.

This is the case with many immigrant families: while the parents remain loyal to the homeland, the children want very much to belong to their adopted country.

Precisely. This was indicative, I think, of the split between my grandfather's family and his working life.

I believe the first-born son in your family is always given a particular name.

Vincenzo or Vincent.

So your grandfather, father, you, your son, grandson and great-grandson have all received Vincent as their first name.

Yes.

But why were you christened Arthur?

After the British king. It was very fortunate because it links me not only with England but with Wales!

It is also interesting to note that in three of the generations you've been teachers.

Professions such as teaching continue because you are introduced to what it means at a very early age. By the time I was five I knew what it was to be a teacher; first it was my mother but later my father. For me it was simply the continuation of a tradition.

And your first wife was a teacher.

Yes, of music and piano.

Another common feature is that you have all been hosts of guest-houses. Your son, previously a teacher, has just opened one recently.

How strange. My paternal grandparents lived at 4 Fentiman Road in Kennington and they took in lodgers. My grandmother, Eliza Jane Sherlock, probably thought my grandfather was wealthy when they married; he would have been about thirty-eight and she about ten years younger. She was an energetic, really very able and beautiful woman, of Irish descent, who had, I believe, several lovers. She owned fine jewellery, probably some it given to her by one of them who was a jeweller – necklaces, bracelets, earrings. She wore many diamond rings and I recall she gave me a tie-pin with a diamond in it when I was twenty-one. Her chest would be covered in jewellery, a brooch with a gold fob watch hanging from it, for instance, studded with diamonds, prickly things as far as I was concerned. When she embraced me I was terrified, though not so much of the prickling, but that I should be suffocated by the volume of her breasts.

She was a vital character and although Irish rather than Italian seems to have had a more passionate nature.

She certainly had and I imagine she made her mark during the Italian celebrations or banquets to which she would go with my grandfather.

You speak very vividly of your visits to your grandparents. What was Lambeth Walk like at that time?

I remember much shouting, each man would be shouting out his wares. As well as shops there were barrows covered with fruit, vegetables and all sorts of other things. The prices were interesting: an item would cost two and three, three, which was two shillings, three pence and three farthings. Mr Shona had a sweet-shop where I could buy sweets for a farthing or a spinning top would cost a penny.

Do you remember some of the cries?

Oh yes, the rag and bone man would shout, "Ragabones! Ragabones!" and that meant if you had any old clothes or any bones you could take them out and he'd give you something for them. Then there was the muffin-man; he came by with a tray on his head and the muffins covered over with a cloth. He would have a bell so you'd hear the bell first of all. Another man who comes to mind is the lamplighter. As it grew dark he would come along with a long pole and pull the chain down so that the gas could flare up in the lamp. It made a hissing sound.

Do you remember the knife-grinder with a large stone wheel?

I do and a scissors-sharpener, a man who'd adjust the scissors, the milkman with his big churn, the coalman or the telegram boy on his bicycle. You didn't always need to go to a shop because the shop often came to you. We now have the fishmonger calling at our house and the milkman, so that still continues to some extent.

What about the barrel organ?

Yes, the barrel organ and the monkey. The great dray horses, they were magnificent, and I must mention the crowds coming home from the Derby. The carriages they travelled in were a kind of bus pulled by horses and inside and on top they would be crammed with excited people. The roads were made of wood blocks and as the carriages were being driven along those on the pavement used to shout, "Throw out your mouldies!" which meant throw out

your mouldy coppers, that is whatever change you've got from having succeeded or failed in your betting. So they would throw down coins as they passed.

It sounds as if it was a much more rumbustious life.

Yes, it was closer to Dickens than it is to me now: it seems very far away. Lambeth was an exciting, energetic area; compared with life today there was very little money but enormous vitality and the local church had an important part to play in all this because the churches were full.

Was this colourfulness of Lambeth in strong contrast to your life in Streatham?

Things have changed a great deal. Streatham wasn't like it is nowadays: it was much more leisurely. We took walks on Streatham Common or Tooting Bec Common and we played cricket on both.

Taught by your mother's father, John Lutman?

He taught me cricket, yes, and gave me his own cricket bat. He was a fisherman too. Whenever he stayed with us in Abinger he used to get permission from the gamekeeper to fish in the Tillingbourne.

A very different man from your father's father. Returning to Vincenzo Giardelli, you've mentioned a division between your grandfather's family life and his work, which might be typical of an Italian patriarch.

My grandfather did, I believe, separate off his Italian life from that of his home. He had fought for the liberation of Italy under Garibaldi in the last battle, at Custozza, and after that there was nothing more for him or many other ex-soldiers to do in Italy so he came to London. He became secretary of the Garibaldi Club in Soho, the *Comizio Veterani e Garibaldini*, and was eventually, in 1931, the last Garibaldian to die in England. The Italian government sent representatives to his funeral, with an Italian flag recently blessed by the Pope to be draped over the coffin. So he was a distinguished man. Quip, the draughtsman, drew a portrait of him making a speech at a dinner, in evening dress and wearing his service medals.

Was that his job or had he done other work previously?

I'm not quite clear. He was secretary to various Italian clubs, I know, but, in particular, to the Garibaldi Club. When G.M. Trevelyan was writing his trilogy on the gaining of Italian independence he consulted my grandfather.

Your grandfather, you've told me, was a great reader of novels.

A voracious reader, when he wasn't cooking – he loved cooking Italian food – and he also used to play the piano, fairly inadequately but for himself, singing Verdi, that sort of thing.

As a boy you would sometimes visit one of these clubs with your grandfather. This seems very Italian, his wanting to show off his grandson.

My father would take me to Fentiman Road and then my grandfather and I would go by tram as far as the Embankment. We would walk up Northumberland Avenue to Trafalgar Square. I must have been quite a little boy and he was a bent old man with a white beard. He would stand on the kerb, raise his stick diagonally in the air, while continuing to look at the ground, grip my hand and after so many seconds, without looking to right or left, walk straight across the Square. He must have done that every day, whether I was with him or not. Once we reached the club the conversation would be entirely in Italian. If anyone poked his head around the door the men would look up and say, "Privato! Privato!" I drank Chianti, ate *risotto alla Milanese* or whatever else they ate. I was in a foreign world.

You were, but being a child you were soaking something of it up.

I was, wasn't I?

And never saying, "I don't want to be here".

Not at all.

So, in a seemingly accidental way, you were being introduced to a world which was to become paramount to you, the world of Italian culture.

Yes. The point is that this varied background has enabled me to be at home abroad. I'm quite at home in Italy or France. And I'm only too happy to be in Kathmandu, for that matter.

Travel and strange places delight you – even if you don't speak the language?

I'm easily at home in the culture of a foreign land.

Your ability to communicate with people, this is rather un-British!

I've never felt any sense of isolation in being British. Never at all.

TWO

When you were about fifteen a chance visit to Wales was to have immense repercussions for you.
That's probably so. A Mr Godber, who lodged with my grandmother, was travelling to Tenby when his motor car had a breakdown at Llanteg, just above Amroth. He was befriended by a local farmer who said, "You can't do anything about your car tonight. You'd better stay with us." So the farmer kindly took him in and next day showed him round his farm. There was a little cottage on the land and the farmer apparently joked, "You ought to leave London and come and live down here. This is the place to be!" Mr Godber no doubt laughed but within three months he'd done it. He gave up London and his job and went to live in that cottage, later moving to another in Amroth itself. He invited my family to visit him; how we fitted into that cottage I can't think, perhaps all squeezed into one room or up in his loft. Anyway, we had our holiday. From there, I remember, we walked down a long path right into Amroth, a beautiful walk. We fell in love with the place and it wasn't long before my father and Mr Godber acquired a lease on The Retreat, my father subsequently leasing The Mead, also in Amroth. I was about sixteen and almost at once felt myself absolutely at home in Wales.

But as you were still finishing at Alleyn's School, your family did not there and then decide to move to Wales?
No, we had this only as a holiday home and, in order to make enough money to have it, we took in foreign students. Quite quickly we became integrated into Amroth and were at that time its only 'foreigners'; the village was entirely inhabited by people who had lived there or thereabouts for generations. Every year an important occasion took place called 'Big Day' when people from nearby came by cart or car to Amroth for a day's outing, and in the evening there was a concert at which I would sing or play the viola. All this happened before the great storm which washed away a whole line of cottages on the seaward side of the road running parallel with the beach. In Amroth at that time every man, practically without exception, was on the dole. It was the time of the Depression and any who did have some kind of occupation worked in their wife's name. The publican, for example, was a woman. It seemed an idyllic spot because you went for your dole on Thursday afternoon by bus to Kilgetty, got it and then came back and lived for the rest of the week tending your garden, helping a farmer, fishing, trapping or shooting rabbits or doing some shadow-boxing on the beach. Families would get a bit of support from the coal – the coal in Dowlais and the coal in Amroth being very different matters. In Amroth they cut it out of the side of the cliff. However, that whole way of life was destroyed when Amroth became so delectable a place to live in that the little cottages began to be bought or leased – as we had leased ours – by 'foreigners'. Amroth is now owned by Mancunians or Liverpudlians. The old village community that we knew is finished and we witnessed the end of it.

Did you begin to feel split between city and country, London and Amroth?
Yes, but more than that. Amongst our first guests in London there was a Jewish girl from Paris, Germaine Oulmann, who came to stay with us when I was fifteen and she eighteen. She had come in order to learn English and remained for the best part of a year, attending London University and learning the language. I became her 'brother'. She was the first grown-up, mature girl that I ever got to know.

Why do you say 'brother' and not 'lover'?
I wasn't her lover, and it was important to me to have a sister.

You saw her more as a sister than as a girlfriend?
I knew of no such concept as girlfriend. She was like a sister because she became part of our family. We would all teach her English, she would visit the British Museum with me or when, for instance, I had an in-growing toenail and had to go to St Bartholomew's Hospital she'd

come with me. We were very intimately brother and sister. I did, in fact, fall in love with her later on but that's a different story. It was she who taught me what it was to have a woman as a close friend.

You've kept in touch with her and her family ever since?

I have. She died in 1996, a grandmother with six grandchildren. As teenagers her children would come to stay with us in Pendine to learn English and quite recently, on one of our last visits to Venice, we were joined by her son, Jean Claude Léon, and his wife Denise.

As a girl she invited you to Paris, so you made your first break away from the family.

I was still at school, I remember, because she used to make fun of me for wearing my school cap in Paris. She was the daughter of a widower, a banker, who lived in Montmartre in rue La Bruyère. I stayed there speaking English – this is the reason her father was glad I was with her because he knew I would help her practise her English – but she began to teach me French. We went about together a good deal in Montmartre visiting her uncle, an antique dealer, Monsieur Fabus, and her aunt, a dressmaker, *la modiste* Jeanne Oulmann. Her father owned the cinema Les Batignolles, where, sitting in a box, we watched a riot in the pit during a showing of *La Grande Bataille*. *Les poules* I used to see about in the streets; this was the Montmartre of Degas and Toulouse Lautrec. She introduced me to a cousin of hers, an artist, Georges Klein, who was a friend of Utrillo. I stayed there about a month and got to know something of the area from the inside. At seventeen or eighteen all this opened my eyes to France! Germaine and I continued our relationship until the War. I recall I was trying for a scholarship at Bailliol when news reached my parents that she had become engaged and was soon to be married. They were so worried about my reaction that they travelled up to Oxford specially to tell me.

Because they knew how fond you had become of her?

I was deeply fond of her.

There's something enchanting about this that would hardly be possible nowadays. The whole process of relating to a woman is usually sexualised quite early on.

I never had a sexual relationship with her.

You could love her almost innocently, we might say.

It's out of date now!

Whereas for you it was a slow unfolding and your staying with her and her father was not considered at all improper.

Not only that but, when she did marry, she straight away invited me over so I got to know her husband well, a fine man.

This first visit to France took place when you were working really hard to get into Oxford, and you succeeded. How did you feel when you first arrived at Hertford College in 1930?

I felt very lonely because I had been part of a family. I had never been away to school; indeed I'd scarcely been away from home.

Was Oxford very class-conscious in that period?

I felt it was, but it may not have been. In any case, other students had a different accent from me. That was very important; I was obviously a cockney.

I don't hear it now but I'm not English.

When my father told my grandmother I was going to Oxford her reply was, "He can't be going there. That's a place for toffs!" And when I returned home after my first term I remember my father mocking my change of accent. I'm extremely interested in accents. Anyway, as soon as I got to Oxford I joined the Ruskin School of Art so as to do some drawing and got into the Soccer XI immediately because I had played soccer at school. But I was lonely because most of the others knew friends from school: the Etonians, Harrovians and Rugbians all knew one another but I knew nobody.

You had a foreign name and were a cockney – did these count against you?

One afternoon I was hanging around the College lodge when the Dean passed by. He looked

at me and said, "Giardelli, come for a walk". I don't think he would have called me Arthur; that changeover happened during my time at Oxford, not much later though. I was first of all Jargles, Jelly-bags, Jelly, Fish, all these nicknames, but eventually did become Arthur.

Who was the Dean?

Tom Boase, T.S.R. Boase, who was later to become the first head of the Courtauld Institute and before that President of Magdalen. He was editor of *The Oxford History of English Art 1800-1870* and writer of Volume X, a very distinguished art historian, so once again...

You were meeting another exceptional man.

He took me for a stroll in Magdalen College gardens. At once I found him interesting: he was what you'd call 'a gentleman', and also a learned fellow. When we came back and he invited me to tea I was really quite astounded because my headmaster, who did me proud, was a very remote sort of man whereas Boase was called Tom by everyone. After that I felt I was in a different world.

Boase was a sort of mentor amidst the complexities of Oxford?

I was never close to him but later on, when he was President of Magdalen, I met him at a dinner-party. As we were chatting, someone in the group said to Boase, "How do you know that about Arthur?" And he said, "Oh, we're colleagues." It was rather like the Queen Mary acknowledging a fishing smack! I was, I suppose, aware that we had something in common which others had not but in most ways he was much closer to other undergraduates than to me since he was from Rugby and Magdalen. I did realise he was interested in the art of painting in a professional manner just as I was although I don't think I ever talked to him, for example, about my close study of the illustrations for *The Divine Comedy* by Botticelli. He'd lent me a poor photographic reproduction of *Primavera*, which I hadn't thought much of, so I did not hold him in any great respect at that time as an art historian. Nevertheless, I remember that when I had my first one-man exhibition in London, at the Woodstock Gallery in 1959, Boase went to see it. I believe he was concerned about me but I didn't have the wit as a student to realise how great a compliment that was.

At that age all you needed to have was the feeling of being appreciated.

It was very important.

The whole world which your Italian studies opened up for you was to become one of the most important features of your life.

Quite right. I had two particular tutors at Oxford: a man surnamed Vincent, who subsequently became Professor of Italian at Cambridge, but more important, was Foligno, Professor Cesare Foligno, who was a delightful man, a bit deaf, but an authority on Dante. The first year I studied Romantic Italian literature under Vincent, and the following two years Renaissance and Mediaeval literature with Foligno. We did the whole of 'L'Inferno' and 'Il Purgatorio' and in the third year I had the opportunity to offer a special subject for my degree. If you wanted to get a First you had to take a special subject but, as I didn't like any of those they offered, I said so to Foligno and asked, "What do I do about that?" His reply was, "Well, you can choose a subject but they may or may not accept it." I chose Botticelli's illustrations to *The Divine Comedy* as my special subject partly guided, I suppose, by Bernard Berenson and a Japanese writer, Yukio Yashiro, who had each written on Botticelli. I got an Alpha Plus in my examination for it: I actually made original discoveries which have formally been acknowledged by the ultimate authority in the matter. Bernard Berenson and Kenneth Clark had noticed that some of the illustrations do not seem to fit the text. When I studied them closely I found that Botticelli was not so much illustrating as commenting upon what Dante wrote, using as his guide the commentary of Benvenuto di Dante. This had not previously been recognised but I proved it in my thesis. After I'd taken the examination, Foligno suggested my sending an article based on my essay to an Italian magazine run by Professor Gardener of London University, but he rejected it. In about 1980 I was invited to study some of the original illustrations at the Kupferstichkabinett der Staatlichen Museen in Berlin. It was

a very great experience to see some of the actual drawings at last. I discussed them with the Keeper of Drawings, Peter Dreyer, who then asked me to send him my article. I received no reply until I prompted him. Ultimately, he sent me a copy of his book in which he acknowledged and used my discovery. My original essay is in the National Library of Wales. That's the only piece of art history where I made any impact, but it was a matter of importance.

In order to write this essay what did you have access to?

Foligno had said, "You'd better go and see Kenneth Clark. He will, no doubt, help you". Clark was at that time at the Ashmolean Museum in Oxford and he did help in that he lent me a book of the illustrations, all of them, which I kept for a year. I studied each drawing and related it to the whole of *The Divine Comedy*. This taught me a great deal about drawing since they are the most wonderful drawings. There is no modelling at all: simple line drawings rather like some by Matisse. If you want to study draughtsmanship, study those illustrations. They are fabulous! So I really entered into the mind of a great artist.

And one of the greatest poets. 'Il Paradiso' you did not study in class but read by yourself; by this time you were able to press on alone?

That's not surprising: I had the illustrations to decipher and that necessitated reading 'Il Paradiso'.

Here you are, a budding artist without realising it, having your first profound encounter with a great work of art.

Those illustrations have remained in my mind ever since.

I know you feel there is something to be said about David Jones's relationship to them. Certainly I believe the figure of Flora in Primavera *is an unforgettable image for Jones.*

It's quite true. He used Flora for his picture of the girl he loved. It is essential for understanding *Petra im Rosenhag*.

And for Trystan ac Essyllt – *turning her round the other way for the figure of Essyllt.*

Jones was a friend of Kenneth Clark and I've wondered if he ever borrowed Clark's book of Botticelli illustrations. After finishing my research on them I thought of doing some work on Blake's drawings for Dante but, when I mentioned this to Foligno, he gave me the impression that Blake was not on a par with Botticelli.

What other aspects of Italian literature impressed you?

Dante was much the most important. Other authors were Petrarch and Boccaccio.

How did your first visit to Florence come about?

There was a Heath Harrison scholarship for anyone taking Italian at Oxford, who wished to study in Italy; you could attend lectures at the University of Perugia. I went in for this prize in my first year but didn't get it. The next year I stood a good chance so my lecturer advised me to enter again. I waited for the moment when I had to apply and the day came when he asked, "Have you put in for it?" I wondered when I should do so and he told me there was a notice in the College porch. When I looked I found I had missed the entry date but my lecturer said, "You are too late but the examination hasn't happened yet. I'll do what I can". He did apply for me but they refused and so I was unable to take the exam. Now, that could have changed my life because I very well might have become an authority on Italian literature. So, thank God, I missed it but I was much aggrieved at the time, as you can imagine. However, the reason I went to Italy was in order to prepare myself adequately for the Heath Harrison scholarship. That must have got me to Florence late in 1931.

Who was paying for you to go there?

My parents, and they had no money at all, which is why they took in guests – in order to send their two sons to grammar school and on to university.

These parents are scrupulous in their attention to their sons' education.

Indeed. And so off I went to Florence for a month. When I arrived I was met at the station by the wife of Commendatore Mariani, in a horse-drawn carriage, and taken to the Pensione Mariani. I quickly got to know two of the young people staying there, one a Swiss girl, Violet Pfeuti, and the other an American, Fairfield Porter. We struck up a friendship straight away.

Violet was a good linguist and a superb violinist and later became a professional. She and I used to attend university together, which I did for the whole month I was in Italy. We would go for walks and visit the museums and Fairfield linked up with us. I remember Fairfield was at that time copying a Raphael, *La Donna Gravida*. He was there to study painting and had another friend, who subsequently became a famous art historian and Director of the National Gallery in Washington, John Walker. He was a bit remote but Fairfield was immediately friendly. We got on very well – he was about my age. We walked extensively over the mountains to Settignano and various other places, becoming quite familiar with the area. It was the Christmas period, December or January, and I went into many of the churches – it was only a matter of knocking up the sacristan and being let in – I remember seeing the great *Last Supper* by Castagno, for instance. Never since has it looked as magnificent as it did then because it hadn't been cleaned. Much later, when I saw it cleaned, I felt it had lost the magic it had for me on that first occasion. Fairfield and I also used to draw together out in the countryside; when we painted by the Arno he gave me his picture and I gave him mine. I've had his ever since and treasured it. Now Fairfield, being an American, was easily able to get an invitation to I Tatti, the home of Bernard Berenson, and he got me one. We walked there from Florence which was a long way but we took that for granted. After we arrived, Berenson said to Fairfield, "Take him round wherever you like," and at lunch Berenson treated me courteously as a guest, asking how I enjoyed Florence. I went into ecstasies over Dante and so on. When I'd finished Berenson said to me, and this was in company I'd never met before and I felt it quite an occasion, "Ah yes, I see. Well, actually, Florence is a sink of iniquity." That I have never forgotten; I felt absolutely crushed. My neighbour at the table was the poet R.C. Trevelyan, the brother of the historian who had interviewed my grandfather but I didn't know that then. He was charming to me because I think he realised I was bruised. It's so easy to hurt a chap of twenty who's not been to Italy before. In a way, in Berenson's own sense he'd treated me as much more grown up than I was. He was generous to invite me but all I remember of him is that. He, of course, didn't consider it cynicism: he was just being his normal clever self. Trevelyan, incidentally, translated the greatest Romantic poet of Italy, Leopardi, whose works I'd already read and whom I still greatly admire.

What did you see in Berenson's house?

There were wonderful things but I can't recall what they were. It was the visit that was memorable. I didn't realise then that Berenson was as important as he was but I already sensed that I was in a very smart, witty world. My later study of Berenson, both as a writer and personality, has confirmed my initial impression.

The Possessed
Fairfield Porter
30.5 x 21.5
lithograph 1932

How did your friendship with Fairfield continue?

After meeting him in Florence I invited him to come and stay with me at Hertford College. He had one of the visitors' rooms for a few days and we dined together. He'd studied at Harvard before going to Florence. After that we corresponded now and then until he died in 1974.

Was Fairfield the first man you met of your own age who really wanted to be a painter?

Yes, he was.

He may well have triggered in you a similar desire.

I think that's possible. I remember one thing very clearly: Fairfield was illustrating *The Possessed* by Dostoyevsky and as we talked about it he asked, "Would you pose for me?" He stuck me up in a corner of the room and began to draw and from the drawing he later made a lithograph, which is still extant. So there is a portrait of me by Fairfield Porter, and 'Birdie' Finch had made a portrait in silverpoint when I was a boy. I think I must have been quite a good-looking boy!

Is this one of the reasons why Boase was so nice to you – that you were an attractive young man? There was nothing disturbing about his friendliness towards you?

I don't know whether this is of any interest at all but I was much disturbed by the attention of men.

At Oxford?

No, not at Oxford, not at all. Before then and, I think, afterwards. I found it astonishing and very disagreeable. At school I first experienced it.

You were studying French as well as Italian. How did the culture of France affect you?

Well, as I've mentioned, the first year I studied Romantic literature, Alfred de Vigny, Lamartine, de Musset, Chateaubriand – I absolutely loved it all – and the great novels of Hugo. It was not till much later that I read Stendhal. After that I had to choose a particular period of study and decided on Mediaeval French.

What made you select that period?

Ah, I know why I did: it was because a friend recommended the finest lecturer in French at that time in Oxford, Eugène Vinaver, who was an authority on Mediaeval literature. He was one of the great minds that I've had the good fortune to meet. He used to lecture on Racine; I attended those lectures but also had private tutorials with him on Mediaeval literature: *The Song of Roland* and Villon, for example. I can still recite Villon by heart. His 'Ballade des Pendus' I think is one of the supreme masterpieces of European literature. I've never read anything else like it.

> Freres humains qui après nous vivez
> N'ayez les cuers contre nous endurcis,
> Car, se pitié de nous povres avez,
> Dieu en aura plus tost de vous mercis.
> Vous nous voiez cy attachez cinq, six;
> Quant de la char, que trop avons nourrie,
> Elle est pieça devoree et pourrie,
> Et nous, les os, devenons cendre et pouldre.
> De nostre mal personne ne s'en rire;
> Mais priez Dieu que tous nous vueille absouldre!

> Human brothers who live after us
> Do not harden your hearts against us,
> Because if you have pity on our poor selves,
> God will the sooner have mercy on you.
> You see us here hung up, five, six;
> As for our body which we have nourished too much,

It is piece by piece devoured and rotted away,
And we, the bones, become cinders and dust
Let no-one laugh at our ill;
But pray God that he may absolve all of us!

This poem gets to the heart of the Christian faith.

And what about the wandering poets of Provence, who made such an impact on Pound – did you study any Provençal?

No, but I read in Mediaeval French Béroul's telling of the story of Tristan and Iseult and also the modern French retelling of the ancient versions of the tale by Bédier.

Talking of the troubadours, what happened to your music at Oxford? You've mentioned your father's amateur interest in music but what about your mother – was it she who had encouraged you in your viola playing?

No, no. My mother supported everything my father wanted to do. She longed to go to Scotland but we never did; instead we went to France or to Amroth. She was intelligent, had a remarkable memory and was fond of music – I remember her singing in a Three Choirs Festival years later – but she always acknowledged my father as head of the family. It was for him to decide what was to be done. She did support me wonderfully, for instance when I couldn't get a certain book in Oxford she actually copied it by hand and sent it to me; her handwriting was beautiful. As soon as I arrived in Oxford I, first of all, joined the Bach choir so I sang in the *St Matthew Passion*. It was one of the wonderful experiences of my life to have studied it deeply: as a bass you know it all because you can hear the other parts above you. And I joined the Musical Club and Union of the University, of which I eventually became president.

The theme of captain of the class is recurring. How did you come to be elected president?

Since I played the viola I was immediately a member of quartets and joined various orchestras; there was, for instance, an orchestra that played for an opera by Rimsky- Korsakov, *The May Queen*. And every week we had a man named Ernest Tomlinson who came up from London to run the chamber music-class. He was the viola player in the British String Quartet and under him I played trios, quartets and quintets by Beethoven, Mozart, Schumann, Dvorak and Brahms. Periodically we gave concerts or played in a College chapel. I became chairman of the College Music Society and president of the University Musical Society and Union. The reason I became president was because I had been made secretary first of all. As secretary my job was to organise a term's eight concerts and then the secretary of one term normally became president the next and so entertained the musicians he had already invited. Lionel Tertis, Harriet Cohen and other celebrated musicians or singers came; I remember particularly Jelly d'Aranyi and Adila Fachiri playing Bach. Jelly d'Aranyi was sheer enchantment, with a fizzy personality. She was an almost biblical character, related to one of the famous Italian families – was it the Borgias?

You obviously enjoyed looking after the visiting celebrities when they arrived.

I did. The Holywell Music Room dates back to the eighteenth century and is the first space specifically designed for making music. It's a very famous and beautiful room; I believe Haydn played in it. That's where we had our concerts and where Ernest Tomlinson used to teach us to play chamber music. When I left Oxford he offered to give me lessons, so after I got a job in Folkestone I used to travel to London once a fortnight to have them. There was a time when he asked if I would like to go and play at Glyndebourne but I declined. He was preparing me to take an A.R.C.M. exam and I could well have become a viola soloist.

Tell me something of your meeting with Tertis at one of the concerts you arranged.

First of all, he made a complaint about the piano not being properly tuned – that was most unlikely. It was a gorgeous Blüthner and we had it tuned frequently. Then we chatted a little and he said to me, "Don't become a professional!" I can't recall much more than that but it

is an interesting remark from *the* great player of the viola. That night he played the chaconne from the Bach solo violin *Partita in D minor.*

At what point did music of the twentieth century enter your life – what would you have heard or played?

Harriet Cohen played from the manuscript compositions by Arnold Bax, and works by him and John Ireland I know were performed at the Music Club. We also played Holst, Grainger, Warlock.

You were hearing contemporary British music but what about Debussy or Ravel?

I used to play Debussy's quartet and *The Blessed Demoiselle* we'd performed at school.

Did you hear anything by Bartok or Stravinsky?

Oh yes, indeed.

These were not frowned on?

Not at all. Oxford was far more aware of music than it was of painting. I did hear a lecture by Roger Fry – but that was an exception! As was T.S.R. Boase in those surroundings.

Tell me how the Ruskin School of Art was run. Could anyone go there to draw?

Anyone who was an undergraduate at Oxford could become a member of the Ruskin. You simply had to sign on.

And could turn up whenever you liked?

Yes, you would arrive, get hold of an easel and start drawing from a model. The first naked woman I ever saw in my life was the model at the Ruskin and I must have been nineteen years old. I can almost see her now and still remember my surprise that she was so different from the statues I had tried to draw at the Victoria and Albert or the British Museum as a boy.

You didn't react as Ruskin did, there was no indelibly negative impact!

Not at all. I thought women were lovely!

Would men pose too?

No. I don't recall ever drawing from a male model.

What about painting?

All I did was draw. That's all I wanted to do but, in any case, I was doing so much else.

I don't know how you fitted everything in!

I was busy. I probably only attended classes for about two terms. Amongst my teachers were Gilbert Spencer and Albert Rutherston but the best was a little, round Jew, Barnett Freedman. He was the one who took a real interest in me, a wonderful draughtsman. I remember he once made on the side of my paper a lovely drawing of his own of the nude girl I was trying to draw. And he would talk to me about music: I think he told me that he'd strung his violin as though it were a viola in order to take a viola part. He was clearly a practising musician and I found out that my music-teacher at Alleyn's knew him. So there was a link-up there. He was a more cultivated man – of broad culture – whereas the others were to me simply artists.

There is a danger in life-drawing, which I certainly experienced, and I'd like to check if it was the same for you. So much attention earlier in the century was devoted to an academic treatment of the nude in art schools that I personally began to rebel after a certain point. I knew I wanted to express something about the figure which academic drawing couldn't help me express. Having learnt how to draw, the whole approach began to frustrate me more and more. Did you have that experience at all in Oxford – or perhaps later?

Not at all, because to me it was a delight like playing music. I wasn't going as a serious student of painting, I was going for sheer pleasure because I loved drawing. I knew when I arrived at Oxford I'd got to carry on drawing and the best way was to attend classes.

So it was a simple activity for you.

Yes.

And there was no feeling of doing it incorrectly?

Not at all. I was simply being shown how to do it.

I'm getting the impression that by not attending an ordinary art school you've never had to submit to a typical painter's training.

I haven't.

That has probably freed you in many ways because you've not known if you were, so to speak, 'breaking a rule' whereas art schools in those days and until my day, or even afterwards, were still places of rules, of particular procedures.

No. I haven't encountered that at all, never really. You see, as a boy there were no rules, you had to make your own things according to your own ability. I think I've always had to find everything out for myself.

Sadly, the breadth of education you received at Oxford is not available to most painters because, by attending an art college, they remain in many ways very poorly educated.

Both the poet and the musician inherit a tradition of work expressed in terms with which they have to become familiar, and painting is no different.

My experience has been that there is often a great lack of general culture within an art college. For instance, classical music, poetry or literature may be of little or no concern to students unless they have to study them.

A lack both in their general sense of culture and in their own language of painting. In their homes artists usually have only their own works and they rarely visit a great gallery. How different from Francis Bacon, for example, or Renoir who when asked, "Where did you learn to paint?" answered, "In the Louvre, of course!" Few of my colleagues know much about the tradition they are supposed to be working in. It's rather like trying to become a novelist without studying Dostoyevsky, without knowing that Homer exists. That's why their work is so fragile.

And fragmented.

I'm not saying that mine is any good. What I am saying is that the way to go about it is to enter the great tradition open to us and for that you need to visit galleries and museums again and again.

You mentioned earlier a photographic reproduction of Botticelli's Primavera, *which you were lent, and said that it was not particularly fine. Even in my time at art college in the late 50s it was not easy to buy well illustrated art books at modest prices. Perhaps, in a way, this was good as well as bad; I remember hearing Paolozzi, the sculptor, describe later how art students are constantly bombarded by imagery: first of all, the entire world of art, then that of newspapers, magazines, television, film and video so that today there are too many visual images.*

They're of the wrong time. What the student or young artist is now bombarded with is contemporary art or what the administrators and dealers have built up as contemporary art, and so they are experts in, say, North American painting but don't know the Mediaeval masters, they don't know the great Renaissance masters. They don't know Delacroix or Ingres. And that is the source you should go to. Modern art is open to all kinds of imitation. We are surrounded by imitations of the achievement of Braque, Picasso, Matisse, or Bacon for that matter. But they don't know the source from which it all comes.

It's interesting that Bacon, being self-taught, was free to look at what he intuitively felt himself captivated by.

His point of departure, for example, is the great Velasquez portrait of Pope Innocent X. And Picasso's point of departure is to copy a Delacroix, Poussin or again Velasquez!

What are you saying here?

That such artists don't imitate their contemporaries, that's my point. Here is what Reynolds wrote in his *Second Discourse*:

> To a young man just arriving in Italy, many of the present painters of the country are ready enough to protrude their precepts, and to offer their own performances as examples of that perfection which they affect to recommend. To follow such a guide, will not only retard the student, but mislead him.

On whom then can he rely, or who shall show him the path that leads to excellence? The answer is obvious: those great masters who have travelled the same road with success are the most likely to conduct others. The works of those who have stood the test of ages have a claim to that respect and veneration to which no modern can pretend. The duration and stability of their fame is sufficient to evince that it has not been suspended upon the slender thread of fashion and caprice but bound to the human heart by every tie of sympathetic approbation

That still seems pertinent.

Although I realise that when you were studying the illustrations for The Divine Comedy *you did not know you were going to be an artist, did you, perhaps, look at them and ask yourself, "Could I ever equal Botticelli?"*

As far as the great masters are concerned, I've discovered that they are far more encouraging than the lesser masters. I hate naming the names of artists I don't like but take an artist like John Millais, the Pre-Raphaelite, as an example. The young Millais I've now realised is a marvellous painter but when I look at a mature work by him I say to myself, "My God, whatever I did I could never do that," whereas when I look at the Botticelli drawings I think, "Ah, I could do something like that!" The great masters I find encouraging. There are ever so many painters, Victorian artists for instance, of great technical ability and mastery in the practice of the art of making big pictures but I have no ambition to paint like them. When, however, I look at a painting by Castagno I don't feel that I'm in forbidden territory. The man who helped me most in this regard was Cedric Morris. He said to me one afternoon when I was at his school in Hadleigh, "I'm going to do some painting. Come with me." He took his canvas and paints and we crossed the river opposite Benton End and then he sat down in the field, put his canvas on the ground, mixed his pigments and began to paint while I watched him. It was so straightforward. That was my practical introduction to the possibility of becoming a professional artist such as he was. His work had already been exhibited in the Venice Biennale. It had been noticed by the great Roger Fry. I recognised that here I was in the presence of a professional. When he knelt down and made a painting and said, "Look, this is the way you go about it," I thought, "Well, I can do that too." It was much more like making my leaping poles than trying to be Millais or Hunt – I've never had an ambition to be Holman Hunt despite my liking his picture as a little boy.

You've mentioned to me that when your father took a lease on a house in Amroth you would go out drawing castles and other subjects. What sort of drawings were you making – were they representational?

Yes. I've always made representational drawings; that's about all I ever make. I sit down in front of a subject and draw it as best I can. But I've come to see that this is an extremely rare thing, a very difficult thing, to do. It's what Cézanne did. He sat down in front of his subject, did his best over three days, seven days or whatever, to give an account on that piece of canvas of what happened to him and to that view by virtue of light and the changes of weather – all this and you've got, finally, to reach the point where you achieve something representing your experience over that number of days. It's got nothing to do with the rules of perspective or anything like that. The purpose, I'm certain, is to allow the artist to understand something he did not understand before. He achieves this by becoming part of a tradition and then developing his own perception, which is expressed in and through the making of his particular images.

In those days it would appear that you were not troubled about how to respond. You had a naïve joy – this is what has been so valuable to you – when you went out to draw or paint. You didn't wonder if Gilbert Spencer or Barnett Freedman would approve of what you did?

Nothing like that.

There were no authority figures behind you.

But there were. My father had taken me to the Victoria and Albert Museum where I saw the watercolours of Turner and Girtin; as a boy I'd got to know these so that when I arrived at Amroth and tried to paint Carew Castle, I was trying to do a Girtin or Turner. I realised that it was the only discipline I had.

This is relevant because later I would like to consider your work as a painter in relation to the British tradition of topographical art, which has produced such a succession of superb water-colourists.

Exactly, but your point here is that I've never had anybody at my shoulder to say, "You don't do it like that. You've got the perspective wrong." I've never had that sort of tuition and I now understand its irrelevance to my interests.

Such learning can take you too far back in time. It seems from what you describe that you were learning to draw but without inhibition and without too much correction. You were drawing at Oxford and painting in the holidays in Wales but at that period you had no thought of becoming a painter?

That decision had been made when I was at school. My art master, 'Birdie' Finch, thought I should be a painter, so I spent all my time in the art room. Well, it was resolved when instead my father decided I'd better go to Oxford, "You've got to become a school-master. Then you'll earn a living."

But in your daydreaming did you ever have the notion that you might be an artist some day?

Not at that time. Perhaps I thought I was already an artist?

Did you do well at Oxford – you got a good degree?

I got a Second Class Honours Degree in French and Italian Literature, with Distinction in colloquial French.

And you were pleased with that?

No, I was disappointed because the reason why I failed to get a First, I imagine, was because I was doing so much else: I was doing my music, singing, viola playing, I was Captain of Soccer at the College and I played cricket.

You've already suggested that you had a near misses at becoming an academic so, if you had got a First Class degree, you'd have been advised to do graduate work and would, as a result, have probably followed an academic path. Instead you followed your father's prompting and decided to become a school-master.

I did.

On the one hand you were disappointed that you had not got a First, on the other, with hindsight, we can say you did something much wiser: you gathered great riches which you were able to make use of subsequently; poetry, literature, music, all had become arts with which you were now famil- iar. Painting and sculpture were already known to you through your visits to museums as a child. How did you prepare for teaching?

I got into Oxford on the basis of a scholarship from London and two teacher training grants, one a national grant and the other from the Thomas Wall Trust, of Wall's Ice Cream – that was for three years and I had to appear before a committee for an annual grant – so having gained my degree I moved to the Department of Education the following winter for a fourth year. After an initial term at Oxford you could take either one or two terms away, practising the art of teaching. I chose the option of two terms away and then returned to Oxford for the summer term because the final term had to follow those you'd spent away.

I believe Sir Michael Sadler had been connected with the Department of Education at the University?

He had been its head until sometime after I arrived, and I remember seeing an exhibition of the paintings from his collection during my teacher training. I'm pretty certain it included a David Jones and, most curiously, the Jones I now own was first owned by him. Perhaps it's the same picture!

If so, one of the many coincidences of your life.

For my teacher training I went to Gresham's School at Holt in Norfolk, which was a very interesting experience indeed because I'd never been to a boarding-school before. I taught French and they also had me teach boxing, which I'd done with great enthusiasm when a schoolboy myself, and I played my one and only game of rugby at Gresham's. But I was very soon aware that it was a school which was extremely keen on music. It was there I first heard Benjamin Britten's name because, although he'd only recently left, he was already winning prizes and having his music performed and broadcast. They were astonished and gratified by his success. There was an aspect of public school life, however, which I disliked thoroughly: you could never meet a woman. That struck me as very damaging. I used to call on the chaplain occasionally because he had a wife who was welcoming; I really did miss the company of women. I missed them so much, I remember, that I cycled twenty miles to Norwich to see Marlene Dietrich in *The Shanghai Express*, and then twenty miles back. It was worth it, I assure you. I've never forgotten it. And I did have one other memorable film experience while at Gresham's: one of the boys invited me to his study to see *The Cabinet of Dr Caligari* with the famous actor Conrad Veidt. The film was projected onto the back of the study door. I suppose these films are unforgettable partly because I could never afford to go to the cinema as an undergraduate. I had very little money. I remember for lunch I always ate bread and butter with blackberry jelly. I had two meals a day, both at the College: a good breakfast and a good dinner. I got my degree in 1933 and a Diploma in Education the following year.

And, tell me, how did you take to teaching? Did you like it?

Like a duck to water. My parents were both teachers and I'd had such good practice teaching the foreign students in our home. Teaching is a great profession: it introduces young people to life itself essentially. That's the purpose of teaching, or it should be. Oh, I loved it.

After your comments about the lack of women at public schools I'm wondering if women were much in evidence in Oxford in the early thirties or was it still a very male environment?

The College was exclusively male and I did feel the lack of the company of women when I was an undergraduate, but there were some who stand out in my mind. Fortunately, I was studying Italian and we were a very small group of eight or ten at the lectures. I can still recall three or four of the women students. One was from Lady Margaret Hall and another from Somerville. I invited them to tea, took them for walks or to Bailliol concerts so I did my best to relate to women of my own age. I also remember one outstanding lecturer who was a woman. My great experience, intellectually, at Oxford was with Foligno, the Professor of Italian, who lectured on Dante. This has been utterly influential in my life, and Vinaver lecturing on Mediaeval French literature, but there was a woman, Mildred K. Pope, who lectured on the *Chanson de Roland*. She was a great lecturer on the subject and, also, over a brief period, she gave me tutorials. In the College Musical Society our custom was to sing madrigals once a week with 'home students', who were women. The two groups met just to sing together, but I recall how surprised I was that we didn't really mix with the women: they were over on one side of the room and we on another. It's curious how awkward the relationship was – except when we began to sing. Then it was real.

THREE

On leaving Oxford you became a master at Harvey Grammar School in Folkestone. How did that come about?

After studying how to be a schoolmaster, in particular a teacher of languages, I had to get a job, but it was very difficult indeed to find work; I think there were over two hundred applicants for the post I applied for. It was after all 1934, during the Depression. I imagine I was selected partly because of my abilities in games and in music. The headmaster was keen that I should take part in both. I was put straight into training the soccer and cricket teams and he wanted someone to take charge of the school orchestra as there was already a kind of orchestra in existence. I was teaching French and did some English teaching, and twice a week taught French and Italian at evening school in the town. I got to know violinists, a clarinettist and a local woman who played the piano well so before long I was playing in trios, quartets, quintets.

Where did art fit in?

As soon as I went to live in Folkestone I joined an evening class at the College of Art and once again drew naked bodies, probably once a week. It's very curious but I could never drop the drawing business.

I like that phrase 'the drawing business'! Speaking of female bodies, how did you come to meet your future wife?

Judy had won the Portsmouth Piano Scholarship to the Royal College of Music, and had spent three or four years there, after which her first job was as a music teacher at Brampton Down, a private school in Folkestone. At the Royal College she had also studied singing and it was made clear to her that being a singer she would need to learn Italian, so she joined my evening class. She came along with a friend of hers from the school, they made a pair, and there was also in the class a young salesman, Jewish incidentally. It's interesting how easily I relate to Jews: they've got such a vivid intellectual power. The four of us began to go out and have dinner together or walk in the country and I remember especially a day when we landed up at some pub or other and Judy sat down at the piano and – just like that – began to play. I was absolutely entranced because here she was playing as if she was herself composing this piece by Chopin. She had a genius for doing precisely that: it came out of her fingers as though she were inventing it in the moment. As you can imagine, I was enraptured by such a gift. She was a very beautiful woman and I fell deeply in love with her and proposed after not very much time. We became engaged on a train travelling from London back to Folkestone. I asked, "Will you marry me?" She said, "Yes", and we continued our journey. I remember also an earlier incident when she was invited to play Mendelssohn's *Piano Concerto in G* with the Folkestone orchestra under a good conductor. I decided to send up a bouquet for her after the concert but sent it incognito. The next time we met there was some discussion, "Do you know, there was this lovely bouquet – who could it have been from?" She rather suspected it was from my Jewish companion but the time came when it was narrowed down to me. So that turned out to be quite a success and I'm almost certain it was soon afterwards that I proposed marriage.

You've mentioned that one of your roles as a teacher was the management of the school orchestra. How did it develop under your guidance?

There was a small orchestra already in existence run by the school secretary, who played the cello. I didn't teach the pupils violin playing, instead I taught orchestral playing as I'd learnt it at Oxford myself and we gave concerts, which I conducted. I remember one concert consisted of the *Kinderszenen* of Schumann, which had been arranged as an orchestral suite, and the boys were taught to dance to it on stage. That was very successful. I also organised midday concerts at the school and one of the people I naturally invited was Judy. Another

recital was given by one of the masters, who sang very beautifully, and I also got the school to buy a fine gramophone so we had concerts of gramophone music as well.

The idea of lunch-time concerts presumably came from your experience at Alleyn's?

Yes, it did. I even tried to persuade the school to buy an organ since we had one at Alleyn's, but they laughed at me. You follow on from what you know out of your own experience.

When Judy and you became very close you formed an amateur dramatic society. Had the theatre been of interest to you previously?

Certainly. My first memory is of my grandfather taking me to a pantomime – I think it was *Jack and the Beanstalk* – where what interested me most was that some rabbits appeared on stage. When I was older my father would take us to see plays or operas; *Carmen* was the first opera I saw and I remember a comedy, *It Pays To Advertise*. At Alleyn's, travelling players would come each year to perform a play by Shakespeare and I acted in plays or played in the orchestra for *The Mikado* and Glück's *Orpheus*.

How did you start your dramatic society?

A French teacher at the girls' grammar school in Folkestone, Vera Walker, now my oldest friend, had a colleague who taught English, a Miss Cody, descended from the most famous of all Codys, Buffalo Bill, I had a colleague from our school, Huston, also an English teacher, so the five of us formed a group round which were clustered a few others. We acted one-act plays, for the most part, publicly on the stages of our schools but we also decided that we would read the plays of Shakespeare and for these we were joined by various other people. One of us would have the responsibility of giving out the parts and each would play several characters – how disappointed I was when we did *Romeo and Juliet* and Judy and I weren't given the principal roles.

Over more than a decade you were gradually made aware of important political developments of the 20s and 30s which for you and your wife were eventually to have dramatic consequences. How did this process begin?

While I was still a schoolboy, among the guests who stayed with us in London were Indians studying at London University, who found it very difficult at the time to get lodgings: they were Indians, coloured people, but we didn't have that prejudice. So over the years we had men who became distinguished in later life, taking their higher degrees or doctorates perhaps at the London School of Economics, for example. It was due to these students that I encountered Gandhi. They took me to their parties and even dressed me up in a turban and Indian clothing. At one of these parties I met Jawaharlal Nehru.

Did you go to one of Gandhi's meetings?

I went to many with them in London.

Which Gandhi himself attended?

I did go to one meeting in Oxford in 1931 where Gandhi spoke. There were not many of us there but it was a moving occasion. For a time I was vegetarian because of some of the Hindus and Jains who stayed with us. One of them, Mohan Sinha Mehta, later became ambassador to the Netherlands. His father had been prime minister of Udaipur.

You seem to have had a whole range of people.

But my mother made a home for them, so I entered into yet another alien culture, this time at an intellectual level. My pacifism owed as much to Gandhi as it did to my Christian faith. Only later did I come to realise that the Christian faith is essentially pacifist. It is a denial of Christianity not to acknowledge that.

Like you I find a contradiction here between the fact that Christ tells us not to kill and a Church which finds ways, from very early in its history, of sanctioning killing.

What put me against war was the teaching of Gandhi; I recognised in his teaching the teaching of Christ. I believe that the Christian faith is a faith based absolutely on love – you cannot bomb and kill, whatever excuse there may be. Those who do believe this stand for something which in the end must win through or the human race will disappear.

You made a remark earlier about feeling at home in Kathmandu; I now see why. Because literally within your parents' house lived men from outside the Western world. And another point, of importance for an artist, is that you began to learn about a nation which did not appreciate the way it was being governed by your own fellow-countrymen, the British. In fact you were learning something about the nature of revolt.

You're quite right.

You were learning about people without privilege in their homeland and this happened around your table in a very simple way.

They were profoundly resentful because they recognised in themselves a kind of aristocracy, which was scorned in our country. And more especially, as you mention, they were scorned by us British in their own country, looked down upon as inferiors. The Indian civil servant, however noble he may have been, had contempt in general for 'the natives' as he would call them.

This word 'contempt' is a pertinent word for you and me since, as artists, we are often looked down upon and we, in turn, have certain comments to make about the society in which we live. We are, whether we like it or not, observers of our society and because of that can become, or appear to others to be, somewhat separated from it. Would you agree?

One of the reasons why I am so much devoted to my village life is because I feel alienated from my civil life. I know that as an artist I am peripheral, so it is important to me to be part of the village community.

To return to your parents' household, here was a family opening its home to people from other countries. You've said already that from your early childhood you had an affinity with Jewish people but now you were becoming acquainted with young adults from a wholly different continent.

I came to realise that it was a great culture outside our own and held in contempt by most of the people I knew, almost without exception, because they understood nothing about it at all.

Going back in time, in your roaming around the British Museum would there have been at that period the wonderful room of Indian sculpture?

I don't remember that at all.

Perhaps, although you were getting to know Indians, you were not initially connecting them with their arts. Were you still thinking more of Egypt, Greece, Rome and the Renaissance?

That is so but through the students I knew about Gandhi, I knew their marvellous dresses, I knew their strange food, which I used to eat when they took me to parties.

Did you hear any of their music?

Yes, I did. I appreciated that it was great music but it took me quite some while to get accustomed to it. I wrote in one of my essays about my experience at a concert of Indian music while I was at Oxford.

> I once had the pleasure of attending a performance of Indian music by a certain Mr Roy. Mr Roy sang to the accompaniment of a stringed instrument, which was strummed, and small drums, which were beaten rhythmically with the fingers. His voice production would have horrified a German voice trainer: his 'Adam's Apple' was high up in his throat, his chin was protruded and he sang through his nose with the result that he made a noise which the bagpipes might make if they were muted. His singing was most unlikely to please European ears. The range of his voice was very small and there were hardly any modulations of tone. The songs were sung in Hindu of which language I am ignorant. I began by disliking the singing: it took me some time to get rid of a state of mind which normally attended on singing. Gradually as I became used to this curious medium the music began to give me pleasure. It seemed to be calculated to produce something like hypnosis. I was reduced to a state of dazed attention.

Your own first direct experience of politics was at Oxford, during the Depression.

I was already aware of British workers' struggles when a boy because of the General Strike of 1926 and my father had considerable Communist sympathies although he always voted Labour, and I personally have never voted anything else. When we heard that the hunger marchers were coming through Oxford a few of us decided we'd do what we could for them because they were going to remain in the town overnight. So we went to where the men were staying, washed up for them after supper and did our best to chat with them. These are distant memories but I remember how concerned we were about what they were doing and can recall washing up again the next morning after breakfast beside a woman from Scotland who was a famous novelist. I can't think of her name! I was surprised to find her there but that was the sort of response this particular experience evoked. Suddenly I understood that something of tremendous significance, something tragic, was happening due to unemployment and when the marchers said, "Thank you for all you have done for us. Will you lead the march out of Oxford?" we of course wanted to say yes. It was a proud thing to do: I held up one pole and another student the opposite pole either side of a large banner on which were the words 'Down With the Baby Starvers' as we walked along the High Street leading the marchers out of town. Gradually we became aware that the Bullers were following us; Bullers are those who serve the Proctors administering the laws of the University where students are concerned. It was only later that I realised we were breaking a University statute forbidding participation in such demonstrations. The Bullers followed and were, no doubt, going to take us into custody whenever we stopped so we continued to march on and on until at last they, and whatever University officials there were, fell far behind. And it was very shortly afterwards that an MP suggested in the House of Commons we should all be sent down, but nothing came of it. For just a moment I had entered into political protest on the side of the unemployed because the conditions people were living in at that time were appalling, but, in a sense I already knew about their grievances because I lived in London, and my father was politically very much aware.

Other students who stayed with your family were to pivot you in quite another direction – towards Germany. How did you first become interested in learning German?

Through Felix Goldner. He and I were in the same house at school but we were very different in that he wasn't athletic at all but a fine mathematician who later became a Wrangler at Cambridge. Although he didn't play a musical instrument he loved music and his mother was very fond of it too. He would take me home to tea and in that way we became close friends so when he won a scholarship to Cambridge he invited me to stay. As soon as I arrived I realised that I would like to study somewhere similar although I was still in the sixth form and only just beginning to study Italian and French in order to get my Higher School Certificate. Felix was a rounded intellectual young person and he decided that he would learn German. He was a Jew coincidentally but, nevertheless, went to Germany, got to know the country well and later on would take groups of boys there from Alleyn's, when he returned to the school as a master. He also thought it would be good if he learned Italian, by which time I was much interested in learning German because I realised that for Europe you needed French, German, Italian and English – later Spanish became important too. Since we were both determined to learn one another's language I began to teach him Italian and he to teach me German. He was a formidable influence on my life: as a result of visiting him I was very interested in getting to Cambridge, so I tried for the Singing Scholarship at Trinity then for a Sports Scholarship to St Catherine's but didn't get either! Then I turned to Oxford.

Around this time you had the possibility of visiting Germany.

Wilfrid, my brother, did an exchange with a boy from Osnabrück, who then came to London and Amroth to improve his English. Eustace was nearer my age and I became friendly with him and the next year went to see him. He was a delightful boy. I'm pretty sure he was a member of the Hitler Youth Movement although he never actually said so; his kind of behaviour, his way of talking to me I found strange but I now realise that it was because he was

enamoured with the notion of the young German hero. However, I liked him very much and made some drawings of him. In fact, I enjoyed the whole visit.

Your next encouragement with the language was from two sisters.

Violet Pfeuti, whom I had met in Florence with Fairfield Porter, came to stay with us in Amroth in order to develop her English and then said her sister would like to do the same. Helen arrived as an exchange to visit us in Amroth and afterwards I went to Berne, where she taught me German and I fell in love with her – I might well have married her – so in Switzerland my German progressed quite a long way.

Your next visits to Germany were to bring you into close contact with the radical political developments taking place in the country.

My father taught French at the Central School in Bermondsey and periodically he would take twenty or thirty pupils to Paris, to Switzerland or to Germany; I would often be included to help with the organising. My second visit to Germany was as a member of one of these school parties, making a trip along the Rhine and subsequently on the Mosel. We stayed in guest-houses where often groups of Hitler Youth were also staying to do their training, and I remember vividly an occasion in a castle where we watched them in the courtyard fighting bare-fisted, not in anger but as a kind of sport, hardening themselves up. How strict the discipline was too, in making your bed in the morning. My father used to say, "You've got to do it perfectly, just as well as they do!" It had to be done absolutely correctly. I got this feeling of some severe physical discipline which was to prepare you to suffer pain or to go to the extremes of your powers. It was quite different from my experience of sports in this country, even worse than army camp I imagine – I doubt whether they make you fight bare-fisted. However, later on when I went to Munich the situation was far more intense, far more challenging. I myself felt personally challenged – I was just a young, inexperienced Englishman. No-one had prepared me.

What took you back to Germany?

Again it was to progress with my German. My father found a family who kept a guest-house. The husband was in charge of sport for Bavaria and his wife helped me a great deal with the language. On one occasion when we were going for a walk in the city she said to me, "Oh, by the way, there's a new story out about Goering." She gestured, "Komm hier!" and we went down a side-street so that she could tell me without being overheard. "They say that he's sleeping out-of-doors now – in the hope that another star will fall on his breast!" This was her daring story; Goering already had lots of medals but was always hoping for yet another. Her husband organised matters so that I could attend classes in a school in Munich because I was interested, being a schoolmaster myself. Before every lesson started a boy in the front row, not the master, stood up and said, "Heil, Hitler!" and the whole class, including the teacher, stood up and repeated, "Heil, Hitler!" throwing out their right arms diagonally. At the end of the period the same boy stood up, "Heil, Hitler!" and again the reply, "Heil, Hitler." What surprised me was that the boy was in charge rather than the teacher. And there was one street which you weren't allowed to walk in without saying, "Heil, Hitler!" as you passed up or down. I never did it, never even went into the street, because I couldn't bear the thought of participating. The son of the family took me to a match, a hockey match against an Asian side, and before the game started the whole stadium stood up and shouted, "Heil, Hitler!" This son was a Nazi and preached Nazism to me. Once he invited me to take an enormous walk in the Bavarian Alps with him, thinking, I suspect, that he was going to walk me to death but he didn't realise that I was at least as tough as he was. Up in the mountains we came to a ridge, which he didn't dare walk across because of his vertigo, whereas I could do it. I think I showed him up a bit – he was extremely combative. He wanted to demonstrate to me that as a Nazi youth he had everything.

Of course propaganda films of great public events made it clear that all young men were meant to be thoroughly fit and well trained.

While in Munich I had experience of their ferocious effort to make everybody timorous of the youth of Germany.

You have a memory of going by yourself to an exhibition of contemporary German art.

I was told it was very important that I go to see this exhibition put on as part of Nazi propaganda. What shocked me was that the paintings were academic and at the same time heavily political, not simply showing how perspective is used or how the study of the human body is part of the artists's concern but aiming at teaching a highly disciplined way of life and celebrating the superior status of this race. It was utterly foreign to my experience of art and I disliked it. 'Kraft Durch Freude' was, I believe, the slogan used.

Were you aware on these visits of mounting antagonism towards the Jews?

Very much so in visiting Munich. In many of the streets there were billboards on which were nailed accounts of what was happening to the Jews; presumably from newspapers run by Goebbels. They were quite terrifying, these notices of the evils the Jews were supposed to have done or were doing to Germany.

Was there any attempt to speak to you about this in the house where you were staying?

Not at all; in fact, curiously, my hostess as I mentioned joked with me in private about Goering. But my friend Felix had asked me to get him a certain book – I can't recall what – and when I asked for it the bookseller looked at me coldly and replied, "Es ist nicht gewünscht" not "We don't stock it", but "It is not required". However, I remember a visit to the Schloss Nymphenburg to attend a concert in the courtyard; and it is that aspect of Germany I would rather refer to because I was especially aware while in Munich that I was in a country with an ancient and magnificent civilisation. The beauty of the city, the splendour of the museums and exhibitions, apart from the political one, or that fine concert I went to – through all this I entered into another great European cultural heritage, and my hostess had, I felt, a sort of ironic detachment from the Nazism I was appalled by. It was a double experience: on the one hand of a great culture and on the other of a situation so cruel and contrary to what I loved and valued. And there was the language itself: I was beginning to try to read Goethe and other writers and already had played the music of Bach and Beethoven so I was well aware of the tradition I was coming into direct contact with.

But for the third time in your life you were faced by political reality: first of all, around the dining-table with Indian students or at the lectures you went to with them, then amongst the hunger marchers in Oxford and now in a much more frightening way.

Oh, quite terrifying. It was that visit which alerted me to the fact that something portentous was happening. They tried to persuade me that Germany was on the side of England against France. A great deal of propaganda was pumped into me but I was protected from it because at Oxford my Christian faith had been deepened intellectually and has never changed.

There are, nevertheless, differences here. Germany was before long to become Britain's enemy whereas what you had learnt around the table was that it was the British who were behaving towards another nation in ways it deplored. And amongst the hunger marchers you could, even more directly, get a sense of ordinary people's grievances against the government of this country. I am wondering if these disparate experiences did not put you against all wars – you knew that the British were not blameless either. And back in 1933, while you were still a student, the Oxford Union had held a debate, which made national headlines, declaring that under no circumstances would students be willing to fight for King and Country. Did you participate in this or were you impressed by the result of the vote?

I do recall the Union resolve; everyone was talking about it and later praised those who changed their minds. The resolution was taken as encouraging for Hitler. I already knew what I believed, because of Gandhi

How was your faith deepened while at Oxford?

I arrived there like any schoolboy but with this great interest in Gandhi. In my first term I took a divinity examination on the New Testament – everyone had to in those days – and I read

the New Testament just about daily. Before long I also became friendly with the Chaplain at Hertford College, Alan Thornhill, who was a theologian, and in discussion with him, in general meeting and friendship, I had my Christian faith intellectually confirmed. He was an able and deep-feeling man who realised this was what I needed. He was a member of the Oxford Group and until war broke out I was a member too. However, when it came to the moment for signing as a conscientious objector and I had to make it clear to them that I was a pacifist they said to me, "Don't relate this to your membership of the Oxford Group," so I said, "I won't." After that I distanced myself from them because, in my opinion, they compromised.

They believed in the validity of Second World War?

Many of them went to it. I speak about this hesitantly because I don't really want to discuss the matter. I'm sure they were acting according to their profound belief but I thought they were wrong and so I left the Group. Their faith may be more powerful than mine but that is my faith.

In returning from Germany something happened which with hindsight is perhaps significant.

When I came home I upset my parents because I told Judy what time I was going to arrive at whatever station it was but didn't tell my parents. They were very hurt – but it was just before I got married.

You were making a break from the family.

I didn't realise it.

The day eventually came when you and Judy did get married. When and where was that?

We got married in London in 1937 from Judy's home. Her father was a Lieutenant Commander in the Navy, so I became closely related to a member of the armed forces. We were married by Alan Thornhill.

In becoming your wife had Judy any idea that she was marrying someone who was on his way to becoming an artist?

Not the slightest idea in the world, I'm sure.

She thought she was marrying a music-teacher who had a gift for the viola?

No, I was a language teacher who played the viola.

And that you and she would play music together with others?

Indeed we did, a great deal.

But you were gradually turning away from the thought of being a professional viola player?

When I left Oxford, I took lessons in London from Ernest Tomlinson once a fortnight for about six years – I used to practise for three hours at night after school. I worked hard at it. Tomlinson suggested my taking the A.R.C.M. and this meant I had to study musical theory. But as soon as I began studying harmony and counterpoint I was quickly aware that I would not become a composer. This was crucial to me because I didn't simply want to be a performer; I wanted to be a musician in the full sense of being a composer. I believe that was the moment when I realised there was a difference between my practice as an artist and my practice as a musician: I painted pictures but played other people's music. I loved playing Brahms, Bach or Mozart, and others. When the war came my mind was already shut off from becoming a musician and, in any case, Tomlinson had to stop teaching me because the whole of my life changed.

What this suggests is that it was at this period you were starting to get more of an idea about your own creativity. Your friendship with the young painter Fairfield Porter had continued and in one of your early letters to him you speak of your wish to become an artist yourself.

I wrote a letter to him in 1934 in which I said:

> I enjoy teaching as you gathered from my letter but am beginning to doubt whether teaching is my line. I know I can teach well but I believe I was built for something else which I could do better. I am haunted by the thought of being an artist. Music, drawing, acting, singing, heaven knows what.

So through the Thirties you would draw when you had time in Folkestone?

I would. I attended the art school in the evenings and I drew and painted quite often. I never stopped making watercolours and also, while we were still living in Folkestone Judy set to music 'I know a bank whereon the wild thyme grows', a beautiful rendering. Since she was a good teacher of the piano we decided to compose songs to be accompanied by very simple tunes, which children could learn. Usually the words come first and the musical setting afterwards, but we did it the other way round: Judy wrote the tunes and I wrote words to the tunes she'd composed. The first book we produced together was called *Up With the Lark*, which was published by the Oxford University Press. Then we were invited to do another, which we did, but that second book was lost.

It never got published?

No, the War came and it was set aside, I suppose, at the Press. But it is a matter of interest, that little book.

By now you realised what your attitude would be towards joining up.

I knew that it was my responsibility to do something so I joined the Fire Service as a trainee and, by the time the War started, had been properly trained as a fireman.

In 1940 the school was informed that it was to be evacuated. As a master what were your responsibilities?

My responsibilities were for the boys in my class, twenty-five to thirty of them. We loaded at Folkestone but the one thing we did *not* know was where we were going. Nobody knew. The train proceeded in a westerly direction and as time went by we saw, as we passed through stations, soldiers standing about and then, later, the platforms would be absolutely crammed with soldiers, wearing all kinds of uniforms; I remember particularly the variety of helmets they wore. It was extremely dramatic. Afterwards, from radio and newspapers, we came to realise that this was the evacuation of France and Belgium, chiefly from Dunkirk. So, as they crowded onto the stations having been driven from the continent of Europe, we were on our way to we didn't know where, further west. The train never stopped. We simply passed through each station observing it all as it was actually happening.

Was this especially awesome for you because of your inbuilt dislike of war?

Who hasn't a dislike of war?

Surely most young men are attracted by war: it holds a heroic fascination for them? A young man doesn't initially realise he may be throwing his life away.

As far as I was concerned we were travelling west. After the War started, you remember, there had been a long pause with nothing happening. Then it was decided that we had to be evacuated because Folkestone was clearly in danger from possible invasion or could easily be bombed. As we passed through these towns we witnessed the British Army leaving Europe, and not only our own but other armies as well.

May there even have been a sudden fear that the War was coming horribly close?

I don't remember that.

These children had been day pupils but here they were in this train realising they were leaving their parents behind. Was there a sense of excitement or sadness?

There was a feeling of considerable anxiety. Where were we going? We had no idea. All we realised was that we were travelling towards some destination in order to get away from the danger which was likely to confront the southern shores of the country.

FOUR

When the train finally pulled into Merthyr Tydfil I felt I'd come home, but the rest of the staff and the children from the school thought, "Oh, my God! We've come to the depressed area of South Wales." It was a real shock to people from Folkestone because Folkestone was entirely different from Merthyr Tydfil, just as England is very different from Wales! Folkestone was a well-to-do town, quite beautiful, clean, and without the difficulties of poverty, whereas Merthyr Tydfil had suffered appallingly in the Depression. It was one of the oldest of the great industrial towns of the world with coal-mines and steel-works. These industries were active again, or were being revived, because the War had begun, and steel and coal were now desperately needed. The whole train-load was horrified that this was where we'd been sent – from marvellous, beautiful Folkestone fronting the sea to this dreadful place. That was the general reaction. Then the question was, "Where will the children be housed?" Well, we were all put up in those streets of little houses, cheek by jowl to one another with scarcely any gardens behind them, whereas in Folkestone children and teachers lived in fine villas you might say. My first act when I got there was to visit every one of my pupils: I went to all their homes and was delighted, but not surprised, to find how well they were received, how comfortable they were made, and I thought, "There's no problem at all; actually they're very fortunate to be in this place." Judy and myself and our new baby were housed with a Mrs Jones, a very kind old lady with a crisp personality and a home that was spick and span.

How did evacuation work? Did each family get a grant towards feeding and caring for the child who lived with them?

I don't know. I wasn't part of the organising.

Did it mean that a family might suddenly be asked, "Will you take in a child?"

Yes, it was almost forced upon people – as an obligation.

It would be simple, working people who housed the children?

I'm not sure what you mean by 'simple'. They weren't simple; that doesn't do them justice. Merthyr Tydfil people were, for instance, highly experienced in music; they were well versed in the Christian faith, which is a profound learning and understanding; they lived in a good community; they had suffered great poverty. It was a very interesting community to enter.

Your work in the Fire Service must have seemed different too because here you were among another sort of men.

My companions, or colleagues, were coal-miners and steel-workers and I soon got well acquainted with them. We became firm friends as you always do in such circumstances. I was intrigued by what I encountered – it was a new life for me.

They took you to see where they worked.

I'm sorry that I never went down a coal-mine. One of the surprises of the place was that in the evening we would see miners coming back on the train, or getting off trains, with black faces and bright eyes. The eyes used to shine out of a black face and a black body. Then they would have a bath in the kitchen and after it they would be spotlessly clean and would go out to practise Handel's *Messiah*, under Mr D.T. Davies, the conductor of the Dowlais Male Voice Choir, who was a famous man in Wales. What excited me in the steel-works was that they showed me the great cauldron being drawn across a rail inside the roof of the works and then, from this red-hot cauldron, the steel would be poured into some container underneath as showers of sparks flew about. This I found astonishing; I became aware of what the Industrial Revolution had come to mean in Merthyr Tydfil and Dowlais because the area had been a world centre at one time. From here it had grown and spread out around the globe.

As soon as your conscientious objection to military service became public, events moved quickly for you and your family.

After a week or two I had to register as a conscientious objector; this was immediately known by the editor of the local paper, with whom I later became friendly, and the results were dramatic. I became front page news in the *Merthyr Tydfil Express*: 'A schoolmaster from Folkestone registers as an objector to military service.' By this time I'd already joined the local Fire Service and my colleagues were friendly, but at the school it was a different matter. As soon as I registered, a teacher at the girls' school who was a pupil of mine, stopped coming to her lesson. The staff of Harvey Grammar School were pretty cold towards me; the headmaster never spoke to me again and the history master, a very nice man and a good friend with whom I'd read Shakespeare in our theatre group, said one day, "Giardelli, I'd like to see you after school." When we met, he said, "I consider you a rat leaving a sinking ship," and that was the last time *he* ever spoke to me.

When did the headmaster terminate your contract?

He immediately applied to the governors for my dismissal. I wrote to them explaining my position and, as far as I remember, had no answer. I also wrote to the Assistant Masters' Association complaining about what had happened but received no answer from them either. Later, when they wrote asking for my membership fee, I replied, "Since you gave me no assistance when I was dismissed from my school, I have no intention of ever belonging to your organisation again."

How did you survive?

Having been sacked from the school, I had no salary so I had to cash in the insurance money I'd been paying towards a pension. All I had was this pension sum and we got free milk because of having a baby. It was a strange time. When they heard what had happened to me, the Quakers nearby got in touch and asked if Judy and I would give concerts at their Educational Settlement, Trewern House, in Dowlais and teach the local children singing. Not long afterwards they also offered us accommodation in the Settlement: we had one room, the use of the common dining-room and the run of the Settlement. What more could they have done? So once a week we'd give a concert towards which the audience made contributions and we taught the children songs, some of which were in Welsh.

How far is Dowlais from Merthyr Tydfil?

They are adjacent; you can't tell the difference really. Merthyr was a fine town and because the owners of the coal pits and of the steel industry became very wealthy indeed some of the buildings were handsome. Dowlais towers above Merthyr; you go up steep hills to get from one to the other and Dowlais was where the actual steel-making and coal-mining happened. The steel-making gave rise to enormous mountains of refuse and when you looked up from Dowlais or from Merthyr to the mountains, which were in fact tips, they were smoking. You could walk on the tips but steam still rose out of fissures in them and it was said that children had been lost in these fissures. I had a friend who used to visit Dowlais, a Hungarian artist named George Mayer-Marton, and he commented, "If I were going to make a picture of hell, this would be it."

It sounds awesome.

It was – I can see what he meant – these tips, still smoking, made by man but gigantic. The energy being released in steel-making for the great railways had gone out over half the world, as far as India I suppose. The residue was still there, evoking a sense of power. Dowlais had its remarkable buildings too: the market place with the stables and a handsome Greek-styled building, which was the library; I also remember a huge arch made of coal. Dowlais was impressive but there was a marked difference between the cottages, which were tiny and ran in lines, each house joined to the other, and the public buildings or the magnificent factory buildings.

Did time hang heavy for you at the Settlement?

A few months after I was sacked, I had a call from the Director of Education in Merthyr Tydfil. So I went down to meet him. He asked if I would teach the violin at local schools,

"We want somebody to teach classes in violin playing." I said, "I don't believe in class teaching. It's an individual matter." "Well, have you ever tried?" was his next question. I said, "No." The situation was that the previous violin teacher had seduced one of the girls he was teaching and was now in prison. They needed a replacement desperately so I agreed to try and began at once.

Teaching a whole class – is it possible?

Well, I did it for four or five years. It was a rewarding job because some of these Welsh boys and girls were very gifted. First of all, I had to get violins from somewhere so my father found a number in Somerset and brought them to me. The children paid for these and then more were produced in one way or another and I began teaching. The headmaster and headmistress were friendly towards me, as were the Welsh generally. We were really marvellously treated in Merthyr Tydfil and in Dowlais by almost everyone; they had suffered the appalling disasters of the Depression and so if somebody was in difficulty they were only too glad to help. There was little antipathy towards me personally; on just one occasion did I have any trouble. When I moved to Dowlais life there had to some extent been transformed because, as I've suggested, suddenly the steel-workers and coal-miners were immensely important to the War effort. They didn't have to become soldiers but many young men were at the War, the sons or husbands of the women who came to the singing classes with their children, so, in the circumstances, my situation as an objector to military service was a delicate one. What happened was this: somebody sent a message to me, "Don't come up to the Pant class tonight because, if you do, you're going to be in for it". Well, we simply went as usual and there in the front row was the man who had threatened whatever it was. The children assembled and we sang while he sat and did nothing. That was the only confrontation that I experienced. Before long, two of the three schools where I taught were made one, boys and girls together, after which I was offered a full-time appointment as opposed to a temporary one, teaching music at the amalgamated Cyfarthfa Castle Grammar School. Ironically, it was host to the school that had sacked me! I suppose the Folkestone school members were astonished to find me on the staff of the new school after only a few months.

Would you bump into some of the people you had taught with?

Two of the staff remained our friends but it was the Folkestone people – almost all of them – who turned their backs. It was perhaps understandable because by that time Folkestone was being attacked from France.

But your wife backed you in your being a conscientious objector?

Absolutely.

Neither she nor her family ever blamed you for this one room in the Quaker Settlement?

No, they were completely loyal, including her father, the retired Naval officer.

What about your own father, who had served as a soldier?

He said to me, "You know we can't support you if you get into financial difficulties." That was about all he did say; he didn't lecture me about not going to the War. He knew I had a little family and that I would get the sack from Harvey Grammar School.

Did you feel any grudge at the time?

No, none at all.

Your brother hadn't joined up by that point, had he?

My brother turned up in his officer's uniform at my first hearing by the Tribunal and sat with me, which was a most generous gesture. The Tribunal – there were five members – ordered me into the Medical Corps. I took no notice of this because our responsibility is to do what we believe we should do and not what somebody else tells us to do. I was a fireman and was by then working in the Educational Settlement teaching music and the history of art. After some time I was called to another hearing, this time by the Appeal Tribunal – I think that's what it was called. There were three members on this occasion and they asked me why I hadn't obeyed. I explained as simply as I could that I was in the Fire Service and was teaching at the

schools as well as at the Quaker Settlement – all that I considered I should be doing. And they accepted what I said.

How was it you went on to become a member of a Conscientious Objectors' Advice Bureau?

It had been set up by the Quakers. One or two people who had been conscientious objectors in the First World War were on it and they asked me to be a member. Anyone who was going to present their case as a conscientious objector was invited to come and see us so that we could advise them on what to do. That was our function.

Did you ever think of becoming a Quaker?

Oh no, no, no. Why should I? I was already a member of the Church of England.

Did you go to the Church of Wales?

As a matter of fact I didn't because I was affronted by the preaching from the pulpit, which I felt was against my understanding of what the Christian faith entails.

Because you saw the Church as backing the War? I very much respect your stance. Was it a sadness for you not to be able to go to church during those years?

I don't remember that. I really only began going back to church when I came to live here in Warren. It is a village and I entered into a completely different community. I felt the need to practise the faith with other people who believed in it.

But in this earlier phase it was more important, paradoxically, to hold to your faith alone?

Well, I certainly didn't go to church!

What was the particular purpose of the Quakers' Educational Settlement?

The Settlement had been established during the Depression. At the head of it was a man called John Dennithorne, who had studied sculpture at the Royal College of Art. He'd had a religious calling and, as a result, had gone to Russia as a Quaker at the time of the appalling events there to help those in the most difficult circumstances. On his return he went to Dowlais, again to help people in great poverty and distress. He was very proud of the fact, and I think justly so, of having got together a group of men to build two houses. He said to me, "Do you know, I'm prouder of doing that than if I had painted the Sistine Chapel." A curious thing to have said.

Was it he who invited you to the Settlement?

He did. After I got the sack he said, "Come and live here," so we left Mrs Jones, the very kind old lady to whom we'd been evacuated, but she would occasionally come up to Dowlais to sell us a cake she'd made in aid of some charity. On one of her visits she saw over the fire-place a reproduction of a painting of Renoir's wife, lent to us by Mary Horsfall who lived at the Settlement next door. My wife Judy had red hair as did Renoir's wife, which in the picture hangs down her naked back. When I left the room Mrs Jones asked Judy, "Did your sweetie do that of you, my dear?"

She wasn't embarrassed by a nude?

By no means. She looked at it with awe. But that does show a lack of understanding of art, doesn't it? She knew nothing about the art of painting but why should she? This is the situation in Wales; I may be wrong but there is still little knowledge of this aspect of European culture. Much has been done to remedy the situation in my lifetime but I think it will take another hundred years to get us to a European level of acceptance that original works of art are appropriate for our homes. Holland succeeded in moving the work of art out of the church and into the home in the seventeenth century but it's never really happened in England and never in Wales. Perhaps, to a tiny extent, it now does occur but it's still very unusual to see a work of art by a contemporary artist in a Welsh home. That is not so in Germany, France or Italy. I enjoy quoting the traveller Peter Mundy who visited Amsterdam in 1640 and wrote:

> As For the art off Painting and the affection off the people to Pictures, I thincke none
> other goe beyond them, there having bin in this Country Many excellent Men in

thatt Faculty, some att presentt, as Rimbrantt, etts, All in generall striving to adorne their houses especially the outer or street roome, with costly peeces, Butchers and bakers not much inferiour in their shoppes, which are Fairely sett Forth, yea many tymes blacksmiths, Coblers, etts., will have some picture or other by their Forge and in their stalle. Such is the generall Notion, enclination and delight that these Countrie Natives have to paintings.

In John Dennithorne you were meeting, as you had with Gandhi and his followers, a very high minded man who actualised his belief.

Definitely.

He must have been a support to you in courageously being a conscientious objector.

Oh, it wasn't courageous.

It sounds so to me.

No. It was the continuation of a conviction: I'd realised that I was going to have to make a decision about the War and I made it. It was simply a matter of intellectual and spiritual conviction.

In your work as a fireman were you called out to many serious fires in Merthyr Tydfil or Dowlais?

No, no. I remember only one or two in Merthyr Tydfil; bombs were never dropped there. The most important calling-out was for Swansea: we were taken to Swansea and spent three days putting the fires out. It looks easy to hold a fire-hose but, in fact, it's pretty hard work because the energy within the hose of the water pouring through is quite considerable; you have to grasp it very firmly. And it was hour after hour that we pumped water into the still burning houses. My first shock was in seeing Swansea itself, which I had known quite well because I'd been to visit it from Amroth as a young man; here it was with no building left standing where we were fighting the fires. Whole areas of certain parts of the town were destroyed. We walked down streets where there wasn't a single house left and I shall never forget seeing a dog sitting in front of what, I imagine, had been his home. The other thing I recall is that the women came out, God knows where from, but out they came and brought us soup, while we did our best with the fires. Each night that we were there we expected another raid but no other raid occurred. I remember also that we were three to a bed. We had to sleep at night but we didn't take our clothes off, we just climbed onto a bed and fell asleep. I can't recollect exactly where it was we stayed but it was a unique experience, that blitz on Swansea.

Was it your worst War experience?

I'm not sure that's true. I don't think you can take it out of its context.

Despite the War and your initial set-back your career began gradually to develop.

After first working for the Quaker Educational Settlement giving concerts and teaching the children of Dowlais singing I was then employed by the Workers Educational Association to lecture on the history of European art and Judy and I continued to give concerts, not only in Dowlais but also in Cardiff.

How did you take to lecturing – I imagine it appealed to the actor in you?

I found out how different it is to talk to mature adults about the arts.

What was the Workers' Educational Association, W.E.A.?

I don't know whether it still exists; I think it may have been incorporated into university extra-mural teaching. It was an association for the purpose of teaching workers: by workers they meant anybody who was at work who wanted to pursue what were called 'the humanities'. We've forgotten this wonderful notion of the humanities, namely the arts and philosophy. The W.E.A. also did a great deal of political teaching.

What sort of people would come to your lectures?

Anybody. In Dowlais it was women teachers from Folkestone girls' school, the Medical Officer of Merthyr Tydfil and his wife, coal-miners, D.T. Davies, and various others – a

whole mixed body of people. I found it fascinating: I greatly enjoy adult teaching because you get back as much as you give.

Would you encourage people to make comments during the lectures?

Oh, indeed.

You always allow for dialogue?

It's essential. A class will gradually become a sort of family and some members became our friends.

And your concerts?

The Quakers owned an old Broadwood grand piano and our concerts were given in The Armoury, a building the Settlement owned a bit further down the hill. It was taken care of by a retired steel-worker. Scottie was a delightful man and one of the remarkable things about him was the way he would pick up a red-hot coal and move it in the fire because his fingers were so much accustomed to handling hot steel. He had a magnificent head: I made a portrait drawing of him, which I've still got. The Armoury was also where my lectures took place and where, from time to time, exhibitions were held. My art history classes were attended by fifteen to eighteen members and there were more for the music.

Did you show slides of some sort?

I did, but it was quite a struggle because the slides were made of glass, two and a half inches square, with a big projector and screen.

I remember these slides. What about an epidiascope?

I never used that damn thing. Instead I always used slides; you could sometimes get a colour slide but the colour was so inaccurate that I preferred to show black and white. I borrowed them, I believe, from the National Museum; somehow or other I got twenty or thirty slides for each evening. Later on I borrowed them from the Courtauld Institute – I think Tom Boase may have helped there – and then from the Victoria and Albert Museum.

And how up-to-date would you come?

My ambition was always to teach the whole history of European Art and it's been my ambition ever since. I'd come as close as I could to the present; for example I'd get Cedric Morris to lend some of his pictures and we'd show them in The Armoury. Cedric was very helpful in these matters.

After some time you found a new employer.

I moved, with Judy, to the University of Wales Extra-Mural Departments of Swansea and Cardiff.

You always lectured on music as a couple?

Yes. I played the viola and Judy the keyboard, the great keyboard music of Europe. She was a superb Bach, Beethoven and Chopin player – a wonderful sight-reader too, otherwise she could never have done all that she did – she would, for example, play for four lectures on the sonatas of Beethoven and three on Chopin. We worked very hard, as professional musicians giving twenty-four lectures each year. I was doing these as well as giving my art lectures. That's how we earned our living. We continued to do this until a year before I left Judy in 1968.

From your work together you developed a particular course, which seems to me to have been years ahead of its time. It included not only the history of painting and music but poetry as well.

I was trained, in a sense, as a literary historian at Oxford: my real, so-called expertise was literature, but I was lecturing on the history of music and the history of painting. I thought how interesting it would be to relate these three arts to one another. So I worked out a course of twenty-four lectures; I might take, for example, three Romantic masters, such as Keats, Chopin and Turner and lecture on each individually. The whole series was made up of artists related to one another either in time or theme. I wish I could find a syllabus; I think I did it for two or three years.

Apart from all this, were you still continuing with your school-teaching?

There were in the beginning three schools that I taught at: the girls' school, the boys' grammar

school and another whose name I don't recall – all in Merthyr Tydfil. The boys' and girls' schools later amalgamated. I soon discovered some potentially brilliant young violinists. The talent was there. I loved doing it as time went on; I had been well trained as a teacher and so was able to keep the classes in discipline and I enjoyed enormously seeing their quick development. At the girls' grammar school there was a Miss Harrison, a cello teacher, and another teacher, Miss Lewis, played the viola so we assembled a little orchestra entirely of strings. It was quite good. We were probably the first children's orchestra in Wales. Czech refugees had come to the town and one man, who played the fiddle, also sometimes joined us and through him other Czech musicians visited Merthyr Tydfil and Dowlais to give concerts, so there was a developing interest in music. Of course, choral music was already an essential part of local life – they were great people for choral singing – but instrumental music started to come somewhat to the fore. Then the Council for the Education of Music and the Arts – C.E.M.A. – began to send musicians so we had many orchestral occasions. These were followed by plays, sent by E.N.S.A., for instance Sybil Thorndike and Lewis Casson came and stayed at our Settlement in Dowlais – Sybil's entrance at breakfast-time was rather like an entrance onto the stage at Drury Lane. She had a glorious way of talking and I was so enchanted that I wrote her a sonnet and gave it to her. The Shakespeare reading group had continued with new members such as John Dennithorne, and Sybil Thorndike and Lewis Casson signed my facsimile of the Folio Edition of the plays.

A more generally cultural situation seems to have been developing.

That was because of the War. There was the idea that the artist should travel and, as it were, give new heart to the people of these afflicted areas – they seem to have forgotten that the need is still just as great!

This is what saddens me about what I'm hearing; now it would be more difficult to bring that degree of culture to many places in Britain and get such a lively response.

I think there's a good deal in what you're saying.

I accept that in some areas the desire for culture continues. Regional festivals are obvious examples.
Sybil was an electric personality and she was also a pacifist, a famous one. She and her husband performed *Medea* and Shaw's *Candida* in Merthyr Tydfil and stayed with us while they toured the plays in the surrounding towns. I remember Sybil asked Judy to play for her – she herself played the piano well – so we all went next door, where there was another Settlement run by Mary Horsfall with a better piano, and Judy performed for Sybil.

This seems very unlike today but now we have television and video. These, with the cinema, have brought about huge cultural changes.

The *presence* of a person like Sybil Thorndike was immensely significant, something quite different.

Has there been loss or gain? The whole notion of mass entertainment has altered our concept of theatre, for example.

This was a time of burgeoning interest in the arts – other than singing. Singing has always been a great gift of the Welsh. One of the things which struck us first when we got to Dowlais was that when you walked about at night somebody might be singing and someone else responding in harmony. As soon as we arrived we noticed it; I believe even Giraldus Cambrensis mentions some such experience.

The one time it struck me forcibly, and moved me too, was on a tube train in London when some Welsh rugby fans began to sing Who Killed Cock Robin? *spontaneously but in harmony. I found this astonishing having often heard the raucous bawling of the Scots or Irish. Here were men singing exuberantly but with a certain sort of beauty.*

That reminds me of once travelling on a train to Llanelli. There was a group of chaps in the carriage and we began talking as you do so much more readily in Wales – you don't talk at all from London to Cardiff but once you get into the train from Cardiff to Merthyr Tydfil it's, "Where are you from, man?" or "Where are you going?" or "My auntie lives there,

number 13 Blue Street. Call on her and tell her you met Neddie on the train." Immediately you are part of a community. On that train to Llanelli one of the chaps looked over at a friend huddled up in a corner and said, "What are you thinking about, man?" He replied, "Oh, I was thinking of the opening chord of *Jephtha*." Where else would you find somebody sitting on a train thinking of the opening chord of Handel's *Jephtha*? I had to buy a record to find out what chord it was!

FIVE

By chance the first artist you encountered in Wales was John Dennithorne, who ran the Quaker Educational Settlement.

John was a sculptor, and a good one. He it was who taught me how to model the head of Judy; it took a long time and still exists in a plaster cast. He showed me how to make the cast and bring the piece to completion. He held classes in sculpture for anyone who wanted to attend but I didn't join one; I was, after all, living and teaching at the Settlement. He brought out the artistic ability of the unemployed men who went to his classes and some of the work they did was impressive. Cedric Morris, for instance, was much taken with it. John devoted himself to those men and felt that the practice of sculpture was something they would put their hearts into, and they did.

Would he put on exhibitions of their work in the Settlement?

He may have done before I went there but I can't recall any. You could always see what they had made here and there in the Settlement.

In view of the fact that you later became a relief-maker did you ever think of doing more sculpture in the round?

No, I didn't.

You mentioned earlier another artist, George Mayer-Marton, who visited Dowlais.

I need first to explain that it was at this time, in 1940, that C.E.M.A. came into being as a successor to another institution whose name I can't recall. As well as music C.E.M.A. brought exhibitions of contemporary art to Dowlais and Merthyr Tydfil and it was in these exhibitions that I first saw work by Graham Sutherland, John Piper and David Jones. George Mayer-Marton was a Hungarian artist with a reputation in Vienna but he'd had to leave because of being a Jew. He was employed by C.E.M.A. to act as a guide lecturer, that is to say he travelled with exhibitions and spoke about the paintings to anyone who came to see them. He was himself a well-trained and experienced painter and sometimes painted while he was in Dowlais. He worked in gouache during that period, which he eventually taught me to use. It was a mid-European convention of watercolour painting that was different from the English, being far more opaque. I later abandoned it but he was a helpful teacher. I don't think he painted on the spot very much although he did work with a devotion to showing

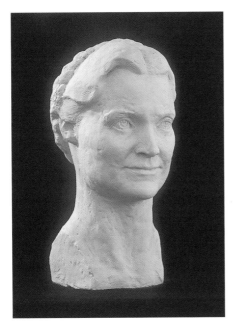

Judy
36.5 x 18
plaster 1943

54

just what he was looking at. He wasn't painting in the tradition of the Impressionists or Cézanne but had a more Expressionist attitude towards art, as you would expect.

Would he sit with you as you painted?

No, he just told me how to do it. We later put on an exhibition of his work at the Educational Settlement and he lectured on it and on painting generally.

Whenever he visited with C.E.M.A. he would stay in the area?

Oh, yes. If he was lecturing in Merthyr Tydfil and Dowlais while we had his travelling exhibitions, he would always stay with Mary Horsfall. Mary was quite a well-to-do lady from Manchester, a fine lady owning a kind of Settlement, Gwernllwyn House, next door to the Quakers. She became friendly with us since she owned a superb Steinway piano, which Judy used to play on.

She was a well educated woman who knew about the arts?

She housed and entertained George Mayer-Marton, as she did Cedric Morris. Cedric and she became firm friends, and that is how I came to meet him. Indeed she had a great affection for Cedric, often buying his pictures. Both of them were much concerned about the distress of the people in Dowlais and Merthyr Tydfil. He would come to stay to help those who were unemployed with some sort of instruction in painting – he believed you could take your art to anybody – and to work himself in Dowlais; in fact he painted the post office looking through a window at Mary's Settlement and other views of the area. His painting was utterly straightforward: he would simply take his canvas and pigments and a mixture of oil and zinc white, look through the window and paint what was in front of him as though it was the most simple thing on earth to do. From working at his pictures and talking with Cedric before long I understood what he was doing and tried to do the same myself. I've always learned in that way rather than by direct teaching; I've had artists beside me and they've said, "This is how you do it". I've rarely attended classes in the usual sense; I suppose I drew for less than a year at the Ruskin.

How did Cedric strike you?

He was a handsome man with a lovely personality, but capable of anger concerning his art. I think he'd started to realise that his own way of painting, his own talent and very great ability were beginning to be ignored. He'd been backed by Roger Fry, he'd shown twice at the Venice Biennale and then gradually, right up to the end of his life, his reputation waned in spite of the fact that he taught Lucian Freud and various other artists of renown. I don't know whether it's a myth or a fact that Freud burnt down the studio they had before they moved to Hadleigh, but that's what Cedric and his friend, the painter Arthur Lett-Haines, used to say. Lett-Haines once came to Dowlais with him and when I asked Cedric to give a lecture at the Cyfarthfa Castle School he said he couldn't talk but Lett-Haines would instead.

How old was Cedric at this time?

In his fifties and very striking, absolutely sophisticated. He'd studied in Paris in 1914 and after the War had worked there again under Friesz, Lhote and Léger. By the time I met him he was a widely experienced artist, famous and very much a gentleman. He later succeeded to the title of Morriston – Morriston in Swansea is named after the Morris family – so he became Sir Cedric.

He sounds very much his own person.

Yes, I've not met anybody like him. He was really intelligent, a beautiful, natural draughtsman, altogether his own man; his independence – that's part of what I admired about him. They chucked him out of the 7 & 5 Society. No doubt that infuriated him but I can understand why – he wasn't part of a movement. There's no-one quite like Cedric although there have been various people who've tried to imitate him.

Was there a certain rebellion there too?

Oh, very strong. I'm sure that's why he devoted himself to people who were suffering. He couldn't be bought. A highly complex personality.

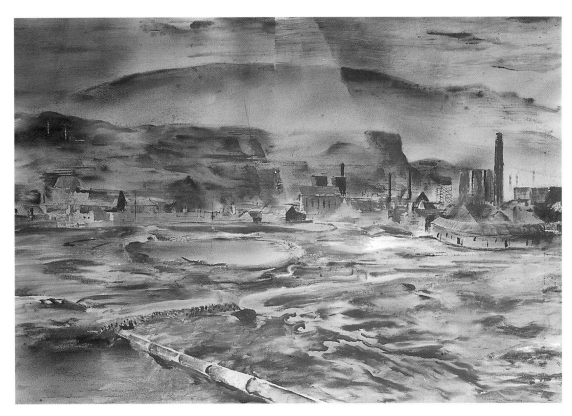

Dowlais George Mayer-Marton 47 x 68 gouache 1943

This man changed your life?

That's true. There was something urbane about Cedric, amused, remote, but he had the power of arousing enthusiasm. His genius was to encourage. His criticism was positive, even if he was given to ridiculing some of your pretensions. He used to make fun of me; he'd pull my leg if I were too serious or a bit pompous. I remember one day I was trying to measure something with my pencil at arm's length and he laughed at me and said, "What on earth do you think you're doing that for?" He couldn't bear anything like that but he was only too willing to praise and that was his secret, "Go on! Do it! You *can* do it!"

He seems to have been much underestimated and it's probably going to take time for us to assess his true position.

He was given a one-man show at the Tate after he died over the age of ninety but I don't know if before the exhibition the Tate owned a work by Cedric. Now they are beginning to display paintings by him.

Meeting Cedric was vitally important for you – I'm reminded of David Jones meeting Eric Gill – he was a formative influence.

I greatly admired him but I also had enough understanding of the arts to be able to separate myself off from him. I was never in his shadow. I'm not suggesting any comparison but he certainly didn't dominate me. He taught me a great deal and consistently encouraged me.

And because of his background he could well appreciate your Oxford education. Whereas many artists would, perhaps, have wanted to ridicule it or put it to one side, he could include it.

He'd been in the Army but had no antipathy towards me although that was the time when I was truly an outsider.

That may have appealed to him.

It could have done.

You later acquired paintings by him?

As I explained I truly was poor. When people say, "If only I'd had the money, I would have bought this, that or the other," I think to myself, "That's actually a lot of rubbish". I was

very poor but I did buy two of Cedric's oils, one of Llanthony and another of flowers, pictures of great beauty. I paid ten pounds a year for them: the first, I think, was sixty pounds and the second fifty. Once when I had no paper Cedric gave me a notebook of his in which there were a couple of drawings. I also bought a watercolour of birds which I've given to a member of my family.

And after Cedric you were lucky enough to meet other, very different painters.

One evening I was lecturing in Pontypridd as part of my University Extra-Mural course on European art – this was organised by a painter, Esther Grainger – and when I finished there came in a man with something of a limp and hair going right across his brow, a little man and clearly Jewish. "I'm told there are painters here", he said and Esther and I replied, "Yes, we are painters", so he had a drink with us and we found out he was a German artist, Heinz Koppel, a refugee from Berlin, and then gradually we discovered he'd been taught to paint by a man who by that time was restoring pictures at the National Gallery in London, Hans Ruheman. These two, by the way, were able later to put on an excellent exhibition of modern German art in Merthyr Tydfil, a superb show for the most part of Hitler's 'degenerate' art. Heinz immediately felt somewhat at home with Esther and myself and we were able to organise things in such a way that Mary Horsfall agreed to put space at his disposal in her Settlement. He had a studio and worked there long after we left Dowlais. Later he got a job in Liverpool teaching painting at the Art College but his start in Wales was the outcome of his meeting with us in Pontypridd.

Through Heinz you met Hans Ruheman.

He visited Dowlais and I remember he encouraged me in my painting. I showed him a self portrait I'd done and he was very helpful with technical advice. Both he and Koppel had been taught their craft in Germany, the great European tradition of oil painting, whereas I was using the 'alla prima' technique demonstrated to me by Cedric. It was they who first explained to me the traditional way to put down a white ground and gradually build up a

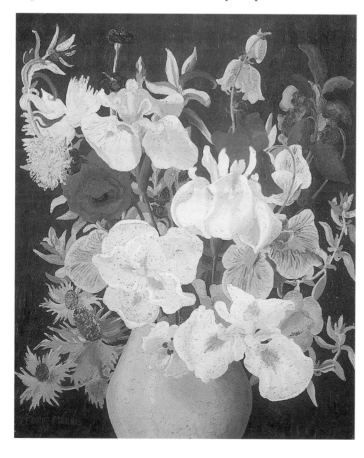

Flowers
Cedric Morris
60 x 49 oil 1939

picture by means of glazes and scumbles over weeks or months. As a result I quite consciously turned my back on Cedric because I couldn't embrace the two methods at the same time. Ruheman was the author of a small book published by Penguin, *The Artist at Work*, which I bought and studied closely. I've subsequently incorporated some of the characteristics of that technique into my watercolour painting because, for various reasons, I later abandoned oil painting.

Did you and Heinz become close?

I got to know him very well indeed; after all, he was our next-door neighbour. However, I found that Heinz, like other refugees at the time, had this mid-European characteristic of supposing us all to be barbarians, as if we had no cultivated understanding of the visual arts. I think 'barbarians' is an exaggeration but I find it fairly difficult to choose the right word. I encountered a similar attitude among the Czech refugees. He felt he had come from the centre of things, which was true of course, to the extreme edge of Europe. He supposed that we knew nothing and he knew everything. That was quite an attribute of his and I imagine it intensified the clash of our personalities and ideas because I realised I knew much more about various matters than Heinz did but there was an enrichment of relationship between us, which grew into quite a deep friendship. I came to admire him while, at the same time, I always had the feeling that he'd a certain blindness to what was not part of this great German modern art achievement. On the other hand, I recognised later that he had an admiration for Cedric Morris, which showed an openness of mind because Cedric's practice was quite different from his own.

Tell me about the portrait he made of you, your wife and children.

He did the painting in his studio; we did not pose for it. It is a strange picture but typical of Heinz. Technically I think it's excellent and inventive. He wouldn't dream of doing anything in front of a subject; he'd do everything in his studio from the image he had left in his mind. It is also a moral or symbolic picture. First of all, he had my wife Judy giving me a cup and you notice that I'm the centre of the thing – that's a Germanic trait, the man being in the

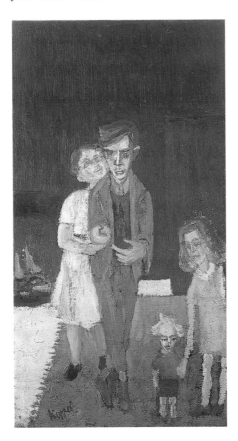

The Giardelli Family
Heinz Koppel
87 x 47.5 oil 1944

centre. First she was offering me a cup and then he realised that she was Eve, so now she's offering me an apple. Then there's this diminution of the animal life in us; he reduces us to some kind of spirits, doesn't he?

You're out of a folk-tale or it could almost be an allegorical story. It has a mid-European quality. That's it. And so you can imagine that with our eyes on Sutherland, Piper and Cedric, when in comes Heinz, altogether Germanic, with a brilliant Jewish brain and painting like that, it certainly was a stimulus, a great stimulus. He was a crucial influence in Dowlais with his varied background and previous association with people who are now regarded as some of the leaders of German twentieth century art. They've got pictures by Heinz in the National Museum of Wales and there's a great collection of his work in the attic of his family home. The trouble is that Heinz and the family have regarded the paintings as so important that they are too precious to be allowed out of their care: they will only sell them for very considerable sums of money and so they are stowed away in the loft. He's still waiting to be discovered although he's been dead some time. And he also wrote and illustrated a remarkable book about the art of painting, which was privately printed.

He sounds a considerable figure.
He was but Joe Herman ridiculed him somewhat. Herman was an open chap. He was a Pole, and he hadn't the intellectual inhibitions of Heinz. Heinz was a Berliner and so there was a restraint about him – I think his intellectual concerns with art inhibited his practice of it whereas the opposite was true of Joe. Heinz was the profound intellectual, as it were allowing his intellect to check the natural movement of his spirit. Nevertheless, having taught at Liverpool College of Art he at last decided he didn't want to teach any longer and simply withdrew up into the lead-mine area of Wales and there it was that he died.

C.E.M.A. was responsible for bringing you close to the work of two entirely different artists, Josef Herman, to whom you've just alluded, and David Jones.
I remember about 1941 or '42 seeing an exhibition in which a couple of paintings by Jones were included. Soon afterwards I went on holiday to Wedmore, to stay with my parents and found there was an exhibition of watercolours nearby in Bridgwater; so I cycled over to see it. In this show was a work by Jones called *The Verandah* which I bought; that was my first purchase of one of his paintings. I also saw another work which wasn't owned, a delicate drawing of a ram with a spear through its side, and I wrote to C.E.M.A. saying, "Nobody seems to own this drawing. May I buy it?"

The drawing of the ram must either have been the endpiece of In Parenthesis *or a study for it.*
That's it. C.E.M.A. replied, It is not for sale but there is a picture *Manawydan's Glass Door* in the exhibition which is owned by Mrs Cazalet-Keir and she wants to sell it. So I bought that instead. It had been owned by Sir Michael Sadler, part of whose collection I'd seen while at Oxford. Then I wrote to David Jones but received no reply. I wrote twice more with the same result – silence. When I got back to Dowlais I decided to write to C.E.M.A. asking if they would send us an exhibition of David Jones and one of Cedric Morris. They did eventually send both and I lectured on each of them. For Cedric's show in 1943 I wrote an article on him in the magazine *Wales*.

By this time you were guide lecturing, like George Mayer-Marton?
I was. In particular I remember an exhibition by Joe Herman some years later in Ebbw Vale; it was the first Herman exhibition to tour in the valleys of Wales. I had to study his work for several days, perhaps a full week I was there, and lecture on it, being in the hall the whole time and talking to anyone who came in. I began to hold him in very high regard as I recognised the tradition he came from, the Dutch and Flemish tradition, with the influence of Permeke especially, and I was interested that he was a Pole. I knew the coal-miners quite well in Dowlais and what I saw Joe Herman doing seemed to me honest and convincing. However, as I lectured I realised that the locals in Ebbw Vale, which was itself a coal-mining community, were offended, many of them, by the pictures – that their husbands, brothers or sons

should be painted like that. I recollect too that in discussion the men were much more diffi-cult to talk to about the work than the women. The men seemed to imply that they knew what they liked and they regarded this as a downgrading of their status, personality and craft as miners, but the women I found much more ready to listen to what I myself felt about these things. I remember a wonderful picture of a man, very tired and spreading his arms right out as though he were being crucified – that sort of mood I was much impressed by – or a mother and baby who looked like a Madonna with Child. I'm sure that when he made these images he had the great tradition in mind. That was my introduction to him and afterwards he invited me to go and visit him in Ystradgynlais, which I didn't do. I'm not sure why. I got to know him later and found him an exceedingly interesting companion and subsequently I interviewed him for the radio, but that was after he'd left Wales.

While in Folkestone, you'd realised you would not become a composer and that the life of a profes-sional musician wasn't of interest to you either. Here in Dowlais, by degrees painting assumed much greater importance for you and in this development your encounters with other artists were crucial – I would say providential in turning you into a professional.

I think it was the fact that these men accepted me as an artist.

Through advising and encouraging you, but did you actually have much time to spare for painting?

I fitted it in. I always somehow manage to do more than is expected.

Were you painting in the landscape around Dowlais?

I was, and now using both oils and watercolours.

Through the War years, although living in Dowlais during term time, you and your wife and two children would spend the school holidays in Somerset with your parents. Now, with the War at an end, you were faced by another decision: what to do next?

In 1945 I gave up my job as schoolmaster and lecturer and we left Trewern House to move to Wedmore in Somerset, not far from Cheddar. The plan was that with my parents and brother, who was returning from Burma, we would run a school for foreign students – a very different type of life!

SIX

When showing me an early drawing of your father you found yourself saying that you thought he had, at a certain period in his life, been ground down by poverty.

He was an intelligent and ambitious man but he couldn't afford what I think a man of culture really needs and so, in order to send his sons to grammar school and collect objects he liked, he used to borrow money and he used to pawn things. He would say, 'Arthur, I've got to go and see the Jew again and you must come with me.' Now you may consider it ridiculous that you should borrow money to buy books and pictures and to send your sons to grammar school, but that was his life!

He must always have organised his money carefully because both you and your brother did go to grammar school and he managed to own two houses in London as well as leasing one in Amroth before you went to University.

I don't think I can comment on that – it was a situation which developed gradually. I imagine the reason why he had me go along with him when meeting the Jew was because he wanted me to understand the kind of difficulties in which he found himself. It may just be that he preferred to have someone with him; I don't know but I feel sure it was to teach me something.

Did he perhaps want to show the moneylender that he was a reputable man: his son by his side and nicely turned out?

I can't say.

In those days people didn't go to a bank – they went to a moneylender?

I'm not able to speak for others; this is what my father did. He may have borrowed from a bank or building society to buy the houses; I remember both houses in London were bought on mortgage. After we moved, the first house was let out in three flats and my father continued to own it until it was bombed in the War.

You mentioned that your father bought books.

And pictures. They were not pictures you would consider to be of importance but in my life they were very important. I've already spoken of a reproduction of a Raphael Madonna and Holman Hunt's *The Light of the World*. Another of his purchases was an original oil painting, *The Raising of Lazarus*, by a follower of Benjamin West. Whenever he found things of interest to him he would try to buy them. We had a piano and an organ, a very good organ which I've still got, made by Constant Laurent with fourteen stops and two keyboards. We used to sing to it as he played.

There was an aesthetic side to your father?

Oh, very much so.

But particularly in his buying of books. Did he inherit your grandfather's interest in literature?

Not only that. He inherited some of his books. My father was a natural intellectual and loved reading in French or English. He developed a very fine collection of books, especially illustrated ones. I was brought up with the notion that part of the delight of a book would be the pictures in it and one of the earliest memories I have is of turning the pages of a book called *The Costume of Russia*. It was printed in 1811 with a very wide range of the types of costume worn by men and women, poor and wealthy. These costumes were often of great splendour and all the illustrations were coloured by hand in this very beautiful leather-bound book. And he loved books about flowers: he had the *Flora Londiniensis* of Curtis, which is illustrated with magnificent engravings, again coloured by hand, in two great, leather-bound volumes and he had others, which were partly for medical purposes, of flowers of the garden or of the fields. He also collected a botanical magazine that Curtis had founded at the end of the eighteenth century and owned the first sixty volumes of it. I grew accustomed to look at books for the qualities of their illustrations.

There is a long tradition in England of quite exceptional illustration.

Yes, part of the richness of British art certainly has to do with the skill artists have had in illustration, much enriched by Hogarth, who would sell engravings made from his story pictures, and this genre was carried on by that marvellous satirical illustrator Gillray. My father owned a book of Gillray and he and then I bought early editions of Dickens, illustrated by Boz and Cruikshank, and Surtees, illustrated by Leech who worked for *Punch*.

So, in many ways an ideal father for a painter?

That's true, and he also took us to public galleries and museums, as I've said.

Here he was not like his father – he seems to have been more artistically inclined?

I don't know how aesthetic my grandfather was. He was a great reader of novels but all Italians are versed in the arts of their country. My grandfather was very proud of being Italian: you can't be Italian and not be proud of Michelangelo or Dante! It's quite different from our British culture. Of course my grandfather knew the Italian tradition of painting and I can remember him strumming on an old grand piano, singing Verdi.

Your parents moved out of London some years before you joined them?

What happened was that my father decided to give up his job teaching in Bermondsey before he got his pension and, since the owner of the house in Amroth had taken it back to run as a guest-house, my parents went to live in Wedmore in 1938.

Wedmore Hall was the great house of the village.

It was the most splendid house in Wedmore, a Georgian mansion of considerable dignity standing in four acres of land with an enormous lawn surrounded by beech, yew and cedar trees. Wedmore was a magnificent little village and the local church a quarter cathedral – I believe that is the technical term.

It was a very courageous act to give up work early and put everything into this enterprise.

It was.

Socially an amazing turnabout had taken place. Your father had grown up in what you described as nearly a slum but now, through dint of effort and with a very resourceful wife, he had emerged into almost being a local squire.

He never acted the squire. He was never a true countryman but he learned to deal with the garden. That he was very much interested in and developed it splendidly. He cultivated a fine vinery and an orchard of apples, pears, plums of various kinds, figs and a mulberry tree and, being in Somerset, he had a cider press. He thought Wedmore would be a good place in which to develop another school for foreign students and a guest-house for visitors, as he'd done in Amroth. At the end of the War we all agreed that we would work together and once it was decided I moved from Dowlais, giving up my work as a teacher because by that time I was determined to become an artist and it seemed to me reasonable to suppose that we could continue our business and there would still be plenty of time for me to practise my art, which I did.

Your family suffered from a certain amount of hostility when the War began.

Two years after my parents and brother moved to Wedmore War broke out and because of our Italian surname they came under suspicion – in the village they were seen as 'foreigners'. My father felt himself being watched by the local policeman for some time but then he wrote to an eminent solicitor he knew in Bristol, who spoke to the authorities on his behalf, and it stopped.

When your brother was promoted to Major that must have made a difference.

It did indeed.

On arrival your principal job was to teach the foreign students English?

It was. I had, in fact, already helped with teaching in the school holidays while we were still living in Dowlais. The students came from Holland, Switzerland, France and Scandinavia.

And, since you were all teachers, your brother and father also taught. Presumably, you divided up the day between you?

Yes, and then sometimes in the evening Judy would perform or we both would.

A full curriculum?

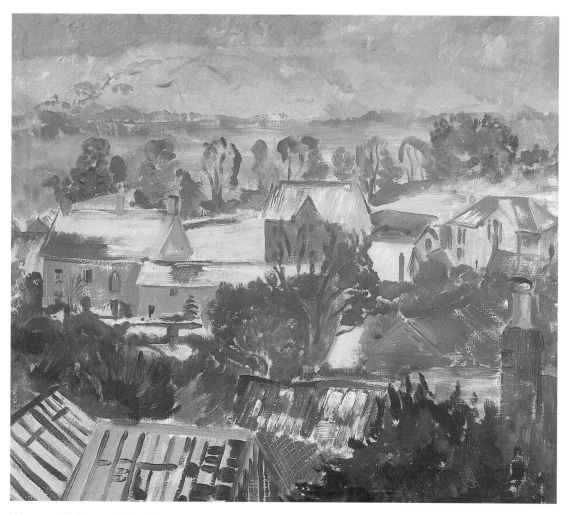

Winter in Wedmore 44.5 x 52.5 oil 1945-6

Absolutely, at certain times of year. There was the big garden that we had to keep going, and as well as foreign students we had families of English holidaymakers so that the students would learn English in conversation with English people; otherwise the danger in such a school is that students who speak the same language talk to one another and learn little English.

The guest-house was run by your mother and she was also in charge of the kitchen?

She was a good cook and organiser.

Her country skills came back to her?

They flourished at Wedmore. Having read up about beekeeping she kept bees and also hens, geese, goats and rabbits.

But that wasn't all she did.

During the War a prep school was evacuated to the big house next door and Mother went back to teaching full-time since they were short of a member of staff and our business was mainly during the holidays.

Had she given up teaching when you moved back to London from Abinger?

She would teach the foreign students who stayed with us. Another memory I have of her during our time in Wedmore is as a member of a choir singing *The Messiah* in Wells Cathedral.

And would Judy help your mother in the running of Wedmore Hall?

She would but Judy had two young children of her own. Gradually it became clear that whereas Judy and I wanted to be musician and artist the rest of the family was devoted to the guest-house – and that situation couldn't really last forever.

At what point had you consciously decided you were going to be a professional artist?

I think it was about the time we moved to Wedmore in 1945 because my concentration upon art began to be irritating to the rest of the family. Although they accepted it intellectually whenever I was supposed to be having a free period and was busy painting I think they felt I was neglecting my duties as one of the organisers of the business. Actually, for some of the year there was plenty of time because the guest-house and school were open largely in the holidays – summer, Christmas and Easter – and for the rest I wasn't lecturing. I did return to Wales for a guide lecture tour, or something like that, but for the most part I was painting, painting hard. I had by this time the confidence, having been taught by George Mayer-Marton and Cedric Morris.

You were always working in front of nature?

I always was, as did Cedric. I'm not sure about George; he was rather a slick painter but very skilful.

Wedmore seems to have given you much needed time to develop your art. Were many of your early oils done in that year?

A number of them were. I started painting oils in Dowlais and then continued at Wedmore. Back in Dowlais I'd made some oil paintings based on what Cedric taught me and saw that it was perfectly simple: all you did was take your palette and your various pigments – he sold me pigments which he assured me were sound – squeeze them out and mix them, adding a bit of white, and then, by the time you'd covered the whole canvas, that was it, like Cedric.

There was no concern about the composition having to be adjusted once you'd filled it in?

No, no, no.

Just the sheer joy of making a painting?

Well, in my mind's eye I not only knew European painting, I'd been lecturing on it.

For some artists that might be precisely what would make their own work difficult; they would feel the weight of this huge kit-bag of tradition on their back.

For me it wasn't a difficulty but a support.

Was it from Wedmore that you went to Cedric's East Anglian School of Painting and Drawing in Suffolk?

It must have been, although one of the visits could have been earlier. I know I went a couple of times to Benton End to work with both Arthur Lett-Haines and Cedric, long enough for me to become accustomed to the extraordinary atmosphere and to feel quite at home. Lett-Haines was a marvellous cook and while cooking used to draw on the walls of the kitchen, so you sensed you were in a most unusual situation! I think I learned there all that I could that was deeply important to me. The whole spirit of the place was very industrious. It was a kind of confraternity of artists, ambitious artists, working really hard and helping one another, a company of people eager to achieve something as painters. Part of the discipline was that we were all treated equally. If anyone seemed somewhat bumptious or showed off Cedric would...

Prick their bubble?

Exactly. He would make fun of you, not cruelly but sharply enough for you to realise that we were all on a level and were trying hard to do what we could. His method was one of encouragement; he taught you to accept what you did and not be ashamed of it. It wasn't a matter of rules – there wasn't a proper way to do things; you were just expected to paint and what you did was appreciated. You always felt he was behind you and that he liked what you were doing. When occasionally I painted watercolours Cedric would say, "Show them to Lett. He's the authority on watercolours," so I learned a great deal from each of them. On one of my visits I fell ill – I think I'd eaten too many plums – and a woman who was very kind to me indeed was Kathleen Hale, who created *Orlando, The Marmalade Cat*. In one book she has both Cedric and Lett-Haines as characters.

Cedric is also considered to have been a fine plantsman with a remarkable garden.

That was why my father was interested in Cedric; Cedric brought him a whole variety of iris tubers when he visited Wedmore because he knew my father loved gardening. They got on well together.

Josef Herman, I'm told, remembered the garden at Benton End as full of weeds. I'm not sure that would be an altogether correct description – unless he saw it in its early stages.

I don't remember it being like that. Cedric was a gardener, not meticulous but energetic, and every year there was a proliferation of wonderful irises.

Perhaps it had a certain wildness?

More a grandeur, it was a grand garden. Joe Herman was not a gardener whereas I have been, have had to be!

Would you paint in the garden?

Yes, we did, when the weather was appropriate. And Cedric would paint his irises – just put them in one after the other. I think he was quite erroneously dismissed by critics because he was a good painter, a real and genuine one. He didn't imitate anybody else but practised his own art with considerable ability according to his gifts.

To me he's a painter with an urge somewhat similar to that of Mark Gertler, wanting to make a sort of folk or popular art in a culture which had lost that kind of bold, direct image-making, although later on in the century Pop Art was to rediscover it in the commercial art of magazines, comics, newspapers and advertising. I see this aim particularly in his flower paintings, those of birds or a number of his portraits.

Cedric's technique was simple and he had confidence in his own view of things. When I look at his birds or flowers or dish of eggs I accept that they are like that. But I see them afresh and am delighted. One of his paintings, of Llanthony valley, I look at most days of my life.

Cedric prompted you to make the next move with painting.

Yes, the day came when Cedric said to me, "You ought to take your work to London and show it to dealers." "How do I do that?" I asked. "I'll give you a letter recommending you to Rex Nan Kivell of the Redfern Gallery," he replied and did as he promised. Subsequently, over a number of years, Rex took my work for mixed exhibitions. From the late 1940s onwards.

You seem to have invited many of your friends to Wedmore.

People I'd got to know in Wales came to see us, Cedric, as I've said, and Charles Johnson. I read some of his writing on art. A close relative was the poet, Lionel Johnson, and his father, I think, was Professor of Logic at Cambridge, so it was a distinguished family. Charles came and he painted; he loved painting. We also invited George Mayer-Marton not only as a guest but to take classes as he had done in Dowlais: we arranged a weekend course in watercolour painting and people painted out on the lawn. He was a sophisticated man, highly cultivated, a musician as well as a painter; he played the violin brilliantly – although not very accurately!

Here's another artist who played the fiddle, as Barnett Freedman did, so art and music were never difficult for you to combine.

No, they weren't. Another of our guests I've remembered, who stayed some months with us was a Mrs Casement, related by marriage to Roger Casement, who'd been hanged as a traitor. She was a beautiful, charming woman, who painted and gave me one of her brushes.

It sounds fascinating, so what led you to move from Wedmore?

Before long I felt a certain nostalgia for the life in Wales but what all of us decided, after about a year and a half, was that we missed the sea and we hadn't realised how important the sea was for our guests, so from Wedmore we hunted for a house back in Wales, as near Amroth as possible, and found one, Broadway Mansion, in the village of Broadway about two miles from Laugharne. The house overlooked, from some distance, Pendine Sands and below the garden ran the road from Laugharne to Pendine. It also had vines, gardens, a splendid conservatory, a billiard room and even an engine to generate the electricity and a windmill to supply water. My mother once again kept chickens, geese, ducks and her bees as well as rearing turkey chicks and fattening a pig. My father made another beautiful garden

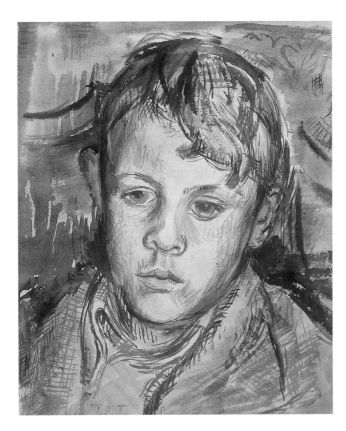

Lawrence
32 x 25.5
watercolour 1950

of flowers and vegetables, tended apple trees and raspberry and blackcurrant bushes. Why? Partly for pleasure and because rationing was still a factor. Our paying guests wanted something better than dried eggs or minced meat so somehow we needed to find food or go bust. I used to call round to local farms buying eggs and chickens. My father told me of a conversation he had with the priest at Laugharne about rationing problems and how to get over them. "Here we are a law unto ourselves, Mr Giardelli," advised the priest, whose name I've forgotten but whose face I can see. Then the parish pump was a reality!

Did the problem of your being a painter continue at Broadway Mansion?

We worked together as a family for another eighteen months. I painted portraits of the guests, one of a young Swedish woman, Margaret Magnuson, who later married my brother Wilfrid, but perhaps one of the best was of my son Lawrence, done somewhat later at Llethr. When we arrived, the situation was rather curious: half the house was still occupied by Mr and Mrs Thompson, who sold it to us on condition that they could remain until they managed to find somewhere else to live. Mrs Thompson was Russian; I admired her a lot and asked if I could paint her. I did her portrait, which she liked, but her husband didn't care for it at all. She had a contemptuous disregard for his opinion, I recollect, saying, "The trouble is that he can see no further than the feet! If he met a giant, he'd see no higher than his stomach!" My picture wasn't much good in any case but I remember the thrill in meeting this woman. She was something quite exotic.

Almost inadvertently Cedric set in motion another series of meetings.

Cedric had painted a portrait of Keidrych Rhys and suggested I meet him. Keidrych was born Jones in Bethlehem in Carmarthenshire, but had changed his name. He was a big man and eloquent, a poet and married to one, Lynette Roberts, whose own poetry was published through T.S. Eliot by Faber. Keidrych founded the periodical *Wales*, a national magazine, and set up the Druid Press in a small room above a shop in Carmarthen, where I used to drop in and talk to him. From there he published R.S. Thomas's first volume of poems called *Stones of the Field* in 1946 and in the magazine he published writings from Aneurin Bevan to Augustus John to Kafka! He struggled gallantly to keep it going, partly by exaggerating the

number of copies he was able to sell. I wrote a couple of articles for *Wales*, one of them on Cedric. Keidrych was a heroic person, part of the history of Welsh poetry.

Was it Keidrych who took you to meet Charles Morgan, the novelist and playwright?

Charles Morgan and his wife Hilda Vaughan came down from London quite frequently to stay in their cottage overlooking the estuary at Laugharne, just above Dylan Thomas's house. One late afternoon Keidrych suggested, "Let's call on Charles Morgan." I agreed willingly and when we got to the cottage Keidrych said, "Well, knock at the door!" I said, "You do," but he replied, "I don't know him." I was astonished and a little dismayed. However, I did as he said. The door opened and Charles Morgan looked at us both in some surprise. Keidrych or I asked if we might come in and speak with him and he agreed. He took us inside and we began chatting and as we went on he invited us to dinner. I remember we had cockles. That was the start of my acquaintance with him. Later Charles and Hilda used to come and hear Judy play at Llethr and he commissioned me to make a drawing of his wife, and then she asked me to make a drawing of him. My drawing of Charles belongs to his daughter and that of Hilda to the National Library of Wales. One of the most intriguing things about Charles Morgan was that he had lived another life. One evening a couple of our students came back from the beach to Broadway exclaiming, "Nous avons rencontré Charles Morgan." I thought to myself, "How the hell do French students know who he is?" but he was, in a way, more distinguished in France, having been awarded the Legion of Honour for his part in the French Resistance.

Did you read any of his novels or plays?

Yes, I did. I read everything up to the one I found I didn't like any longer, and his wife gave me a couple of her books. Actually, I enjoyed Hilda's novels more.

Was it also while you were at Broadway Mansion that you met Dylan Thomas?

Keidrych took me to meet Dylan and Caitlin, his wife, in Brown's Hotel in the main street of Laugharne. They lived in the Boat House overlooking the estuary and his parents lived near the hotel. By the time we moved on to Pendine I knew him casually. One day I had a phone call from the secretary of the Tenby Art Society saying, "Dylan Thomas is to lecture to the Art Society but we understand that recently he was going to make a speech at a dinner given by the doctors of Swansea and he simply didn't turn up. What can we do about this?" I replied, "If I were you, I'd send a telegram." Well, they did and got a message back from Dylan, "You need not have worried, I'll be there." Dylan didn't give a damn for anybody. The doctors were probably going to have a grand dinner and had asked him to make a speech without payment. Anyway, I decided to go and hear Dylan in Tenby. He was to speak in a hotel room. We waited and just about on time Dylan came in and sat down at a little table; I thought that nobody was going to be able to see him as the place was packed. Dylan started and for three or four minutes he insulted the audience, "I don't know why you turn up here. You don't really take any interest in poetry. You don't really want to listen to what I have to say" – that sort of line. He ridiculed them for coming but, having got them all sitting on the edge of their seats, he then spoke superbly about certain poems and poets, reading poems but not his own work. It was electrifying, a masterly performance, with his wonderful druid's voice. At the end I had a problem: I had to get back to Pendine but there were no buses and it was a long walk so I went up to him and asked how he was getting home. He said, "I'll take a taxi so come with me," and he took me back to Laugharne to meet his parents, who were very friendly.

Around that time I met him on a bus and we chatted about a mutual friend, the painter Fred Janes, whom I'd also met through Keidrych. Fred and Dylan knew one another well and Janes had made a fine portrait of Dylan. Or I sat with him outside a pub – just where you'd expect to find him. On one occasion Judy and I went to tea with a distinguished doctor, a professor of gynaecology, and his wife in Pendine. She asked me, "Do you know that man Thomas?" I said, "Yes" and she told us that one day recently he'd come to tea and before

leaving had asked if he could borrow half a crown. I thought to myself, "Ah, that's why he came! He probably needed the fare to Carmarthen next day." Another time I met him and said, "We don't see any of your poetry these days." His reply was, "I don't publish in England any more – you don't get any money for it – I publish in America." I answered, "That's a bit hard on us." "If you want to see it, I can let you have my manuscripts." "I probably won't be able to read them!" I replied. "Arthur, I write like a child. You'll have no difficulty at all. I'll send you some." "I'll let you have them back," I promised. "Oh, that doesn't matter. You can keep them." But he never did send them. That was part of Dylan, charming and friendly but completely unpredictable. While he was living in Laugharne he'd spend a lot of time at Brown's Hotel. He drank heavily but it was beer and this didn't do him any harm; he was said to wheel his wife Caitlin home in a wheelbarrow at the end of an evening's drinking together. I once visited them in the Boat House, a perfectly ordinary kind of visit except that his eloquence was natural. He was fascinating to be with but when he went to America it was, I'm sure, completely different for him because he was celebrated like a strange god. They filled him up with whisky, which was really cruel.

Was Caitlin an equally vivid character?

Oh, she was, very vivid indeed. I remember chatting with them once and Sir Maurice Bowra was mentioned. Dylan had spent some time in Oxford where he was befriended by one of the historians, A.J.P. Taylor. While a guest in his house I believe there was considerable trouble because Dylan loved to be contemptuous of the mighty and on one occasion was particularly contemptuous of Bowra, who was the Warden of Wadham. Caitlin was like that as well. It's difficult to describe their mental atmosphere: it was one of contempt or ridicule of those who are accepted as being eminent.

Did she strike you as being beautiful?

Yes, she was beautiful but in personality rather than structure. She was fascinating and certainly had glamour. I remember a friend of mine in Broadway, a blacksmith, an intelligent, interesting man to linger and talk to, telling me that Caitlin had come into the pub one evening – in Broadway the pub was the meeting place where the men chatted the evening through – she came in and was showing off but nobody took any notice of her so, with one swipe of her arm, she swept everything off the counter sending it crashing to the floor. Later on, after Dylan's death, I met Caitlin once more. I was coming back from Llanelli, having lectured, and she was on the train from London; by chance we were in the same carriage. She'd been living in Italy and there were all sorts of myths about her being associated with the Mafia. I asked, "How are you getting on in Italy?" "Oh," she replied, "Arthur, it's nothing but Laugharne from Laugharne!"

Dylan never asked to come and see your paintings?

I don't think he showed much interest in painting despite his friendship with Fred Janes and Augustus John.

You've already alluded to Lynette Roberts, Keidrych's wife; did you know that she painted as well as writing poems?

It was Keidrych who first told me about the pictures. He had a great admiration for her understandably and wanted me to accept that they were attractive and interesting works. I don't think she ever spoke to me about them herself.

How do you remember her?

She was quite a lovely lady, with a strange temperament: there was something almost fey about her, living somewhere slightly different from everyone else, but at the same time also very actual, very alive. She gave me a beautiful pot as a present. She would give surprisingly; unexpectedly she'd make you a gift, and she talked about her poetry as though it were a natural thing to speak about.

Did you have the feeling that she was slightly in the wrong place, that she didn't quite fit in?

That's right. She seemed to be, to a considerable extent, out of her own world but she

refreshed me. Her range of knowledge and experience of great writing was something I was at home with because, after all, I'd spent my life studying French, Italian and English poetry and here I was meeting someone quite unusual in those days in Laugharne. I was at that time out of my element in Wales. It took me a long while to accustom myself to this country which I've come to love so much.

She wrote a poem which she calls 'The New Perception of Colour' and adds underneath "And I shall take as my Example the Raid on Swansea". It's about watching the raid happening from afar whereas you were active in its aftermath. I wonder what you think of it?

It isn't like my experience at all: mine was about the fear that the planes might be coming over again, the enormous energy required to put the fires out and utter fatigue. It was a most extraordinary event, exceedingly dramatic but to me about complete devastation: fires still burning, smoke, the dash of water out of a pipe hour after hour.

Reading the poem I am reminded of Paul Nash and how he sometimes depicted air warfare in the 1940s in schematic, almost abstract configurations of image and colour.

It is Nash, but Nash wasn't underneath the bombing! I was only potentially under it but wondered if more bombs might be dropped.

The poem is that of a poet painter observing the disaster from a considerable distance.

Yes, that's the point. It is a superb poem but she's using her intellect, her imagination and vision. She knew celebrated poets including T.S. Eliot and Robert Graves and, speaking of painting and writing, it was she who prompted me to purchase a Wyndham Lewis. She gave me an introduction but he had gone blind so instead I bought a painting of his from the Leicester Gallery. Another author Lynette knew was W.H. Hudson and because of her I read his extraordinary *Green Mansions*, illustrated by E. McKnight Kauffer.

She didn't spend a great deal of time with Dylan and Caitlin?

She was not really like them. Her experience of highly sophisticated people was quite considerable and it wasn't casual, it was a deep friendship with these writers. What a range of friends!

Her husband's poetry seems to have faded away whereas hers is being reconsidered.

You couldn't miss the fact that Keidrych was a poet. He hadn't Dylan's genius but he was a good one.

Do you recall Keidrych's way of speaking? Lynette wrote that he spoke like a prince.

He did speak beautifully – that's one of the great gifts of the Welshman. The lilt, yes, it's a musical way of talking. Those who are public speakers, for instance the preacher, speak beautifully, and when Dylan read his poetry he became the Welsh orator speaking from the pulpit in the tabernacle.

Were you still at Broadway Mansion when Lynette turned up at the door late one night?

No, I wasn't. We were by then living at Llethr but I heard about it. What happened was that she'd left her husband and come to my parents in desperation at two in the morning with both of her children.

Later your father prepared her for her divorce proceedings.

My father had some experience of the law before joining the army and he realised that she needed support in presenting her case. He used his knowledge to advise her how to answer when in court because there was something timid about her, although underneath was plenty of courage. He gave her confidence and she must have done well because she won her case.

Your daughter has a disturbing memory of coming on Lynette when her whole life had changed, but you no longer knew her by that time.

Judith saw her again by chance about forty years later while driving through Llanybri. She was wandering through the village carrying a bible and pamphlets. She'd turned into a drab, pale, grey figure, bleak and lost. Later a friend told Judith that Lynette had become a Jehovah's Witness and was to be seen knocking on doors locally. I feel rather guilty; I ought to have tried to find her. I'd lost awareness of Lynette. She was from those days when I lived in Laugharne.

In Laugharne people were now taking you seriously as an artist: you were a painter amongst other painters, poets and writers.

Yes.

But after some time in Broadway the tensions with the family rose again because of your art.

Judy and I realised that our directions were not theirs so we left Wilfrid and Margaret and my parents in Broadway and moved about five miles along the coast to Pendine.

So a whole pattern of living was, first of all, created within the larger family at Wedmore and Broadway and then you and your wife continued it together in Pendine.

We did – for the next twenty years.

SEVEN

Llethr is a fine Edwardian, three storeyed house overlooking the village of Pendine with views across to the island of Caldey and Devon. It was built by a ship's captain on the site of a stone quarry, which was known in the village to be haunted by a witch dressed in white. The house perches on an abrupt cliff side long ago abandoned by the sea but there still remains a ring for ships to tie up in what is now the dingle.

Did you and Judy intend to do anything differently at Llethr?

No, at first just the same. We took in foreign students and during the holidays paying guests. We could accommodate up to thirty people in the house at one time.

Were you not in competition with Broadway Mansion?

There was plenty for everyone.

And did this move heal the wound between you and your wife and the rest of the family?

I don't think there was much of a wound. My father lent me some of the money that I needed to buy Llethr.

But before long you discovered your house guests were not to be accepted indiscriminately.

We wanted to have people who were interested in what interested us so we started to advertise only in *The New Statesman*. The people who came were usually intellectuals, professional people with their little families. Many of the men were brilliant but at the outset of their careers: one later became Lord Chancellor, Lord Elwyn Jones, another a judge, another the benefactor, Lord Michael Marks. I remember the Mowats, one brother was a distinguished schoolmaster, the other became Professor of History at Bangor, Dr Kerr became an M.P. and there were several more doctors. These were the kind of people who were interested in mixing with the young students we began to have from Switzerland, France, Holland, Germany or Norway. And the students often sent their brothers or sisters or friends in subsequent years or returned again themselves.

How did you organise the complicated schedule of guests and language students?

During the morning students were tutored individually in the dining or drawing-room by Judy or me and they had homework to do overnight, which was corrected next day. Then frequently picnics were organised to include all the students and usually the families staying wanted to join in. Sometimes we were twenty or more piling into cars to visit beaches, the Deer Park, St David's or to make a boat trip from Martin's Haven to Skomer or Grassholm or we'd take large walking parties round the coastline; at some point on these various outings I nearly always painted a picture. For breakfast and lunch families would sit together but in the evening the youngest children were given their meal first, then the older children. Later teenagers and adults would change and have dinner, all of us sitting together at one long table. Afterwards the adults would take coffee in the drawing-room and once or twice a week, when everything had been cleared away, Judy would play the piano. Sometimes I'd accompany her on the viola.

How had Judy time to practise as well as running the guest-house?

She took part in the teaching – she was a very patient teacher – and managed the household; she arranged the bedrooms, as to who would go where, and she cooked the meals. We had only one woman helping us, a woman from the village, who became a very good friend. I agree, it was a marvellous achievement and if she hadn't been such an excellent sight-reader she could never have given the concerts.

For what part of the year would you have people staying?

At Easter and Whit but mainly through the summer months; there was no Extra-Mural teaching from Easter to September. It was the guest-house, in fact, which kept us going rather than my lecturing and only when I was taken on as a permanent member of staff at Aberystwyth did the strain of running the guest-house become rather less.

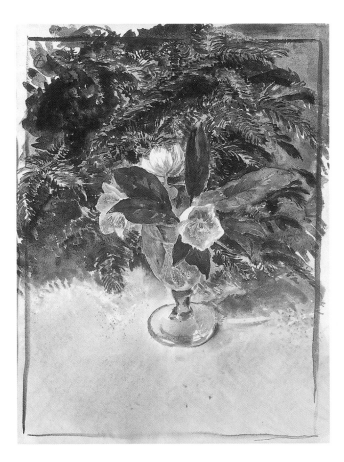

Three Hellebores
49 x 39
ink and watercolour 1950

Was Judy made a member of staff also?
No. That's what was curious. It was a joint enterprise as far as the music was concerned but I was the one who was paid.
Despite all this work you still managed to get on with your art. Was your wife supportive of your painting, interested in it as well as music?
She had a natural talent for drawing and my son and daughter both have little pictures by Judy.
During the summer months how much time could you devote to painting?
I painted watercolours and had my studio in the cellars of the house; that's where I made my big reliefs for my first exhibition at the Grosvenor Gallery in 1965. I did whatever I could find time for.
So the whole venture at Llethr turned out to be a creative one?
Oh, immensely. And guests even invited me up to London to stay with them while I hawked my pictures round the galleries.
Did you also continue to invite friends who were artists?
Cedric Morris came to stay and George Mayer-Marton, in the early years, later Ceri Richards and his wife, Diana Bloomfield the engraver and near the end, in 1967, Fairfield Porter with his wife and two of his children. By the time we moved in, in 1948, I was working seriously as an artist as well as making more lecture tours for the Welsh Arts Council: I travelled around Wales lecturing to schools and art societies on European or modern British painting.
And you were starting to exhibit in London.
I've mentioned Rex Nan Kivell at the Redfern Gallery; he accepted my work for mixed exhibitions from the end of the 40s until 1964.
What were the first watercolours like that you showed there?
They were still-lifes with flowers because Cedric was a wonderful painter of flowers, my parents were by this time good gardeners and I myself love flowers: flowers in a vase on a

table, the sort of set-up Cedric would arrange, and most likely I showed watercolours of Wedmore and Amroth. I also painted oils at Wedmore or later in Pendine and a couple of these were included in mixed exhibitions at Gimpel Fils.

Did you move from Redfern to Gimpel Fils?

No, I didn't. I was free to show in other galleries. Gimpel exhibited a few of my pictures, one of them borrowed from the Redfern. Once I called with some oils which Pierre Gimpel was considering when his brother walked in, looked at them and said, "Tu ne dois exposer ça. C'est moche." He assumed, I suppose, that I wouldn't understand French; I was extremely annoyed. I showed something at the London Gallery and even went to Wildenstein, who asked, "Why have you brought me your pictures?" "Well, you sell pictures!" I replied. He took one of my watercolours but when I returned after a month or two he gave it back to me.

Did you know the work of young painters exhibiting at that time, men like John Minton, John Craxton or Keith Vaughan? I see slight resemblances to their ways of structuring foliage in a few of your oils.

I didn't know any of them personally but I went sufficiently often to the galleries in London to be aware of their existence and also of the Scottish artists, Colquhoun and MacBryde.

I wondered what you thought of these men's paintings of landscape.

I don't think I thought of them as something I should emulate. My own approach at that time followed Cedric's, who simply sat down in front of a subject and poured out his soul in terms of oil paint. It was a very straightforward way of doing things and that is the way I worked.

Soon after you moved one of the guests at Broadway Mansion proved particularly helpful in the development of your art.

A Dutchman, Hans Polak Leiden, and his wife came to stay with my parents in 1948, recommended by Lynette Roberts. He was a small, vibrant Jew, who liked to draw the magnificent plants my father cultivated in the garden and conservatory. I didn't quite understand why but, when I got to know him better, I realised he was making drawings in order to turn them into designs for his curtains and draperies. He was a famous fabric designer, selling curtains to the Dutch Royal Family, and not merely a designer but a maker; he had a studio in which he made up these beautiful things. I was painting hard and he got interested in what I was doing and bought pictures from me. Then he suggested, "Why don't you come and lecture in Holland? You can also teach me the violin." He was a great lover of music and extremely eager to play. "There's a society called *de Nederland Engeland Genootschap*, the Netherlands England Society, and we can arrange a tour for you next year." I grasped the opportunity with both hands since by this time I was practised in public lecturing. I began in the Hague with a most distinguished audience, which was a pretty formidable start, and afterwards I went to Maastricht, Leiden, Utrecht, Leeuwarden and Amsterdam. I gave one lecture on the development of English art and another on modern English painting. The lectures were on history and appreciation and each would last about an hour and a half. One of the difficulties I had was that the organisers always gave me some Bols, an outrageous gin, before I started, so with a very muzzy head I'd begin; it was particularly bad on the first occasion in the Hague, when I had to lecture in front of that august crowd. There they were pouring gin down my throat just before I was going to speak! No doubt for a Dutchman this would be a help but for me, terrified of the circumstances in which I had landed myself, it was an ordeal. But I did get to the end of the lecture somehow and Hans looked after me wonderfully.

You were a guest in his home?

He and his wife invited me to stay with them in Wassenaar, a village just outside the Hague bordering crown property. They owned a beautiful house, which contained a drawing by van Gogh. One of his forebears had bought it from van Gogh, probably before van Gogh left for

Paris. I can recall the clear, strong lines of the flat landscape. It was a great rarity at that time to possess such a drawing. I brought along my viola and Hans and I played together: I remember particularly *The Golden Sonata* by Purcell, where I took the second violin part. Hans loved playing but was distressed by the stiffness of his fingers. Although there was very little physical delicacy about him he had considerable intellectual power and artistic understanding so I did my best to help him with his bowing and fingering. It was very enjoyable. The house they lived in was almost surrounded by water. He owned a boat and used to take me out on the canals, telling me that Holland depended for its life upon the windmills, and it was while we were out in the boat that he spoke of his time in a German concentration camp in Holland during the Occupation. I suppose I must have stayed about a week with him and his wife, then lectured through Holland for a week and stayed with them a little longer before leaving. At the end of that first year the Society asked me to go again, which I did gladly.

On leaving Holland you did not return home immediately.

I decided that on my way back to England I would try to find out what had become of my childhood friend Germaine so from Holland I travelled to Paris and called at her house. She opened the door and naturally was astounded to see me. She put me up, and over the next couple of days gave me an account of all that had happened to her and her family since we lost touch. Shortly after the Germans occupied Paris her husband was taken away by the Gestapo and she never saw him again. Before long she found out that he had been put on a train because he'd thrown out of the window a note, which miraculously was picked up and sent back to her. She discovered nothing else about him until the end of the War, when she learned that he'd died in a concentration camp fairly soon after being arrested. During the Occupation all Jews were ordered to wear the Star of David but Germaine decided she would not; years later she gave it to me. Although, no doubt, other Jews knew she was one she managed to hide from the authorities her Jewishness, but eventually conditions became so bad that she decided she must send her three children to safety. She dispatched them to the south and then before long realised she'd have to get away herself. Having made arrangements with those who assisted in such escapes she set out. After she had crossed a key river – once you'd negotiated it you were in unoccupied France – and was trying to climb the bank on the other side she was almost dragged back down by a man clambering over her, using her body as a support to pull himself up. She eventually reached the south, found her children and took them to the safest possible place, the Vercors, which lies just south of Grenoble. It's a mountain area dominating Grenoble that was the heart of the Resistance. But the day came when German troops arrived at her door. She wondered what was going to happen because she and her children knew like everyone else that in other houses those who were found to be Jews were shot, all of them, or that as punishment for connection with the Resistance in the Vercors some villages had been wiped out entirely. A small group of soldiers stayed in her home for a week and then went away without discovering that it was a Jewish family who had looked after them. So the position in Vercors proved to be as terrifying as it had been in Paris but somehow she survived and so did all her children.

After renewing contact you remained friends for many years.

Our families exchanged visits and I would stay with her whenever I went to Paris.

Your second visit to Holland seems to have had far greater significance in the development of your art than the first.

This second time Hans's wife took me to see the great museums of modern art showing me amongst other things the work of the De Stijl group: Mondrian, van Doesburg, van der Leck and Vantongerloo. My eyes opened in amazement at Mondrian. What especially fascinated me was his starting from very intense depictions of nature herself towards a gradual movement into a more penetrating sense of what forms underlie the obvious forms and what colours underlie the obvious, already discovered colours. I saw that Mondrian's abstraction

was indeed an abstraction in the sense that he kept taking away that which he realised could be done without in order to emphasise the centre or heart of the matter.

You also saw for the first time contemporary work by the Dutch painters who called themselves the Cobra Group.

Appel, Jorn, Alechinsky, Corneille – much more Expressionist artists. Here was an opening I was only too ready to fall into; I thought it much richer than what I had already experienced of English painting.

You'd admired two utterly opposed aims in painting: the greater and greater refining of Mondrian leading him to squares of red, yellow, blue or white within horizontal and vertical black lines and, the antithesis of this, a deliberately intuitive painting with childlike drawing that Appel and Jorn in particular were attempting.

Curiously it didn't occur to me in those intellectual terms. It was a revelation of possibilities.

But there is a huge contrast. In fact it's hard to believe both of these styles came out of Holland and yet, in a way, van Gogh may be a forerunner to each of them in his simplification of drawing to a series of marks, lines, dots, dashes, and, on the other hand, the Expressionist passion of many of his later paintings.

Perhaps.

Were you interested in any of the small constructions of De Stijl as well as the paintings of Mondrian?

It was Mondrian who caught my attention; van der Leck and van Doesburg as well but mainly Mondrian. Although Hans's wife and others were keen to show me van der Leck it was Mondrian who really got me!

Whereas Hans's wife showed you work in museums Hans took you to meet living artists.

Two or three, one of whom was the puppet maker, Harry van Tussenbroek. I remember his house in Amsterdam. Hans didn't tell me anything about him until we arrived so Harry was a complete surprise. He was exquisite. You went into the house and were astonished straight away by the fact that on the chairs were seated dolls or marionettes, even on the mantelpiece more were sitting. You felt it was a place inhabited by beings who were creatures of his own imagination and, by virtue of his presence, they seemed to have a vitality that pictures never quite do because they were little people. He offered us tea and I recall that the cups and saucers were also very small and delicate and the sandwiches tiny little sandwiches. I suppose that put us at ease with the puppets. We became part of the company already present; it was a sort of tea party for all of us. Then after tea he said, "I will show you some more puppets." He was a delicate, charming, intelligent man and very courteous. He walked over to a big cupboard in the same room and as he opened the doors the puppets appeared to spring forward towards us; they were, no doubt, packed quite tightly but I shall never forget that moment. I can shut my eyes and be there seeing these creatures emerge as the doors were opened! I don't recollect them in detail, I simply remember them as being alive. On our return home, as we talked about them Hans told me, "Harry has decreed that they should be burnt at his death."

What he decided eventually was that he would radically reduce the collection to what he considered the finest items.

The intriguing fact is that Hans decided it was to Harry he should take me. He was evidently already a celebrity.

In studying photographs of his work I was struck by his use of found materials: for instance he has a group of puppets made entirely out of bones and skulls with props of shell or cork. Looking at them I thought of reliefs of yours made in the 50s using similar materials or found objects. Perhaps these puppets were indirectly an influence?

It's very likely. This aspect would have stimulated my interest particularly.

Curiously Harry writes in an introduction to one of his catalogues that a number of artists have used his puppets as models for sketching or painting.

I see him as linking one art to another.

You did not return to Holland for many years but, after finding her, would you visit Germaine and her family regularly?

Just about every year and I'd stay with them over the period, visiting the commercial galleries and at the same time I'd make watercolours, straightforward topographical work. I've painted frequently in Paris.

So you are interested in urban imagery as well as that of the countryside?

I was born in London and lived there until I was five and was brought up in it again during that immensely impressionable period from eleven to twenty; London was then, as far as I was concerned, the biggest city in the world. I love painting cities; when I go on holiday I want to go to a great city because I enjoy the life of the streets. I got to know Paris well. I went to the Folies Bergères and the Casino de Paris as well as to the Opéra and Opéra Comique.

You mention that you were not only making watercolours but also visiting the galleries in Paris so presumably you saw the work of younger artists such as Manessier, Soulages, de Staël, da Silva, Dubuffet and others.

Yes, and a marvellous Russian, Poliakoff, and the German, Wols. There was a whole range of abstract painting being shown that hadn't the character of contemporary Dutch art at all, although there was a certain degree of de Stijl-like formality in the work of Vasarely.

You saw his work at the same time?

And the work of a Dane, Mortensen, who showed at the same gallery. I bought a painting from him in his studio – and we talked about Dylan Thomas. Apart from these younger artists I was also able to see paintings by Braque, Léger, Picasso and Matisse in the commercial galleries. I glimpsed Braque arranging one of his exhibitions and passed Rouault walking in front of Notre Dame.

How did you take to all this?

Like a duck to water, I certainly did.

This is what fascinates me, and also your friend David Fraser Jenkins, that your beginnings as an abstract painter situate you in the post-war School of Paris.

Much more, I think, than anywhere else. But that's not altogether surprising. When I met Cedric Morris in Dowlais or when he and Lett-Haines taught me at Benton End we would talk about Paris because they'd both worked there.

Whereas your watercolours stemmed from the British topographical tradition.

Definitely they did, but once I'd seen the watercolours of Cézanne I felt a sense of power in the pigment and clarity in the form. There wasn't that reticence you find in so many British watercolours.

Do you feel that power more in Cézanne than in Turner's or Constable's watercolours?

I suppose the greatest of watercolour painters is Turner but I loathe categories; this business of first class, second class, third class is all very well for school or even university but has nothing to do, in my opinion, with painting or the arts generally. After all, you can't say, "Keats isn't really quite Shakespeare, is he?" That doesn't mean anything at all. Painting isn't a game or a sport.

You've said that you first discovered the English watercolour tradition as a schoolboy.

At the British Museum and the Victoria and Albert, with my father. Also he owned a book of great English watercolours which I used to study.

And you had particular favourites.

Certainly Turner, and Girton I liked too.

What did you think of J.R. Cozens, who painted so much in Italy?

Oh, wonderful.

And his father Alexander? He particularly interests me because he develops out of the Italian tradition a concept of making landscapes from particular types of marks, blotches, scribbles.

Indeed. I've actually used his method of conjuring up images as a result of chance gestures, the inkblot for instance. Amongst the paintings in my first one-man exhibition in London in

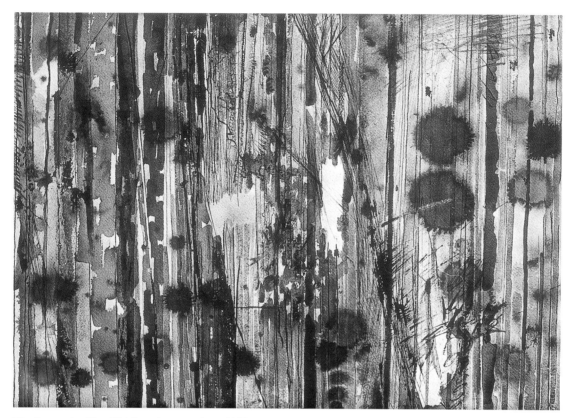

The Serenade 39 x 57 ink and watercolour 1958

1959, at the Woodstock Gallery, were abstract watercolours made like that and I've still got some of them. This was the exhibition Tom Boase went to see, by the way.

Although all on paper some of these big watercolours foreshadow reliefs you would make years later. They certainly do.

The paintings are mostly abstract and quite unlike anything you'd done before. Apart from your use of Cozens's technique they seem to derive from what you'd been seeing in Amsterdam and Paris, or perhaps in London?

Yes. R.S. Thomas told me how for him a poem might start from a chance phrase which he would jot down on an envelope he happened to have in his pocket or on the back of a bill. An image comes intuitively over the period of an hour or a week or months. You only know where you have gone when you reach it. There it is and you stop.

How did this exhibition come about?

I cannot remember.

And I believe it went afterwards to Paris?

Galerie Creuze first put on an exhibition in Paris in 1960, 'Expressionistes de Londres', which I was part of.

This was the time when your watercolour painting came closest to complete abstraction; usually these two strands, of topographical artist and abstract relief maker, seem quite far apart.

To me they are interrelated. The yellow in my picture may be the sun but as a colour it is related to other colours. My process of thought is in shapes, lines, colours, tones. The rectangle, whether of paper or board, and the flat surface dominate whatever I'm doing.

While in Paris, I believe you once peered into Léger's studio through the window but made no attempt to visit him whereas a younger artist, Hans Hartung, you did actually meet.

I used to drop in to the Gimpel Fils Gallery in London and got to know Pierre, one of the brothers. On one visit I asked him what galleries I should go to in Paris and he mentioned amongst others, the Salon de Mai. I did go, and saw the work of Hartung and found it so

Red and Black 57 x 38 watercolour 1958 Sea Forest 57 x 38 watercolour 1958

fascinating that I decided to try to meet him. I found out his address, I can't recall how, and knocked on the door of quite a large house. A woman's head appeared from an upper window and asked, "Qu'est-ce que vous voulez, Monsieur?" I said I would like to see Monsieur Hartung. "De la part de qui?" – "On whose behalf?" "Oh, for myself," I replied. She closed the window and I stood waiting outside until the door opened and, to my amazement, there stood in front of me a big, handsome man with one leg. I'd no idea he'd been wounded in the War and lost a leg. Very coldly he said, "Eh bien, Monsieur." I asked if I might see his work and he answered, "Come in," equally coldly. There was a bench in a big studio, all very neatly arranged, strictly clean and precise, and he took out a couple of works to show me. This wouldn't do at all, I thought, and decided to mention the fact that I was an artist and had been advised, I suppose I said by Gimpel, to come and see him. When he heard I was an artist he changed utterly, becoming very friendly; he brought me more works to look at and we chatted away most amicably. I left with a gift of two items, a lithograph and a little sugar aquatint. Not long afterwards I remember seeing him at an exhibition and we waved to one another. It was solely the fact that I was an artist that had opened his mind to me. It was heartening. Just like that. And I've found this again and again: the artist is so delighted to find someone who's really interested in his work.

What was it that fascinated you in his painting? I find it difficult to appreciate.

It has that extraordinary spontaneity which I also admire in the paintings of Olivier Debré. It is as though he wishes to make the picture as a result of deep thought and comes to the conclusion that it must be made in the time it takes for lightning to strike. Suddenly it's there and when you look it's so vivid, so immediate, just like a fork of lightning. I admire the means he uses to express emotion and create space, wonderful rhythms, as it were by mere chance, by mere movement of his hand. I've always been interested in how you can sense a person's character and temperament by the way they've written their letter – that's why it is so boring to get a typed letter. When you receive a handwritten one, intuitively you know how the

person is feeling, what kind of person it's from; you don't translate it but it's there in your mind. With Hartung it is taken to an extreme degree, this immediate and spontaneous connection of mind and vision.

Is the work nearer, for you, to the making of a piece of Chinese calligraphy?

Yes, it is, isn't it?

The final, masterly stroke. This is not the same as Tachisme or Abstract Expressionism though.

No, it's not. It's something quite other – a whole series of masterly strokes having to do with what we convey by gesture, as in the dance.

As well as seeing friends, making watercolours and visiting the galleries you gradually found an additional reason for your journeys to Paris: you began to buy prints for collections you were helping to form in Wales.

I bought for myself, for family or friends and for the University of Wales at Swansea and Aberystwyth.

Had you an introduction to William Hayter, the master printmaker, or did you go of your own accord?

I went off my own bat. I was drawn to his prints out of sheer interest for their originality. 'Monsieur Étère' – all the French artists knew about Hayter, many of the most famous having worked with him at Atelier 17. He was an electric personality, vital, friendly, and utterly self-confident. He told me of his techniques and how he had introduced colour into the printing of engravings. I bought a couple of engravings from him, which cost me little; he was very generous. He came from a distinguished family – his brother was a don at New College I think – and he was extremely proud of his tennis playing, proud of the fact that he'd play all these young people and beat them because of his dynamism. While you were there you felt you were his close friend but at the same time he made you aware that he was a most distinguished artist. I went twice and thoroughly enjoyed being in his presence.

You were drawn to him and his work for yourself?

Oh, absolutely; but what I bought for other people were always things that I would have bought for myself if I'd had enough money.

Anaïs Nin wrote of Hayter's intensity being overwhelming, "He was like a stretched bow or coiled spring every minute. Witty, swift, ebullient and sarcastic."

Yes, but there was a great pride behind it all.

Justifiable too.

Completely. As I saw him he was a young old man, an elderly gentleman, but the youth in him was still vivid.

You had started to exhibit in London by the end of the 40s showing watercolours but about eight years later, after gradually simplifying your oil paintings of landscape and painting two almost abstract compositions based on still life, you began to explore complete abstraction, initially in watercolour and ink and then in oils starting with Pendine Panel, *a red painting done on sacking, using an all-over surface of collage. How did this come about?*

In the first painting I made using collage there is the impact of Paris rather than those rectilinear shapes of Mondrian but it was the art of Mondrian which over time more deeply fascinated me: the way you could study nature and then allow those aspects which weren't necessary to fall away until you finally got to the essence which was man and woman, earth and sea, upright and horizontal. But I realised that you had to go through the whole procedure. You couldn't start at the end. You've got to find your own way to the heart of the matter.

You didn't fudge it. Many contemporary artists try to go straight to simplicity and that's what makes their art so meagre.

And that is my criticism of Ben Nicholson.

You don't believe he moved gradually towards abstraction?

The difference between Nicholson and Mondrian in my opinion is that Mondrian finished up with some mighty images. Nicholson's are bloodless, boneless and weightless.

I won't reply to that! Why was oil painting a medium you began to have grave doubts about?

Pendine
53 x 63 oil on board
1955

Ah yes, oil painting. I wanted to paint out-of-doors but I began to prefer watercolour, which I could finish quickly or could leave for another day; there wasn't nearly as much paraphernalia. Sometimes I'd paint on the ground like Cedric but sometimes that would be impossible: I'd put up an easel and get all my materials out and then it would start to rain and my pigment begin to slip on the canvas.

In painting outside at your easel did you see yourself following on from the Impressionists?
I suppose so.
It was the natural thing to do.
It was a natural thing to do because it was what Cedric had shown me could be done. There are a number of paintings from that time which I've kept because I think they're quite interesting. My departure from oil painting came about as a result of my being forced indoors so I was obliged to find another way of making pictures. I didn't want to make paintings in oils from watercolours or drawings because I liked to work at the final image from the very start.
An important point.
It is. Had I wanted to continue oil painting in the traditional European manner I could quite well have changed to making drawings out-of-doors and then brought them inside to copy onto canvas and built up the image. I never did that. I simply decided that I would make my pictures in the studio on the basis of... I wasn't quite sure what. I just began to do it.
It's important to stress the intuitive nature of your making. It's intuitive, it's explorative and it has an element of play in it.
It has – and no preconceived rules. It takes what chance gives me, from a power outside myself which can be received in no other way. The work has to take on meaning but it doesn't until it's finished. I don't foresee what I am going to make.
This is an essential belief of yours.
I want to quote Michelangelo. It is a fundamental notion but I only thought of Michelangelo afterwards.
First you do it and then you find justification for what you've done!

> Non ha l'ottimo artista alcun concetto
> Ch'un marmo solo in se no circonscriva
> Col suo soverchio, e solo a quello arriva
> La man che obbedisce all' intelletto

Work Table
49 x 61 oil on board
1955

The best artist has no concept which
a single block of marble does not enclose
within its surface, and only the hand which
obeys the intellect arrives at that concept.

Michelangelo sees the making of a work of art as a journey towards an end only known when the artist arrives there. And he doesn't get there until his craft is under the control of his mind. *As an example of what can happen when completing a picture you've told me how you were painting the red picture one day and found yourself mixing a particular grey... a patch of bluish grey that was to have considerable repercussions in the development of your work.*

I was still using oil paints but was already working with sacking, building up forms according to an intuitive need. In the picture you mention I used not only the sacking but actual strands of string drawn out of it to create a variety of texture; I had grasped the fact, no doubt inspired by works I'd seen in Holland and France, that the texture of the ground you were employing, whether sacking or pigment, was possibly eloquent in itself. Then I began to use the string to make lines. It took me a long time to paint the picture, mainly using various reds, and then almost at the end of the work I thought, "Now, somehow or other I've got to get a great chord into this picture." I wanted a colour, one colour, to alert my reds. I had great difficulty in finding an appropriate element at the base of the composition but at last I achieved a beautiful matt grey effect. As I was looking at it I suddenly thought it looked just like a bit of slate and got the idea of doing one with slate itself, so I made the next picture with pieces of slate and added shell dust, which I found on the beach.

Were you aware at the time of the Cubist practice of using sand? I wonder how near to Cubism you felt then because later paper collages do seem to develop out of Cubism.

I was certainly aware of Picasso and Braque. Yes, it's very possible but it was also the conviction that I had to work with the materials which were available to me. By then we were living in Pendine and it was very difficult to make ends meet: we were trying to run a guest-house and we'd got an enormous mortgage, which took us a long time to pay back. I felt that buying oil paints was something I really couldn't impose upon my family so I began to work more cheaply. First of all, I began to use old sacks and prepared them as Cedric had taught me. Then I used bits of wood from the beach either to paint on or incorporate somehow. As I've explained it was as a result of going to Holland that I became aware of how to make an image that was the result of peeling away from the obvious one whatever was unnecessary until you reached something superficially quite unlike the initial image, but yet it had within it the heart

81

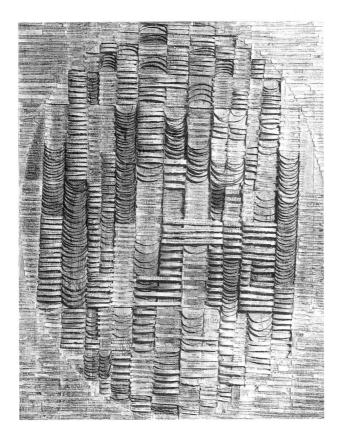

Towers
82 x 68 paper on board
1973

and soul of the matter. Incorporating slate started me using sheets of hardboard onto which I would stick down sacking and then stick onto that bits of slate. The slate had blown off the roof. It had a beauty of its own and an association with the roof because it was rectangular, like a shape of Mondrian. I put the slates down at right-angles to one another and to the edge of the board as would Mondrian except that some of these slates were broken. I came to see that the broken edge, because it was related to all these rectangles, was in itself eloquent. I couldn't put words to this eloquence but it was clear to me. Then I realised that the sack could be treated to make the colour of the slate redolent of a chord of music. I worked on the sack to find a pigment which would say to me, "Well, isn't the colour of the slate beautiful?" And I began to use different coloured slates; I must have done a dozen at least of these pictures. I was now using crude materials, mainly the sack, broken slate or shell dust to build up images of considerable complexity, which demanded a sense of colour, a harmony or clash of colour, and which were quite rich in texture.

What you're saying about finding takes you back to your childhood, making out of whatever was available to you in the countryside.

I didn't need to buy any art materials for quite a long time because a chemist working at I.C.I. came to stay with us, Len Pearson, who gave me pots of powdered pigment, the genuine pigment, and I'm still working with them today.

You mix these with a bonding agent.

With a bonding agent; I use Unibond.

In the B.B.C. television film made of your work in 1965 you are seen on Pendine sands beach-combing. It's clear that for you the finding or gathering was part of the joy of making.

It was. What you could find in those days was excellent wood: I found teak for example, fine wood, the wearing of it by the sea was beautiful bringing out the graining and sometimes there would be pigment on it which I would employ as well. And I used cork from the fishing nets; the fishermen used to make jokes about seeing me go down to the beach to bring back a sackful of corks. But I gradually became aware that rubbish, discarded things, remind

us of what they have been: a slate has been on a roof, a sack has contained potatoes, cork has held up a fishing net, and once you use sand you find that if put on canvas it may become the beach. It can become a great stretch of sand through the arrangement of the sacking in relation to the sand.

Apart from brushes what sort of tools did you use?

I used a saw, penknife and a jack-knife just as I had as a boy. I took it for granted that that was the way to go about making anything.

When you came to use something like a tap what sort of saw did you use? Surely an electric saw.

Oh, no. It wasn't.

Still a handsaw?

Entirely. I couldn't use an electric saw on the brass. Later on I did but only on wood. Later still when I came to use paper I didn't cut but tore it with my fingers.

So you were able to make those minute cuts in the tap by hand?

Yes, and I still can.

After a while people began to pass on to you their rejected objects.

They gave me old taps which had become out-of-date.

That was quite a jump: it's one thing to cut up an oar or the leg of a table but another to cut up a machine-made brass tap.

I don't know of anyone else who's done it.

I'm an admirer too of your wheel reliefs. How did you come to use wheels?

Our neighbour had a broken-down trap and gave me a wheel. A couple of farmers also let me have wheels which were of no use any more. I've actually got the remains of a wheel in the shed now.

Do you think you might use it?

No, I don't.

You've gone beyond that.

No, it isn't that I've gone beyond it but I'm interested in other things.

You obviously still enjoy this idea of re-making, of transforming.

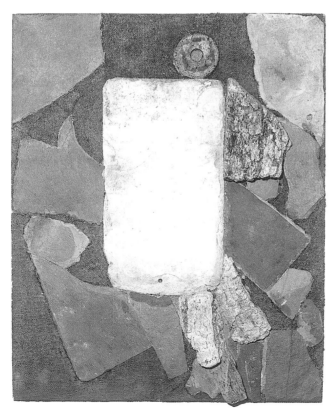

Untitled
dimensions unknown, sacking, slate, cork
on board 1957

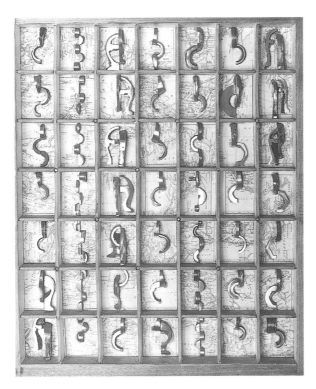

Old Worlds
40.5 × 35.5
brass, paper, wood 1969

What struck me was that the thing has interest in its own right, say as a tap. But then to transform a tap into an image of some sort of living creature capable of movement, that transformation was to me intriguing. I was also interested in showing what a tap was by taking it to pieces and laying it out exactly as it came apart. I made a couple of reliefs like that: putting the pieces precisely in the order in which I had managed to separate them out. It wasn't a map but an opening up of the tap; I was interested in the being of the tap laid out before me. I was able to reveal something of its quality and beauty. I remember I had to write an essay at Oxford on a saying of Le Corbusier, "La conformité d'une chose avec la fonction qu'elle doit remplir, c'est la beauté." I had to think a lot about it. I found myself intrigued by an object when it no longer functioned but was still beautiful.

I suggest you made the object function in another way. What you're describing in cutting up the tap is a form of dissection isn't it?

That's right.

Would you say that when you began to use parts of watches you were also dissecting?

Yes.

But for you the watch face is a beautiful piece of craftsmanship which you don't lose sight of.

Not at all. This is why I disagree with your word 'transform'. The object isn't transformed. It still exists in its own right and at the same time has other resonances.

Would you tend to use your watch face facing upwards?

I'm aware of when I use it facing upwards but I'm quite prepared to shift it around. It's not only that; you see, the watch face takes me back to the Roman period.

Because of the numerals?

Exactly. It alerts an interested observer to all sorts of things such as the Arabic or Roman numerals – the extraordinary beauty of a Latin eight which has come down to us from Rome, for instance.

It seems to me that here you are nearer to someone like David Jones than to Picasso. My hunch, and I must look again at his small assemblages, is that Picasso wants me to see the Edwardian, bobbled edging of a table-cloth as a series of forms rather than as anything else whereas Jones, in his later work, like you, wants the actual historical association to be taken into account.

I do very much so, oh yes. The watch seeks to systematise something which, because it's systematised, loses some of its quality. The trouble about the measurement of time is that it imprisons our minds in the thought that time can be measured. The notion of infinity takes you out of the range of mathematical or even logical thought.

So that while your watch face may be embedded in a wave form you are also making a comment about time itself?

I am not making a comment. I'm inviting the onlooker to consider this handless and machine-less image. The more you think about it, the more fascinating it is. The circle itself is infinite. Whereas what is put inside it seeks to measure that which is limitless. The more you ponder on it the stranger it becomes. My picture doesn't say a word, it is simply there to be concentrated on. You see what you make of it.

You're helping me give myself bearings. I would say that in your description of the watch you move towards a more Surreal or Metaphysical view of the object than a Cubist.

An artist must see for himself, and seeing includes understanding.

Surrealism concerned itself with very different aims. For instance, the melting clock faces of Dali are not a concept that a Cubist would be much concerned with.

No, and I'm not doing that either!

You aren't but I sense that you and Dali have more in common in this instance than you and a Cubist.

What you're doing is to theorise on what the Cubist has done and you're imposing upon him a limitation which I'm not at all sure he would be willing to accept.

You may well be right. To sum up, you have particular ways of using the object you pick up or have been given; you don't put the object in as a thing in itself.

I don't *only* put it in as a thing in itself. I put the watch face in because the enamel, that white enamel, has a quality that nothing else has and that would alert a careful viewer to the difference between the white of paper and the white of enamel, if adjacent to one another. I'm very much concerned with the shapes but I'm also concerned with the watch's history and its function when it was used for a practical purpose.

How do you see Duchamp's use of a urinal or bottle rack? The urinal is displayed on its back and has gained a signature whereas the bottle rack has gained a title Hedgehog. *Otherwise it is unaltered. Jasper Johns has written, "I want to render the object useless", and that is an aspect of those particular Duchamp pieces also.*

I'm not looking at the bottle rack as an object which has been transformed from a bottle rack into something other. What I'm doing in my work is to ask the viewer to use his or her imagination, judgement and concerns just as I have in finding out what different values common things incorporate.

You go further than Duchamp. You won't just use a tap; you dissect it. You won't use an entire wheel in a relief, you cut it into segments.

In order to open up the beauty of its shape in one way or another, but I'm also interested in the fact that when I use a sack it has already been used in the field to gather potatoes.

While I may enjoy it as something which has been used I will, in your relief, probably appreciate it primarily for its quality as sacking or texture.

In which case I have somewhat failed to achieve my intention. I don't want to imprison the mind of the onlooker; I want to spark him, make him look and say, "Why the hell doesn't he use some decent materials?" Once he asks that, a genuine question, he will answer it for himself.

Is this experience very different from looking at a painting of a tree? The tree is a tree 'under the form of paint' as David Jones would say. You take watch parts and encourage us to see them anew. Both experiences occur in relation to the real or everyday world.

They do. And my picture or relief is part of the real, everyday world as well.

I've noticed as I walk round your home that often your reliefs lean against a wall or lie on a table, which is very much how the Cubists wanted their work to be considered, as objects amongst other

objects. They didn't initially think that they only had to be given so many centimetres of space on a wall and looked at as works of art.

Some of the reliefs I'm making at present I would like to have on a table so that people could pick them up and look at them as though they were reading a book.

They wouldn't necessarily look at them vertically?

Not necessarily.

I think this is an intriguing concept but I find the actual experience wholly unnerving.

EIGHT

Graham Sutherland was much admired in the 40s and 50s. What did you think of his painting at that time?

I first saw Sutherland's work when I was in Dowlais in some of those C.E.M.A. exhibitions. Because I knew Pembrokeshire so well I recognised the magic of his little paintings. They appealed to me intensely and I bought the first book of his work published by Penguin. I admired his vision since I was deeply interested in Blake and Palmer and saw in Sutherland a similar kind of magic derived from nature herself. I realised what he'd done was to peer into nature like the young Palmer and Palmer grows out of Blake's tiny wood-engravings from Thornton's Virgil. But I've never felt that Sutherland did anything more than that. He became a 'grand' painter and he had immense skill as a draughtsman but his portraits to me are lifeless. They are rigid. If you look from a Sutherland to a Holbein, for example, it's a profoundly different matter: Sutherland's portraits are masks. They're dead. But the more immediate his drawing, the more wonderful the picture. I know Sutherland's work well because I have lived close to the Graham Sutherland Gallery at Picton Castle. I was in awe of those big pictures framed in gold but I didn't love them. Whereas you can always learn something by looking at the little drawings: those small sketchbooks penetrate deeply into a quality of nature which hasn't often been revealed. It is revealed in Palmer and to me the essence of Sutherland derives from him. Another person I find it in is Paul Nash, but it's the whole gamut of Nash's art which fascinates me.

I ask about Sutherland because from time to time you have painted similar motifs in your watercolours.

Well, I tread the same roads and paths. What intrigues me is that he never goes down to the sea. He never paints the beach. He paints inlets but, to me, the glory of Pembrokeshire is that the next stop is Mexico. This infinite stretch of ocean, the power of it, is overwhelming compared with these charming and lovely inlets, which *are* magical but the sea is mighty.

When did you start looking really closely at the sea and its rhythms?

I think I first began painting the sea when I was a boy of fifteen in Amroth.

Those would most probably have been views of the sea but later you were captivated by the rhythms of its movement or wanted to look into its depths.

The sea is that which makes me aware of my own physical being. When you get into the sea you are naked and you feel your whole body by the touch of water, especially of cold water. You have power but you are being used by a far greater power, as when you plunge into a wave. That exhilaration I knew from the time I used to go to Amroth as a youth. When I draw the sea it's that which interests me, the immense power I've mentioned. The difficulty is that I must paint it on the beach. I can't remember it so I draw or paint on the beach and it's very difficult in the wind and rain. I have to get the protection of a cliff or rock to make my watercolours. In making bigger pictures of the sea, three or four foot reliefs, containing much more than can possibly be included in a watercolour, I have used many drawings that I've done on the shore but I don't imitate them in the larger work.

A number of these reliefs seem specifically to deal with the rhythm of the edge of the tide or of a particular breaking wave or a series of waves. Did your fascination with music affect you as you were creating, for instance, structures reminiscent of the breaking of waves?

I can't read while listening to music but I love painting to music so when I'm working in my studio I normally put on a symphony or some Bach.

Yes, I see a Bach-like quality in some of your reliefs of the sea. Particularly in those you made in the 60s I'm reminded of Bach rather than a Romantic composer although later reliefs are sometimes Romantic. In these earlier examples it is because of the lay-out of your structures, which seems to be both visual and musical in phrasing; and the variation and repetition of phrasing remind me of Bach.

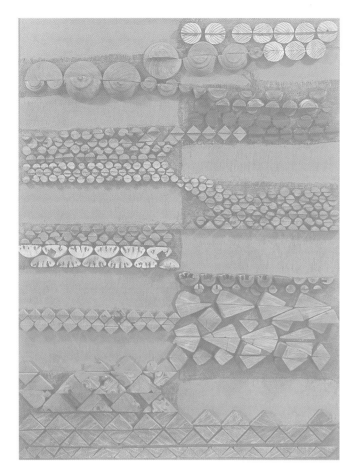

Laugharne Panel
121.5 x 91 wood, sacking,
pigment on board 1964

Most of these reliefs were bought by the Grosvenor Gallery from my first exhibition there in 1965 and they are almost all about the sea: they show the tide coming in, wave followed by another wave, and then becoming foam as it rushes up towards the beach. That is the inspiration of the big relief sculptures and they're made, for the most part, from debris picked up on the beach or from sawn-up bits of furniture.

So some of the raw material has an identification with the sea. Another aspect we must mention is that the sea itself has an infinite range of sounds.

A remarkable insight of the critic David Fraser Jenkins, who writes about the sound that seems to emerge as he looks at my reliefs! That I find penetrating because I'm quite unaware of it; it explains something to me which I didn't know about my own work. I am deeply concerned with sound because, after all, at one time I worked very hard to become a musician.

And what about a poem suggesting the imagery for a relief or collage?

I never remember which comes first, the title or the picture. I think titles often come halfway through or sometimes at the end. There's a collage in the other room which is directly related to a verse of one of the great poems in the English language, Henry King's 'The Exequy: To his Matchless never to be forgotten Friend'

> But heark! My pulse like a soft Drum
> Beats my approch, tells Thee I come;
> And slow howere my marches be,
> I shall at last sit down by Thee.

And Thomas Traherne?

Traherne gets to the heart of my own grasp of nature when he says:

You will never enjoy the world aright, till the Sea itself
floweth in your veins, till you are clothed with the heavens,
and crowned with the stars: and perceive yourself to be
the sole heir of the world, and more than so, because
men are in it who are every one sole heirs as well as you ...

It seems to me you are innately connected with land and sea.

Well, I know I'm an animal, I'm part of nature and I think that is what I intuitively seek to show in my work. "The Sea itself floweth in your veins", because we are animals, we are part of nature. Whatever else we may be we're certainly that.

This is what you learned in Abinger as a child.

When I read Traherne I go back there to understand what he writes.

Maybe that was the time when you came nearest to Blake's seeing not with the eye but through it? I would suggest Sutherland sees through the eye in his early work: it has a molten quality.

'I see' has a meaning of 'I understand'. That is the nature of seeing. What an animal sees is quite unlike what we see. We see out of our understanding, out of our experience, out of our gifts. Blake is reminding us of this. That is why the image on the retina is an inconceivable simplification. Nobody can know what the image on the retina actually is.

If you are a farmer you will most probably look at a ploughed field by van Gogh in a very differ-ent way from that of an artist.

If there had been a farmer there when van Gogh was painting his picture, what the farmer would have seen would be unlike what van Gogh saw. People look at my pictures – I'm sure every artist finds this – and ask, "You don't really see it like that, do you?" assuming that there is only one way of seeing it. According to Chardin, "The eye needs to be taught to look at nature, and how many have never seen and never will see her?" I've come to understand that that is true. Traherne says, "The world is a mirror of infinite beauty, yet no man sees it".

We have mentioned your love of music and its probable influence in the making of certain reliefs. We've touched on certain poets and poems. I know that you are, like your grandfather, also a lover of novels in more than one language so do you see your love of literature as having a relationship to your work, as enriching it to any degree?

Immensely. I've been trying to catch up with the past in literature all my life; French, Italian and English literature – and at one time German – I've read in the original languages and Dostoyevsky, Tolstoy and others in translation. It's a necessary part of our being to read these books. I love *Don Quixote*; I must have read it half a dozen times. And *Moby Dick* is one of the works of which I would say, "It's the greatest of all novels." There aren't many that you'd say that about. Another day I might say, "No, it's *War and Peace.*" *Moby Dick* is an epic – and it's about the sea, of course!

Interestingly, David Jones compares the white whale of Moby Dick *with the savage boar, Trwyth, of* The Mabinogion, *from which he takes the theme of his poem 'The Hunt', seeing both creatures as symbolising 'the evil one'.*

I'm sure that's right. I've known personally two great writers, David Jones and R.S. Thomas. I knew Thomas well. I used to go up and see him when I was doing my month in Aberystwyth at the University each year. I went to his services and was surprised to find only the villagers there but nobody else – they would have had the opportunity of hearing him preach. I'd go to tea with him and Elsie, his artist wife, and take walks with him. I can't ratio-nalise it but it was a profound experience to get to know him and talk about his poetry. I've read all his poems. He used words in such a way that I perceive truths which are normally out of the reach of words. I think he was a true mystic. In five lines he can arouse my sense of wonder at the impenetrable mysteries.

Have you been inspired by any of the images of R.S. Thomas or used a line of his as the title for one of your reliefs?

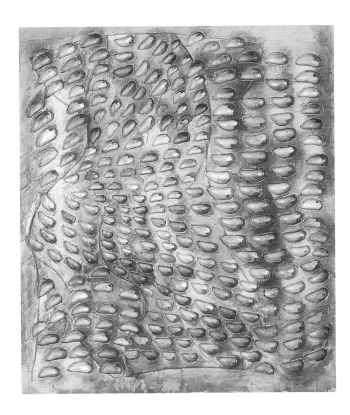

The Sea's Drift
91.5 x 81.5 mussel shells, paper, pigment
on board 1988

Reading his poetry makes me aware of what I cannot understand in any other way. I try to do the same when I make a picture.

What happens when you turn to the composite figure of David Jones? For me his painting is very different from his poetry and I'm surprised that certain critics consider them as one; when working at his best, I don't find them at all similar.

Nor do I. I probably don't know his poetry well enough, but one of the joys of David Jones is the naturalness of his creation as an artist. He's a natural painter whereas his poetry is manufactured.

I don't imagine he'd much appreciate your saying that!

Manufactured? Oh, I think so. He works at the written word and he manipulates. In some of his later pictures he has to do it too in order to get to a meaning which he cannot achieve with an intuitive gesture, but something of the great beauty of his earlier work is lost in the enormous endeavour. Certain masters are able to use 'difficulty as their plough' and that brings them a result which, without enormous effort, they would never attain. Milton is an example; when you read him you feel that the amount of thought and endeavour have been tremendous but the result is perfect. Endeavour both in David's poetry and his painting, in the last phase, never achieves that kind of perfection of a man like Milton or Dante in the *The Divine Comedy.* R.S. Thomas appears to do so by virtue of a gift of the Holy Ghost; Milton doesn't do it as simply but at last he gains perfection.

How much are you concerned with genre here because Jones writes more in the epic mode whereas R.S. Thomas in the lyric?

Oh, Thomas is a lyricist and readily accepts that. He has said, "I'm only a maker of little things," but I think he's a profound maker. Where David is concerned what I have learnt so much from reading are his essays in *Epoch and Artist*; the one I find most helpful of all is 'Art and Sacrament'. The virtue of it is that he tries to make me understand what he's explaining to me: how the Christian faith is dependent upon the notion of art and that the notion of art is shown forth most gloriously in the sacrament, when you take the bread and wine. This is wonderful writing, to relate art to the central faith of Europe and the western world. And, of course, his first long poem, *In Parenthesis*, you cannot but be amazed at, but

when I move to his other poems I am often daunted. I find myself thinking, "He's really trying to write to himself rather than writing to or for me. He's not trying to explain matters, as he is when he writes his essays." Instead, according to his enormous knowledge of all kinds of things David is putting together a poem which primarily will show *him* what he's convinced about. Of his shorter, late poems, however, I do love 'The Hunt', for example, which I think is gorgeous. The difference with 'The Hunt' is that when I read it I find myself imagining there was a time when he as a boy must have rushed about in a forest and got his face torn by brambles. The real feel of the hunt he expresses vividly while at the same time referring you back to *The Mabinogion*, with its depiction of the hunt culture. That's really powerful. In 'The Fatigue' I can also understand what he's saying, the mood of it. He has the strange thought that some soldier from remote Gaul or Britain will have been on duty at the time of Christ's crucifixion on Golgotha and yet not have been aware of that event which signifies more than anything else what Man is. This concept that the Son of God dies for the sake of all Mankind has again and again enriched the arts of Europe. When I read this poem or 'The Tribune's Visitation' I am able to sense an aspect of what it was like to be a member of a Roman garrison in Palestine at the time of the Passion. Through his own soldiering experiences David makes the period come alive, the time when they hang "the gleaming trophy on the Dreaming Tree".

How did you and David Jones eventually meet?

It was through the painter Ray Howard-Jones, while David was living at Northwich Lodge in Harrow. Ray – no relation of his – I met on the island of Skomer and in conversation with her happened to mention my admiration for the work of Jones, saying how much I'd like to meet him but that I'd never had a reply to my letters. It turned out she knew David and offered to take me to visit him, which she did. I remember him coming to the front door wearing three overcoats. I say this because when we got up to the eagle's nest in which he lived and worked he took them off one after the other. What also caught my attention was a wonderful inscription above the mantelpiece. Since, it seemed to me, we immediately got on well together I asked him, "Why didn't you answer my letters?" and his reply was, "I thought you would be some bloody mid-European", but at the end he said, "Come and see me again whenever you're on your way to London". And that is just what happened. I used to phone David the night before saying, "I'm coming to London. Shall I call?" and he always said, "Yes". My memory is that when I arrived he would be looking extremely forlorn: his normal expression was one of deep gloom. He would begin by looking sad but gradually, as time moved on, he would become happier and sometimes he could be absolutely radiant. He had the biggest gamut of facial expression that I've ever encountered. He might look ecstatic or wildly unhappy. All in a single afternoon.

Raymond Moore captures this extraordinarily well in a series of photographs he took around that period.

First, I'd knock on his door and this little voice would say, "Come in". I'd go in and he would greet me, taking me by both hands, and then we'd begin to talk and before long I'd ask, "Can we have a look at some of the pictures?" He would reply, "Well, you know, I haven't got anything really now," but he'd take the portfolios leaning against the wall and open them on the table, turning over the paintings and telling me about each of them. He was very much concerned that I should be able to understand all the signs and symbols and be familiarised with the story; he was completely involved in making quite sure of that. This would take a long time and then, when I was about to leave, he usually held my hand and began on some other topic or perhaps would start another story. His stories took a long time, rather like his letters, and the end would bring you back to the beginning: they would be circular. At last I'd get away, reluctantly of course, and after I got home he might write me a long letter to make the whole matter clear yet again; you can see that from his wonderful letter about Tristan because in that instance he realised that I was just as concerned with the story of

Tristan and Iseult as I was with his picture. It's a mighty story and I knew it well because I'd read it in the earliest French version of Béroul, while studying at Oxford with Vinaver. David asked me what Vinaver's view had been and I told him. "Well, it's something like that!" was his response. Occasionally I would ring him up for a further explanation, either because I was lecturing on his work or because, in 1972, I was asked by Meic Stephens for an article, which I called 'Three related works by David Jones'. Again, in the winter of 1973, I contributed to the *Agenda* special issue on Jones an article on *Trystan ac Essyllt* and to the *Anglo-Welsh Review* an account entitled 'Another meeting with David Jones'. In this I made reference to our conversation and to a letter David had written me about the foxglove Mary is holding in *The Annunciation in a Welsh Hill-Setting*. He says he wanted something "sufficiently lily-like in form to keep within the iconographic tradition" but "most typic of the site intended", "that wild tir-y-blaenau" as he describes it. "It was the nearest I could get to the lily," he explains. You wouldn't have found a lily in the wild country of the Welsh mountains whereas you could have found a foxglove. And there was actually a foxglove growing in his garden.

So he goes into the garden and draws it to see if it will make a suitable equivalent for the lily.

The symbolic or metaphorical is fundamental to all painting and poetry but specifically to Mediaeval art. You need to know what everything means; if, for instance you see a columbine in a painting it relates to a dove and so symbolises the presence of the Holy Ghost or the lily, due to its whiteness, great purity. This kind of symbolism is what we would discuss.

How do you view these last two pictures of Jones from an art historical point of view? In Tristan ac Essyllt *and* The Annunciation in a Welsh Hill-Setting (Y Cyfarchiad I Fair) *we see Jones reviving a much earlier phase of the great European tradition. These pictures are akin to Dürer in their symbolic complexity, brim full of references, whereas in his work of the late 20s and early 30s the references are lightly touched on. This is a curious aspect of art history, observing a painter step deliberately out of his time.*

Blake was like that.

Do you not see Blake as ahead of his time as a painter?

Both. These two paintings of David's you've mentioned: I love each of them.

And you've written most persuasively about them but, after lecturing for so many years on the development of European painting, in what context would you place them? It was you, incidentally, who told me that Stravinsky wanted to buy The Annunciation. *When Stravinsky uses the style of an earlier period in his music he nevertheless always manages to remain a modernist. Jones seems more wilfully archaic.*

There is something pathetic and admirable in his final version of *Tristan ac Essyllt*: he dared to spoil it. And so he showed that the story is not capable of telling. All the details from the cat to the constellation are relevant. It's all very well to say, "It isn't really resolved." That is the problem of the picture: the story itself is still in the making. But to answer your question: I just accept these pictures as the achievement of a unique personality. He was a Roman Catholic with a deep intellectual concern for his faith and through it was related to a tradition going back beyond the birth of Christ because the Christian tradition contains a great deal of what went before. So he had within him, within his mind and experience, the ability to express aspects of a very ancient tradition which somebody who was not a Roman Catholic couldn't possibly achieve. David, after all, practised his faith every day of his life. And part of what I take delight in is the way in which he makes these images almost as though they were words, like the birds of Rhiannon he draws or the creatures of Culhwch against which he puts numbers so that we should be sure of the order in which Culhwch visited them.

Do you mean that in The Annunciation *there are actual numbers?*

Yes. You'll find each of the five creatures is numbered: the ousel, the stag, the owl, the eagle and the salmon, and that leads us back to the story itself 'How Culhwch Won Olwen' from *The Mabinogion*.

Jones's letters to you ranged over many topics.

They did, and so did his art. They were really extensions of our meetings and therefore quite different from those I received from other artists such as Ceri Richards or Fairfield Porter.

It's not easy to convey their variety. Certain passages start simply but end by raising intriguing questions. For example, you gave a lecture on the Welshness of Welsh painting and he writes to you about Richard Wilson, the first painter he thinks to have caught the Welshness in the landscape of Wales.

Wilson left out none of that. Of course Jones admired Turner enormously but without Wilson you can't have Turner or Constable. He's an essential element in that development of an interest among painters in the landscape of the British Isles.

But much as Jones loves Turner he says he feels that Turner did not catch the Welshness of the landscape as well as Wilson and then makes a point I've often wondered about: you may come across terrain in different countries which appears similar and yet it is subtly different. Jones suggests it's probably something to do with light.

I suppose so.

I wonder if it isn't also a matter of perception: we see places as different because we know them to be so? Has this become an issue for you when painting in so many countries?

I think the question is more interesting than any possible answer. The French say, "Vive la difference", and Bim and I have travelled widely because we are greedy for new places in which to paint.

I feel that Turner and Monet eventually free themselves from topographical differentiation – essentially they are an eye seeing – whereas for Jones place becomes of greater importance as he grows older.

For me the difference matters. In Venice, for example, year after year we paint the palaces and churches bordering the Grand Canal, as did Guardi, Canaletto, Turner or Monet. They are irresistible. Here in Wales we paint the sea, thorn trees, castles, wild flowers.

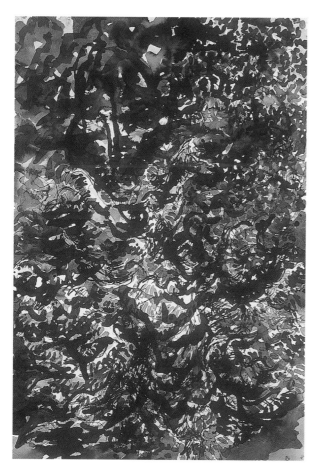

Black and White Foliage
57 x 38.5
watercolour 1976

Another point Jones raises is as a result of your talking to him about one of his paintings of flow-ers in a chalice. He gives it a title in Welsh, Caregl Blodeuol, *meaning 'the flowering chalice' but, as soon as he writes that, he adds that it has other meanings too: it's also an allusion to a girl made by magic out of flowers,* Blodeuwedd *from* The Mabinogion. *Jones makes the point, perhaps to you and certainly in his essays, that if he paints flowers he is reminded of the goddess Flora. When you are painting flowers would you think in that way?*

No, I wouldn't. I'm wondering why I don't.

My pleasure in looking at your flower paintings is in looking at the flowers. I do not sense a need to consider the goddess behind them.

The picture takes you from the painting to the flowers, that is to say it is transitive. In look-ing at the still life paintings by Jones I am struck by a similarity to Zurburan in one respect: they look as if they are made for an altar. Jones's paintings always imply more than we see. I'm deeply in sympathy with David's notion that poetry and painting are based upon the metaphor that what we see we see with the mind and not merely with the physical power of the eye. We see through the eye and with the mind, and the mind incorporates all the metaphorical aspects.

To my surprise some of his letters at times veer towards the psychological – almost inadvertently it would seem. You sent him a copy of the Everyman edition of Mallory and that prompts him to discuss an unfinished drawing of his of Gareth of Orkney and Dame Lyones, whose attempts to make love are repeatedly interrupted by a heavily armed knight breaking into the room. Jones writes, "It struck me as being of great psychological interest, and symbolic of certain realities."

This has to do with his deep understanding of his Roman Catholic faith and also of Mediaeval thought. In this respect we came together considerably because, as I told you, I'd studied both French and Italian Medieval literature. In that story what is disturbing is the sense the lovers have of the sin of lust and, countering it, this overwhelming sense of being in love. The battle between the sin of lust and the tremendous impact of love is what fasci-nates him, as in the story of Tristan and Iseult.

This apparently reminds you of a passage from Petrarch.

It was while he was staying in Avignon that Petrarch went up a mountain – what he calls the Monte Ventoso, the windswept mountain – and when he reached the top he revelled in the splendour of what he was seeing, rather like Leonardo in the mountains making his wonder-ful drawings, but Petrarch suddenly reminds himself, "What I am enjoying are the pleasures of the senses". He becomes aware that these pleasures lead to sin and writes:

> Nothing is wonderful but the soul, which, when great in
> itself, finds nothing great outside itself.

You would see this as akin to Jones's thinking. Do you have sympathy with such a dilemma or antithesis yourself between flesh and spirit?

No. Flesh *and* the spirit make a man.

I'm frequently reminded of his poetry in reading these letters because a great many of them are concerned with etymology, word forms, their transformations, recessive meanings, mistranslations. Jones writes of a text being 'highly ambiguous' and obviously is intrigued by that.

He's well aware of the fact that you can't, by means of words, necessarily say what is in your mind and that is one of the reasons why both music and painting exist independently: there's a great deal that is unsayable.

Another comment on a certain passage reads "What the true significance may be I do not know" and that could be said of Jones's own poems at times. Or he writes "There is clearly a great complexity surrounding these matters" and I again have the sense that he takes delight in that complexity.

The delight was in finding himself up against these difficulties.

Despite his acute sense of history I don't think either of us would wish to give the impression that Jones was removed from the art of his time.

Not at all. Once when I went to see him I'd just been to London and on an impulse gave him the abstract relief construction I was bringing back, which I was happy to see he took great pleasure in, telling me why he liked it.

Yes, he hung it on the wall amongst his own work and I'm told he spoke to others about it with equal pleasure.

On another occasion, knowing my devotion to the story of Tristan and Iseult, he gave me one of the pencil studies for his picture.

You said earlier that on your first visit one of his inscriptions caught your eye. That doesn't surprise me because the inscriptions combine this sense of ancient and modern in marvellously idiosyncratic ways. Mention must also be made of the extraordinary beauty of some of the pages in these letters. He has a habit of leaving the left-hand border free and can, therefore, add in anything he wants and these addenda are often in different colours. Then, as he grows older, the top of his column of writing will be much wider than it is at the bottom. It tapers off considerably.

He doesn't do it on purpose. He doesn't strive for it. All that is an intuitive gift for visual presentation, isn't it? He can't help it.

But he turns it to magnificent effect because what happens intuitively in the letters is developed further in the plotting of his inscriptions – the letters sometimes demonstrate the possibility of further inscriptions – and had printing been as evolved as it is now his poems could have been laid out across pages in much more astonishing ways.

The lay-out of his letters had to do with a need he felt to annotate what he'd already written. He wanted firmer explanations but at the same time to continue with the narrative, so he organised his letters to satisfy this need. That's the point. He once said to me, "I'll do an inscription for you," but in fact he never did; instead he gave me the drawing. And when I was a member of the committee of the Welsh Arts Council, at one meeting the question arose of how the Investiture of Prince Charles as Prince of Wales at Caernarfon Castle might best be commemorated. I suggested we ask David Jones to make an inscription relevant to the occasion but when I did ask he looked at me and said, "Arthur, the Prince of Wales was killed in a minor encounter in a wood in 1282."

One of the most important dates in Jones's calendar.

That story is indicative of his living in all ages. He didn't just live today; his thought encompassed thousands of years.

People have told me that they never experienced so vividly a particular historical period as when in conversation with him.

It had something to do with this understanding of eternity that Blake had so intensely:

> To see a World in a grain of Sand
> And Heaven in a Wild Flower,
> Hold Infinity in the palm of your hand
> And Eternity in an hour.

Similarly, everything was present to David.

And I would suggest that is why Jones's long poems were so difficult to make: they had to be inherently epic because he sought to encompass all of time.

That story of Tristan and Iseult from the Middle Ages, and God knows from where else, is as immediate to him as eating lunch, and perhaps far more important. Once I happened to mention Caldey to him. He repeated, "Caldey? What do you mean? You mean Ynys Byr – those bloody Scandinavians!" Well, the Scandinavians overran Caldey centuries ago but as far as he was concerned it was yesterday!

Sometimes while the work of an artist is outstanding, you don't get a feeling of greatness emanating

from the actual man or woman you are meeting. Did you sense with Jones that you were in the presence of a man who, in some humble way, was great?

Not very humble; I didn't think that. I found him confident. He was confident in his faith and in his art. He made it clear to me that he knew T.S. Eliot and had the admiration of Kenneth Clark, so it was evident that he was highly regarded. I don't think he did it purposely but he established himself as an important person, which I already recognised because I'd studied the Penguin book on his paintings by Robin Ironside.

Did he seem to you a great man?

Yes, great in terms of independent thought in relation to the current run of materialistic views, a man in touch with the long tradition of Roman Catholic theology and aware of the fact that he was battling against what he saw as the evil of our time. He took on the big issues. He had considered contemporary attitudes, the basis of contemporary life and current beliefs, and he found them altogether inadequate.

Did you find him in any way saintly, as the poet John Montague has said to me?

I think he was a suffering man, the normal state of his mind was of suffering, but at the same time he was capable of a kind of radiant happiness. He was capable of jollity, he'd laugh, he would be delighted. Another point I remember was rather odd: I once interfered with the arrangements for his lunch, which was about to be brought in – I've forgotten what I did – and he said, "Ah, no, no, no. This has got to be done properly." So the actual laying of the table was a rite to him. He was very particular about that and then, after the woman had given him his lunch, he took some of the meat, wrapped it in *The Times* and put it in the wastepaper basket. I watched in some amazement as he explained, "I don't like to hurt their feelings." He didn't want to have them think they had not satisfied his needs correctly.

In his finest letter about the making of his preliminary drawing for Trystan ac Essyllt *he quotes from* The Battle of Malden: *"As our might lessens, so our will strengthens." Here, once more, I wonder if he, as an elderly man, may have been implicitly alluding to himself?*

I don't think it's only true of elderly men. It's true of anyone tackling the problem of making a work of art. You work very, very hard and your power begins to fade and then it is by means of your will, rather than your gift, that you achieve the final work. I value most particularly that notion.

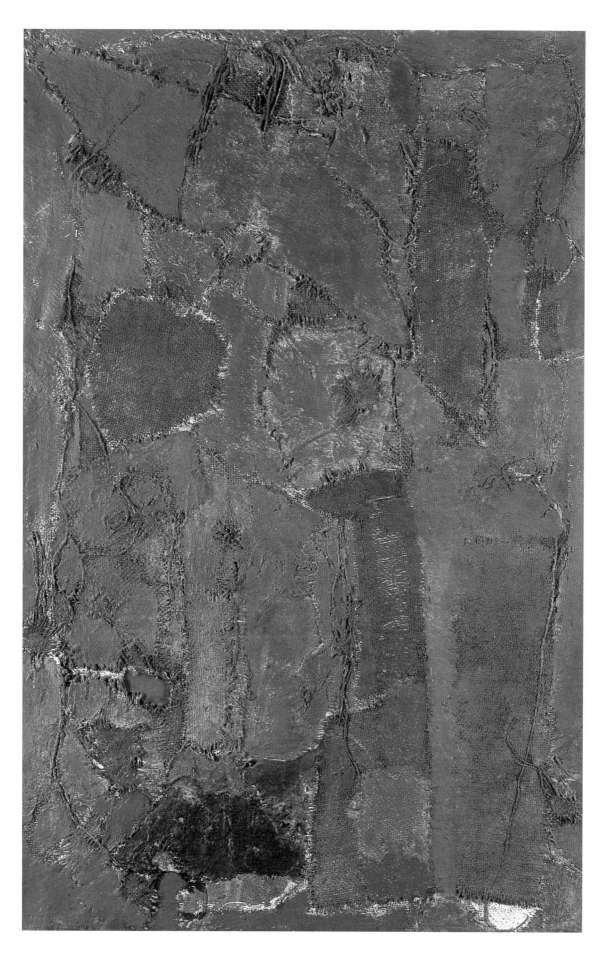

Pendine Panel 91.5 x 61 sacking, string, pigment on board 1955

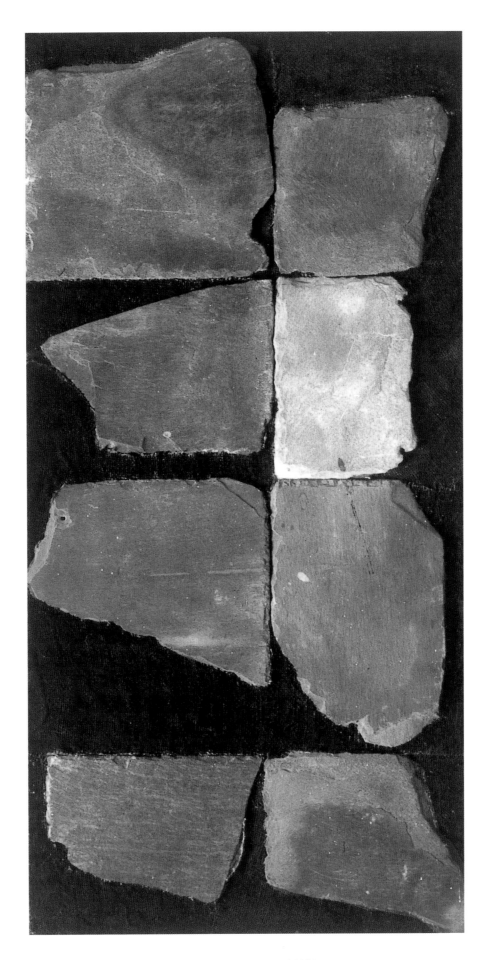

Telpyn Panel 91 x 45.5 slate, sacking, pigment on board 1956

Marros Panel dimensions unknown, slate, sacking, pigment on board 1957

Carmarthen Bay I 91.5 x 45 sacking, wood, cork on board 1956

Carmarthen Bay II dimensions unknown, sacking, wood, cork on board 1957

Winter Sea 121.5 x 91 wood, sacking, pigment on board 1962

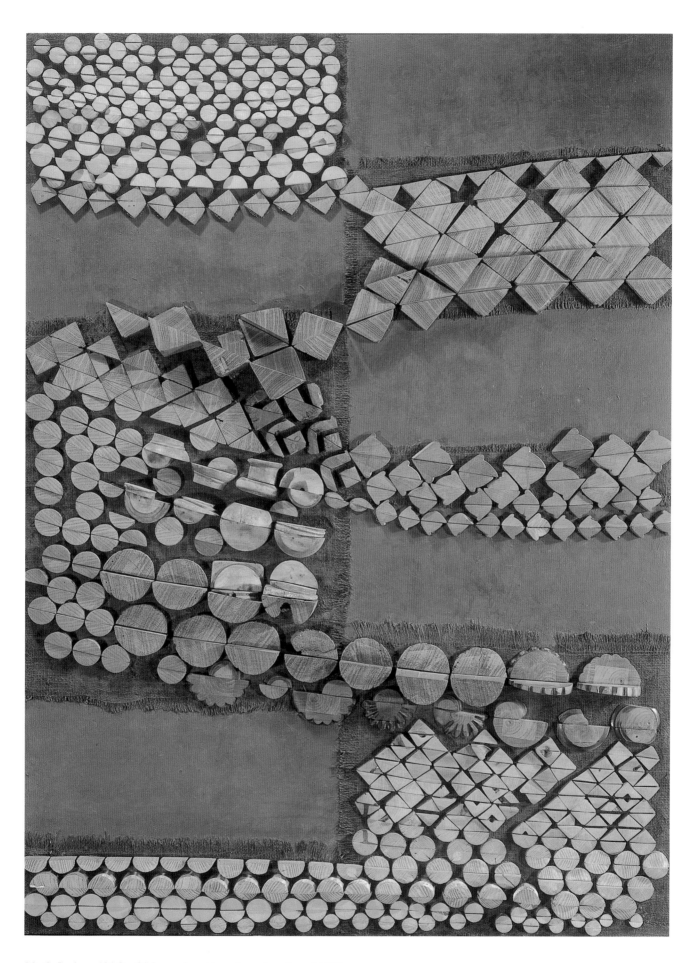

Morfa Bychan 121.5 x 91.5 wood, sacking, pigment on board 1963

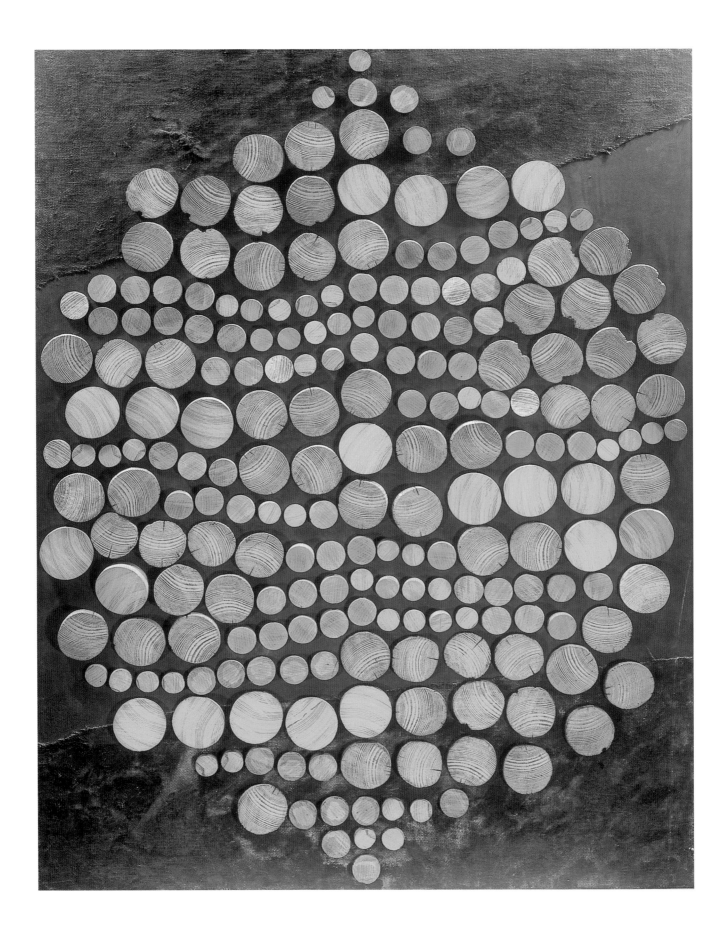

Black Fugue 122 x 91 sacking, wood, pigment on board 1965

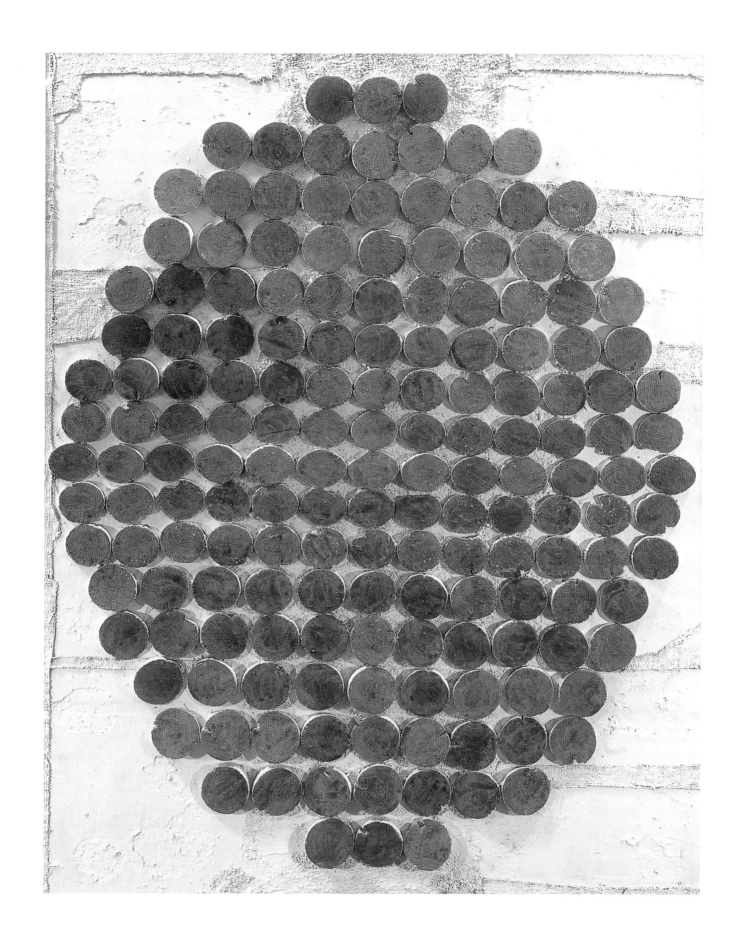

Between the Violet and the Violet 161.5 x 91 sacking, wood, pigment on board 1966

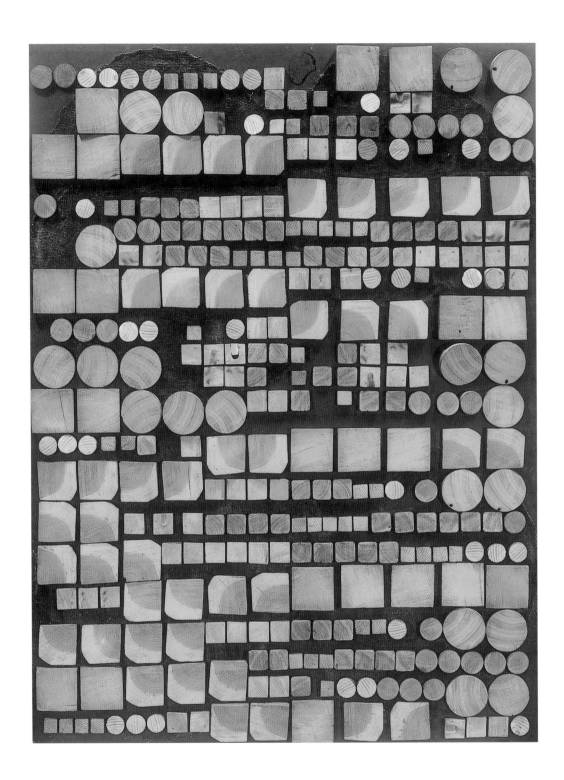

Five Part Invention 122 x 91.5 wood, pigment, sacking on board 1961

Beach Rhythms II 24 x 70 wood on board 1959

The Hub 91.5 x 91.5 wood, brass, sacking, pigment on board 1967-8

Evening Sea 91 x 91 brass, wood, damask, pigment on board 1967

Semicircles 121.5 x 91.5 wood, pigment on board 1971

Reflections 91.5 x 91.5 string, wood, pigment on board 1968

Jetsam 45.5 x 33 watch parts in wood panel 2000

Time Pieces (maquette for Brook Street door) 29 x 33 watch parts, pigment on board 1972

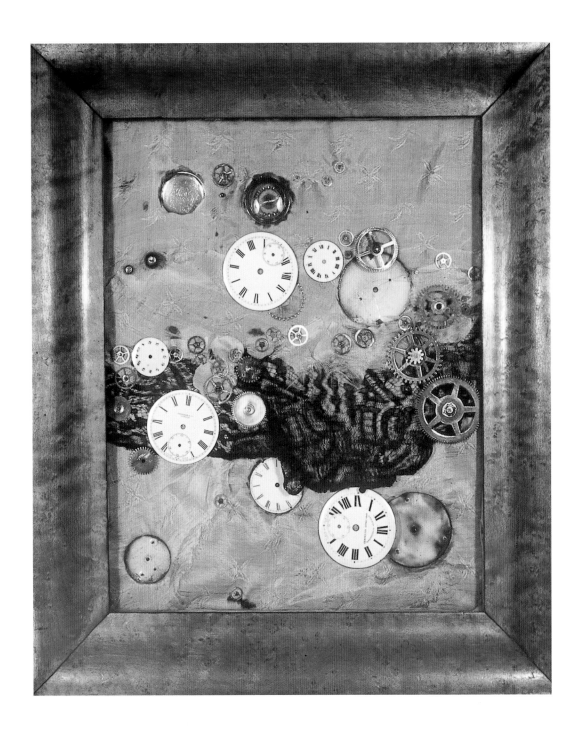

A la Recherche du Temps Perdu 36.5 x 30.5 silk, lace, watch parts on panel 1968

Eternity the Other Night 51 x 44.5 silk, watch parts on panel 1973

Between Tides 57 x 66 paper, paper rings, pigment on board 1981

The Wave 61 x 81 paper, paper rings on board 1976

A Shoal of Time 94 x 77.5 paper, ink, glass, shells, stones, watch parts, coins in wood panel 1995-6

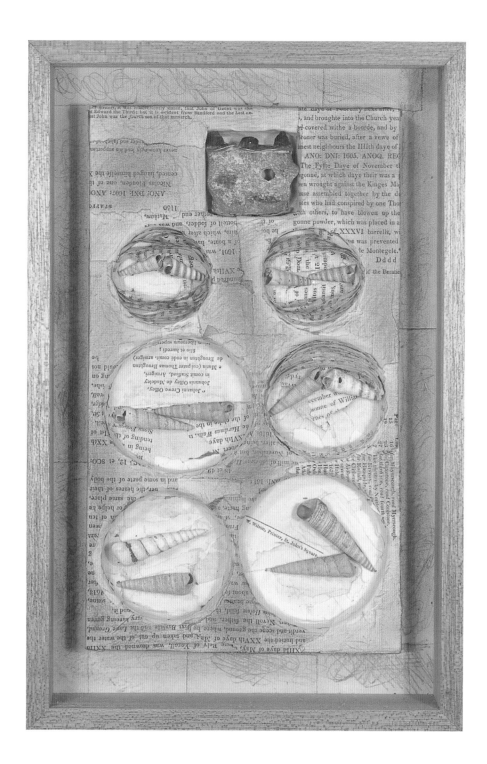

Once Upon a Time 32 x 21 paper, graphite, shells, metal 1997

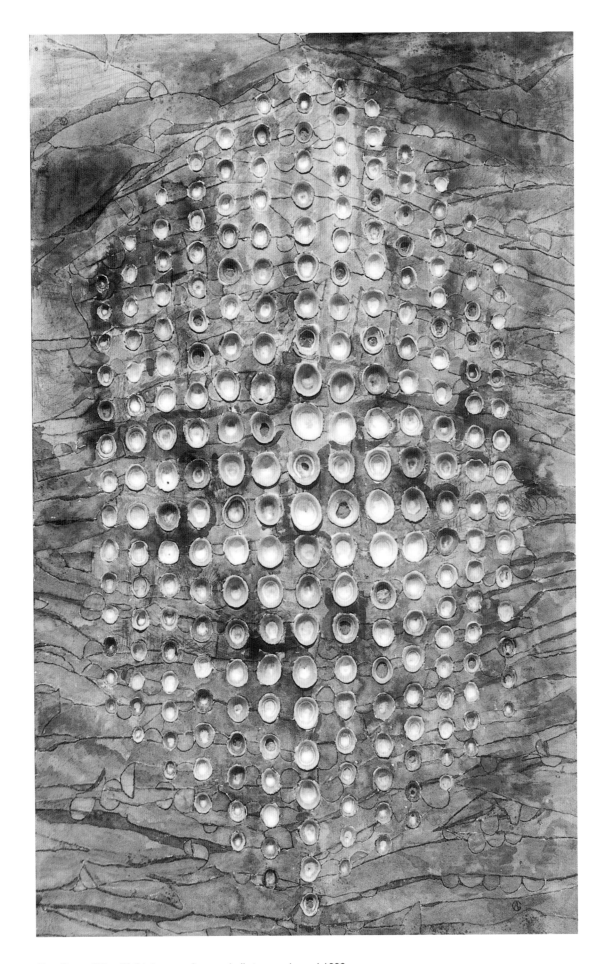

Dwellings 122 x 71.5 ink, paper, limpet shells in wood panel 1999

NINE

From being a school-teacher of languages and of music you became a lecturer on the history of art and music. From that developed your guide lecturing for exhibitions of paintings in Wales and this led to your making broadcasts, the most important of which were a series of interviews recorded in 1965-6 with five painters and a photographer for a B.B.C. Wales programme, Spectrum. *Can you recall how they came about?*

I believe it started by my being asked to comment upon the Eisteddfod exhibitions. This I found fascinating. I would go up to the Eisteddfod to select whatever I considered to be of interest and then be interviewed by the B.B.C. After doing this at least twice it was decided that I should conduct a series of interviews and I was asked to decide which artists I would like to select. The programmes were divided, I think, into two sets of three, the first in 1965 and the second in 1966. I travelled with a B.B.C. technician, who made the recordings, and we visited all but one in their studios; the discussion with Raymond Moore took place instead at Broadcasting House in London.

Whom did you select?

John Piper, Josef Herman, David Jones, Ceri Richards, John Selway and Raymond Moore, the photographer. Only Graham Sutherland refused, for whatever reason.

Major figures, most of them famous.

They were all artists I knew personally, except Sutherland. I selected according to my own judgement. There are famous artists I've never had an opportunity to interview. It occurs to me now that I didn't interview Ernest Zobole, and I have a great admiration for his work.

What led you to include amongst the others an artist who was far younger and much less well-known?

I chose John Selway because I admired his work. I met him again recently; he's now teaching at Carmarthen School of Art.

He's still a painter?

He's a good painter. Contemporary celebrity isn't a proof of quality.

I wondered why you hadn't included Cedric Morris?

It suddenly occurs to me what an extraordinary thing not to have done. I'm astonished. However, it would have meant going over to Suffolk and perhaps that was a bit beyond what was expected of me.

By way of introduction I should describe your manner of working. You adjust yourself to the presence of each artist, coming across as thoroughly professional, well prepared, at ease and always able to improvise in response to where the artist may lead you. Your voice, although cultivated and precise, is carefully modulated, even cajoles at times by its gentle tone, but you are persistent, knowing when to interject – nimbly side-stepping interruptions – if you see the need to make a point clearer or amplify it, gauging when to probe, provoke or be directly confrontative. And I'm struck by the way you keep in mind the ordinary observer's probable questions while being sensitive towards the painter and admiring of his art, if need be describing a particular painting in considerable detail. You help him focus, lead him towards another aspect of his work or discuss its relation to the public in terms of sales, patronage, commissions. Wales is of predominant importance and usually figures in your opening questions. Ceri Richards and John Selway were Welsh artists, David Jones had a Welsh father while John Piper, Josef Herman and Raymond Moore discovered, for different reasons, a particular affinity with Wales. What, for instance, made you choose John Piper?

I chose Piper because I admire him enormously – because of his integrity. When I look at his work I feel there's a health in him which I don't find to the same degree in Sutherland. He's a fascinating English painter with a love of Wales; he re-alerted us here to our own culture and traditions. In the interview I asked him, "Why do you paint Welsh chapels?" and his reply was that "They are very often the most gorgeous feature of the Welsh village, architecturally Italianate in feeling." He recognised in them remote echoes of the grandeur of the

Renaissance. Nobody else had seen that. I was also intrigued by his ingenious way of making collages – through collage he'd make his chapels. He'd collect all sorts of paper and then stick selected pieces down before drawing details of the chapel on top. I think this very likely inspired me or re-enforced my own practice.

Hearing him describe the different varieties of paper "collected all over the place" and his use of scissors and adhesive I was reminded of Schwitters. Piper called his procedure "a primitive form of hard-edged work" and when questioned further connected it with Cubism. You then wondered if the name of a chapel also had an impact on him, a poetic overtone. You mentioned that you saw grief in a picture of Gethsemane Chapel.

He thought there was a good deal in that and cited romantic names such as Bethlehem or Salem, "like a small poem in the middle of a large landscape", he said. "One sees them on the map and wants to go to them." I was interested in the breadth of his culture: a writer on art, a lover of architecture and music, a devoted Christian.

You discuss also his painting the landscape of Wales and ask if it was Welsh landscape which had wooed him away from pure abstraction.

Piper explains that he came to Wales after having been an abstract painter for five years, which had left him feeling "constrained, rather limited in range". "I wanted to nourish myself... with some forms from nature by looking more closely at nature and Wales was where I did it."

That reminds me of what you have often said and I wonder how you respond to his further aim? "I was trying to get at the bones of the landscape to understand what the mountains are basically made of, the geology if you like, to see what is underneath, what one walks on." You seem in your watercolours to be more concerned with the lushness of foliage or grass or hedgerow.

I like most the bare trees of winter and the coast where the land meets the sea. I draw the flowers in the hedgerow and pick up shells on the beach. Such things take me back to my boyhood. When I get into my studio my memory still holds the forms of nature, which I've watched and painted on the spot.

Towards the end you describe most eloquently one of the Welsh landscapes Piper is painting and you both speak of the eye and the hand working together through gesture "to create a form, a cliff or a great rock" you tell us. "Is it rather like a ballet dancer's movement?" you ask him. Here I was reminded of what you loved about the gestures of Hans Hartung, but they create an abstract image rather than the form of an identifiable object, don't they? Calligraphy has these two discrete possibilities.

Hartung made his pictures out of the meaning that lines and colours have in themselves.

Almost at the start of your interview with Josef Herman you ask a question which leapt out at me as being one to put to you. When Herman speaks of his decision, as a young man, to become a painter your first thought is to query his father's reaction. You haven't yet mentioned to me your own father's – or mother's – response to your finally becoming a professional artist after you moved to Llethr and began to exhibit in London.

When I was asked on the occasion of my appointment as lecturer at Aberystwyth what research I would do, I replied that I was an artist. That was acknowledged as an adequate reply. By then my parents and I knew that I was an artist and that also I had to make a living.

The impact of Wales on Herman, a Polish Jewish refugee, could not have been more different from that of Piper. "Sheer chance" he says took him to the south Wales mining community of Ystradgynlais – he went for a fortnight's holiday – but he adds, "Something told me I would stay." After three years in Scotland and one in London, "I felt the need for new roots and a new environment." Amazingly, he stayed for about eleven years in all. Or was it so surprising? On quitting Poland he had settled in Belgium for two years and discovered that there could be "a link between the artist and the community". "A fundamental earthiness" prevailed, "art with a small a, not a capital A." In Ystradgynlais it was the coal-miner who became his whole subject and by extension the town and landscape of which the miners were part. "A few telegraph-poles on a road" might

inspire him. You lived in Dowlais at the same period and have described in one of our earlier conversations what it looked like. To a complete outsider such as myself it sounded as if there was an almost awesome grimness about the whole area. Were you, like Herman, ever attracted to paint or draw that feature yourself?

I made drawings and paintings in Dowlais because that's where I first practised what Cedric had taught me. I know I made an oil painting in the garden at the Quaker Settlement but the idea of painting Dowlais because of what was derelict never occurred to me. It is the excitements derived from nature which are the source of my art. And it was John Dennithorne who first quoted to me the mystical passage from Traherne I've already referred to.

For me Herman is most engrossing when you ask him about his subject matter. Apart from the impact of Wales on each artist this is your principal theme. Your precise question is, "What makes a subject attractive to you?" and here is his answer, "This is a very important problem. In our times no single element has been so much neglected. The subject matter is one with the artistic imagination. It's not something that you apply: it's one with the symbolic effect of the form." He then elaborates, "Once you discover your own style the whole world somehow becomes more alive and you find everywhere the same form, tonality, the same subject, the nearness of the same moods." What could be more succinct or authoritative?

Ever since we'd made bows and arrows or music pipes or decorated our leaping poles with our knives I had made things. At home we had pictures so I made pictures. They have always been about where I'm living or where I've travelled.

Herman regarded what he painted as the key to anything he did later. He found himself attracted to the theme of the labouring man and from this male standing figure – with "very little happening" – was able to develop "a whole set of symbols". He sums up, "In all, my period at Ystradgynlais is the most important in the whole of my working life."

What Ystradgynlais was to Herman Dowlais was to me. The acknowledgement of my painting by an artist of Cedric's calibre gave me enormous confidence.

Your interview with David Jones forms part of a broadcast celebrating his seventieth birthday, beginning with a short tribute by a fellow poet, Elizabeth Jennings. This is followed by no more than an extract of a conversation between you and Jones which ends with your request that he read his poem 'The Hunt'. As a result you have little time to emphasise the transformation of Jones as a painter – somewhat similar to the experience of Josef Herman – when he encountered the Welsh landscape around Capel-y-ffin or the coast of the island of Caldey. Instead you focus on his preoccupation with 'ancient love stories', particularly the two complex pictures we have discussed in our last conversation: The Annunciation in a Welsh Hill-Setting *and* Trystan ac Essyllt. *Your enquiry about the first picture is apt, "Why did you situate the Annunciation in the Black Mountains?" a question that could have been asked of so many Mediaeval or Renaissance artists who, often astonishingly, vary the location of biblical scenes. His reply appears deceptively simple, "I have to have some physical contact – a thing I really know about." This allows you to shift his attention to the second picture and have him speak of his problem with the selection of an appropriate type of ship for the lovers to sail in. He remarks wryly that he had to avoid the scene looking like the death of Nelson and adds to his previous statement, "I jolly well have to know exactly how things work before I can draw them." This surely allows us now to understand why he does something extraordinary in depicting the structure of the ship: he draws the ribs outside rather than within the vessel. In a letter to you he had written "pure licence, a bit of surrealism if you like", but, paradoxically, by turning the ship inside out he can show more of how it is built, thus pivoting our attention towards its making, the thing in itself, rather than have us concentrate on what type of vessel it may be. For Jones the art of making is a crucial human activity, art a sacred kind of making, sacred because of having otherness, significant because gratuitous. Many years later when writing about his paintings you quote St Thomas Aquinas: "the corporeal metaphor of spiritual things" you see them as being.*

What David calls *Manawydan's Glass Door* is a piece of paper on which he's drawn with a

pencil and then stroked on coloured pigments with a wet brush. He made the picture in one of the Hove seaside villas built bang on the beach; at high tide rough spray would break right over them. A clue to the title he gave the work can be found in Lady Charlotte Guest's translation of *The Mabinogion*, where he first read of Manawydan, who remains four score years in a palace on the island of Gwales – Gwales is thought to be the wild island of Grassholm, west of the Pembrokeshire coastline. Manawydan waits there before taking the head of Bran, his king, to London. "See yonder is the door we may not open." David saw himself as having waited behind a similar glass door before he started writing of his wartime experiences in *In Parenthesis*. Such rich and varied material is condensed into a "corporeal metaphor of spiritual things."

Speaking of the corporeal how obliquely he responds when you ask him about the theme of Aphrodite, "I just suppose that is because people love girls."

Because of the "difficulty of his friendships with women" and his "fear of sex" his heterosexuality has been called in question by some reviewers. I wonder who in his right mind is *not* afraid of sex. It embraces the whole gamut of emotions. It's about as pacific as the Atlantic!

His visual work makes abundantly clear his predilection for women. During your visits did your conversations relate more to his art than his writings?

On the contrary, we did talk about those also. He gave me his publications as they came out and signed them. Our conversations sank deep into my mind and enriched my understanding beyond any expectation, which nobody else could touch. I read your whole book on David as one who loved the man; he was not a tragic figure but rather a great comic one: the idiot, the clown, a man who like Cézanne knew, "Je suis faible dans la vie." That was no pretence on David's part, he was so.

Just before reading his poem he sheds his reserve, "My great grief is that I can't speak Welsh, or can only read a little, and that was my grandfather's fault because he disencouraged my father from speaking it and the link was, to some extent, broken. That I've never forgiven him for." While your son was a pupil at Llandovery College you began to learn Welsh from one of the members of staff. Why was it that you broke off your lessons?

Llandovery College generously lent me a room in which to give my University lectures once a week and in return I taught some boys painting during the afternoon. While talking with a member of staff, Carwyn James, a famous Welsh rugby player and later coach of the British Lions, I mentioned that when I was given my job as tutor at Aberystwyth I'd said I'd learn Welsh. "But who can teach me?" I asked him. "I will," he answered and despite my offer he adamantly refused any payment for lessons. He came a few times to Pendine but more often he taught me in the evening of the day I gave my lecture at Llandovery. We got far enough for me to try out my skill on Peggy Richardson, who helped us at our guest-house, but when I addressed her in Welsh she retorted, "That's old preachers' Welsh!" There was no Welsh spoken in Tenby or Pendine so I was unable to make progress. And I was overwhelmed with work but I did wholeheartedly support the Welsh language campaign of the 60s and 70s and much admired the stand taken by Saunders Lewis, whom I knew slightly.

Jones's reading of 'The Hunt' takes the programme to another level. It's hard to believe it is the same man that has answered your questions who now compels the listeners' whole attention: he matches the rhythm of his voice to the gradually accelerated pace of the huntsmen riding in pursuit of the boar until by the end his rendition has attained an incantatory fervour. Nowadays we tend to forget how capable the voice is of shifting into poetry or song – an ability which has, however, not been forgotten by the Welsh.

David was glad to be asked to read his poem. He knew that it needed his voice and his rhythm.

You often talk about Ceri Richards so presumably you knew him well before interviewing him?

What I recall about Ceri is that I went to see him in London because of an invitation when

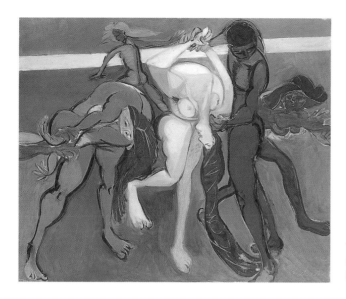

The Rape of the Sabines
Ceri Richards
81 x 98.5 oil 1949

I was buying a watercolour from him at the Glynn Vivian Art Gallery in Swansea, in about 1954. I saw him several times and then there came a period when I travelled to Paris frequently to visit the galleries, on the recommendation of Gimpel, and was beginning to buy what I could afford. After a while I went back to see Ceri since I would always include calling on an artist on my trips to London; sometimes it would be Ceri, later it was David Jones. I remember his greeting, "Oh, I thought you'd stopped coming," which was a very nice one as it seemed he had regretted that I'd ceased visiting.

Your understanding of how oil paint might be used changed when you met Richards.

When I saw Cedric Morris painting in a certain way I painted like that. When I went into the studio of Ceri I saw something quite other.

Whenever you called on him would there be much conversation about art?

It was almost entirely about art. He always took me up to his studio and showed me what he was doing – this was what I loved – and I would take him my work to look at. I remember a relief sculpture I'd made, which was to go to America, that Ceri had a look at and thought the colour unsatisfactory so I repainted part of it as a result of his comments. We did almost always discuss one another's pictures. I was more interested in his, maybe, than he in mine but he was generous. I had a profound regard for Ceri. He was a unique kind of person. After he died his wife said to me, "He was a lovely boy," and I felt that really described him. He was so delightful a personality. As well as being Welsh he had French blood and I think I quickly realised that in his painting he went right back to Titian through the great tradition: Titian, Rubens, Delacroix, Matisse and Picasso. He's part of that European lineage, not in the least like Paul Nash, let alone Ben Nicholson. As you know, he was devoted to the art of both Matisse and Picasso and as a result, I believe, has been critically underestimated. He has a natural genius for drawing, brilliant drawing of naked people, and is a superb organiser of forms, superior to Bacon, for example. Bacon doesn't relate figures to one another but Ceri does, wonderfully. Not only that. He uses colour like Titian. His Welshness provides the passion, an immediate response to feeling – it's his lyrical quality that is Welsh – and he loved poetry and music. He read a great deal of poetry and had been involved with music since his childhood. His instrument was the piano and sometimes he would play for me.

Almost at the start of your interview you ask him how he translates poetry or music into the forms of painting: paintings based on poems by Dylan Thomas or derived from the piano music of Debussy. His answer is relaxed, and I find it heartening, "I do not think that these art forms should be so exclusive... they overlap quite a lot. Painters are interested in writers, poets are interested in musicians and music. I think there's quite an easy interplay between those particular arts." From your own experience as an artist have you found that to be so?

I've already talked about the impact of poetry or literature on my work and have mentioned that while teaching in Folkestone I'd go up to London to take viola lessons from Ernest Tomlinson. He encouraged me to study harmony and counterpoint with a view to taking a music degree, but all this stopped when the War began.

Then you become more exact, "What made you first make a picture about a poem?" and Richards answers, "I'm quite instinctively interested in making my forms metaphorical. As well as having the visual representation... there's also a deeper level of meaning. It's not merely representational in an objective way. It also has this overtone of symbolism. "A symbolism of what?" you enquire. "The cycle of nature. Existence is a form of complete cycle: birth through life into death, like the seasons backwards and forwards, incessant. The whole creative process is that and death is part of it, just as birth is." He then poses a question, "Why should an artist do something, make something, which he feels has got an element of permanence – when he himself is going to disappear?" and concludes with an essentially spiritual comment, "Anything that's worth doing has an element of permanence. It extends beyond the moment of doing."

Where art is concerned the passing of time is not necessarily destructive: Homer has not become out of date nor the walls of the caves of Lascaux.

In speaking to you about his series of paintings inspired by Debussy's La Cathédrale Engloutie *Richards is able to provide an example of what he sees as "the easy interplay between arts". He points out that he is doing 'the third thing': Debussy worked from literature – using a Breton legend he'd read of the submerged cathedral of Ys – and he, Richards, from Debussy, turning music into a representational art form.*

I agree with him entirely. When Schubert takes a poem by Shakespeare and sets it to music, he not only draws our attention to the poem but enriches it.

When you ask about his commission for paintings and stained glass in Liverpool Roman Catholic Cathedral he remarks on how difficult it is now to use religious themes, "You've got to introduce the same lofty feeling, an equally profound feeling of spirituality, into any sort of forms that you use. And I think abstract forms can possess this because you feel the quality that does emanate from the great works, spiritual quality, is an abstract quality really." Having heard what Josef Herman has to say about subject matter I find myself querying this statement. I don't believe you can detach the impact of abstract shapes or forms from the figurative theme, do you?

Any work of art is an abstraction. The artist, musician or poet expresses what is possible in the medium he uses, according to his intelligence, skill and emotional sensibility. When we read the poem or hear the music we use our own qualities of understanding. Hartung and Mondrian, with their colour, tone and line, are nearer the musician, who is master of sound and rhythm. The musician when he composes a song, holds the hand of the poet.

In the Curtis interview he states that none of your work has been specifically religious. Would you agree?

I wonder what he means? Most recently I've made two small watercolours of the snowdrops which shoot up under our thorn trees. First they drop, then when the sun shines they spread their petals widely, and now they've been blasted by icy winds from the north. For some months previously I've been working on a 3 x 3 ft panel composed of limpet shells I pick up at Freshwater West or on the sand at Angle. You find them among the rocks and the sea washes them in at high tide level along the beach. They're dwellings made of sand and rock and sea by their departed inhabitants and are no less beautiful than flowers. My problem is how to introduce them into a home. They don't any longer serve a useful purpose so David Jones would, I imagine, accept my work as being religious.

Provocatively you ask Richards about the influence of certain other artists such as Ernst, Matisse, Picasso in his paintings – a question often raised when considering his work. He answers, "Your implication is that I should be annoyed. Not a bit. I moved from one enthusiasm to another quite instinctively because those particular artists have answered my enthusiasm or feelings at a particular moment." And he sums up, "I'm trying continually to find a definite expression for my own

capacities and see how to find the right sort of definition in my work and I use anybody who comes along who I feel is working along the same track."

I don't want to speak intellectually about this, even if I could. I can only say how I look at pictures. I don't assess Ceri art historically, or anybody else. I see a picture in a gallery and think, "It's marvellous. I'd like to meet that chap." Then I go and knock on his door and have a look at his work. I just look at Ceri's drawing and love it or his colour. I don't say, "He hasn't escaped from Picasso." That isn't my approach; I'm not a critic. I simply try to help people to enjoy the great tradition that we have. We've got a fine draughtsman, a lovely colourist, who's so Welsh! In the art of Ceri there's a kind of physical passion, an ardour, an adoration of the beauty of a naked woman or the movement of a naked man and a sense of the music of colour. When he attacks a canvas it seems to me that this ebullience, this Celtic temperament, comes pouring out across the surface. There are pictures of Ceri which I don't much like but I don't analyse them.

You had a long correspondence with Richards.

There are many letters to and from him. Because I thought him a magnificent draughtsman and painter I bought pictures or drawings from him for myself and, as a result, my children and a number of my friends have pictures by him. The University of Wales asked me to recommend the buying of work for Aberystwyth and Swansea so other pictures were acquired in that way too. All of this understandably involved much correspondence. I also remember attending a lecture by Ceri at the Glynn Vivian Gallery. He was explosive in his lecturing but intriguing to listen to. On the other hand, I didn't altogether agree with some of what he said and wrote him a long letter. He replied with a fourteen page answer, which I found quite difficult to grasp but some of the points in it I recollect vividly. For example, he quoted T.S. Eliot: "Each poem is a new start and a different kind of failure." I had to think hard about that and came to the conclusion, "How true it is that that which is perfect can sometimes look rather dull." I imagine every real artist has a sense of failure and it's that humility Ceri is insisting on as an essential factor. The chap's an artist who says, "I must do another because I'm sure I can do better." What I also loved about this letter was that after fourteen pages Ceri writes, "Mustn't think so much but work on." That was typical of him: he expressed himself spontaneously in a flow of words. He was uninhibited in talking but I don't think he found it easy to write.

Did you see him long before he died?

Within a week of his death. He had been taken on by one of the top London galleries and he found their methods oppressive. They said to him, "We will multiply your prices by four and later on we'll put them right up." This has to do with the dealing conventions in London, nothing to do with quality. It's simply a matter of promotion, which is something I detest about the whole situation an artist finds himself in. Henry Moore began to rise in fame and then it was Sutherland and Piper. Ceri's gallery started to neglect him and he found that depressing. He hadn't that kind of ambition and he didn't like to be pushed into making a series of this or that subject for them. When I last saw him I asked where a particular big picture of his was. His dealer had taken it. He said, "I didn't want it to go but he gave me £1,000 for it." He was damaged by all of this. If only he'd been allowed to float on according to the demands of his genius. Essentially he remained a young man from Swansea.

He had a remarkable voice, the sort of sonorous voice we've already commented on when speaking of Dylan Thomas or Keidrych Rhys. Beautifully modulated, with a musical tone to it: emphatic, clear diction and an upward inflection to the end of his sentences – I listen avidly because I never know how the next word will sound – but there is, too, a vulnerability behind his, now and then, edgy or combative responses whereas John Selway, another Welshman, comes across as the opposite. His voice has a quiet, soothing quality and, although only twenty-eight at the time, he never seems offput by your questions. Selway's subject matter, he tells you, is taken from what may be seemingly inconsequential: "fragments of what is actually happening, not the complete story."

I asked him what his purpose was and he says simply that it is "to involve people with their everyday existence in particular situations." He adds, "People do all sorts of things – we take it all for granted."

He illustrates this by suggesting, "The fact that you put your socks on in the morning doesn't matter to you but it might matter to me."

He's quite clear that his work doesn't have a decorative or satiric or moral purpose, nor is he much interested in colour. That astonished me. But when I asked if his pictures were about enhanced awareness he agrees, "Yes, of things which are commonplace but, nevertheless, are very important."

Sounding rather like a writer of short stories, although his pictures are not literary, he says, "I try to take in everything, just emphasising a few important parts of the whole set-up to give it meaning."

I had to ask him, "What do you mean by 'give it meaning'?" He wants to prompt the viewer's imagination; he might focus on a cigarette-end or a human head. "That's the link between you and the painting, so you start with that and the whole thing begins to fall into place."

I was struck by the fact that the painters who interested him were all Americans: Rosenquist, Lichtenstein, Johns and Oldenburg – but it was 1966 when American painting was considered pre-eminent. Having studied his work, were you surprised?

No, I wasn't. I'd looked to Paris when I started. He looked to New York.

It is a great pity that the interview with Raymond Moore is missing and the transcript of it no more than a fragment because these interviews have stood the test of time and still have value as documents of artistic practice. Strangely, never do you allude to the fact that you are also an artist. By this point you had been given your first one-man exhibition at the Grosvenor Gallery and a television programme had been made about you and your work.

I got the job because I was an artist but I didn't want to draw attention to myself. Instead I was concentrated on illuminating for the listener the power of each artist's ideas.

I'd like to ask you about the relevance of place since it figures in each of your programmes whether made explicit or not. What has tended to happen throughout the twentieth century is that artists have gravitated to great cities such as Berlin, Paris, London or New York. From the end of the 30s onwards, for instance, many American artists, even if not born there, ended up in New York. For some it was undoubtedly fortunate because theirs was an art of the studio, for others less so because they were now rootless. I believe much of the art of the past hundred years will be seen as unimportant in relation to place whereas for painters like Cézanne, van Gogh or Gauguin place mattered. Picasso, as a Spanish exile, despite his moving about France, is surely an artist of the studio? I sense some sort of division between artists who are connected to place and artists who are not. If we take David Jones as an example, he would paint wherever he was staying but usually only visited places where his friends happened to be. He had no intention of going back to France after the First World War until the Gill family asked him to and, in spite of the beauty of paintings made there, never went again. Something crucial has happened in relation to place and placelessness in the art of the past century and there is an undercurrent of this in your broadcasts – only two painters are Welsh; Ceri Richards left Wales while John Selway returned after completing his training in London. Where is loss, where gain?

I've never considered this before. I've always assumed that place was fundamental because Michelangelo was in Florence and Rome, Titian in Venice and so on. Ceri became displaced, I think. He was really a Welsh artist but could more easily earn a living in London through teaching and selling his paintings. Essentially he was of the place where he was born despite the impact on him of international art and a growing knowledge of the great tradition. Londoners sensed him as exotic; he had what Dylan Thomas had, a passionate, sexual sensuousness, which is un-English. An extremely important matter is involved here: there are those artists who are said to be 'international' and those whose ambition it is to be international or who talk about art being international. There's a deep misunderstanding about this notion because I would say that my art is directly based upon Pembrokeshire and my experience of

life in Wales. However, my art has been enabled to grow because I've studied as deeply as I can the whole history of European art, I've travelled and have gained some little knowledge of Indian and Chinese art but essentially I'm an artist of Wales. I'm not an international artist. I don't know how to define it more precisely but I'm so determined that to imitate Joseph Cornell or the great Jackson Pollock is death. Other artists may make you aware of certain aspects of your possibilities but your art must not derive from a kind of studious copy of them. Around me I often see artists destroyed by that kind of ambition.

You would say it was a good thing that you found Pembrokeshire?

What a blessing!

But look who you are: you're an Englishman of Italian extraction born in London, a graduate from Oxford speaking French and Italian, you find yourself in Wales, have come near to learning its language but yet have not quite done so. And you're to this day a traveller to many other countries.

The great thing for me about Wales was that I was welcomed here most warmly by the people of Merthyr Tydfil when rejected by some of my English colleagues. I was, after all, given the sack for being a conscientious objector and the staff of the school, with whom I'd been working over a number of years, virtually ostracised me. That was a very hard knock. Two great experiences I've had: one was being welcomed into Oxford when Boase said, "Come for a walk," and I felt myself in a new world and the other in Wales when it was said, "Come and work in our school and teach our children music." That was marvellous.

So happenstance had a lot to do with it; like Josef Herman, "happy accident".

Yes, chance. Sweet chance. I'm fascinated by luck or chance. Why did this happen and not that? There is a Christian belief that God knows all. Well, that means we've got no control ourselves. On the other hand, we have responsibility as part of the Christian faith. You can only have both in a faith but not in logic.

Do you then see your life as a series of chance events?

Oh indeed I do. I was very fortunate to be sacked as a result of being a conscientious objector. I'm extremely thankful for that disaster: because of it I was taken away from schoolmastering, where I might well have been what is called 'successful'. And because of the War I came to Wales and met all sorts of people I would never have met in Folkestone.

TEN

You have already referred to buying works of art but, as you've mentioned, this was not always for yourself. You've actually helped form collections, both public and private, in Wales. Were there many or just three or four?

I've helped a small number of people form collections but I will not speak about private individuals in any detail. Collecting has enriched my own life and others have asked my advice, which I've given them readily. Occasionally I've bought pictures for people when in Paris, for instance, and in that way have encouraged some individuals to begin collecting. I also remembered it was Kenneth Clark who initiated in Oxford a scheme that students might well have pictures, modern pictures, in their rooms to enjoy, which would belong to the College but could form a kind of library. I think this started at Merton but I'm vague about it. Something like this gave me the idea of proposing a similar plan to Aberystwyth, so in 1961 I went to the Principal and asked him what he thought about it. His reply was, "You tell me!" By this time I was advising the Gulbenkian Foundation on what could be done for art in Wales so I told the Principal I'd ask the Foundation if they would give us a grant to buy pictures. Their reply was, "Yes. We'll do this provided the University matches our grant." So each made a contribution and I bought a collection of pictures, partly by artists I knew working in Wales or from Ceri Richards or Joe Herman in London. I made other purchases in London and Paris. They were all originals and included paintings, drawings, lithographs and engravings of various kinds. Artists and a few dealers were generous in their offers. I decided to pay no more than £10 to £20 per work.

Your list amazes me.

I bought Welsh artists such as David Tinker, John Petts, Will Roberts, Ernest Zobole, Jeffrey Steele, Terry Setch, Kyffin Williams, English artists such as Walter Sickert, Graham Sutherland, John Piper, a rare David Jones drypoint and in Paris, amongst others, Chagall, van Dongen, Dufy, Braque, Matisse, Picasso, Hayter and Sugai. I gathered together all of this and by the time I'd enough took it to Aberystwyth. If you worked in the Extra-Mural Department in those early days you had to spend a month in residence at the College during the summer term and I did this with great pleasure because there was an intellectual environment there which I found most stimulating, especially amongst members of my Department. Elwyn Rees, for example, was a fascinating and formidable intellectual and Brynmor Thomas one of the most penetrating analytical minds I've ever met. It was a rare experience to work with these people and it was during that month that I went round the halls of residence with my pictures asking, "Who would like to borrow what?" I did this for a couple of years and then it became impossible for me so the whole matter was handed over to the Art Department and borrowing of pictures by the undergraduates lapsed, but the collection is still being developed. It lapsed partly because of organisational problems and partly because some of the students were either thieves or they just forgot. In any case, several pictures were lost and it was realised that the scheme couldn't work without someone supervising it properly, who was at the University throughout the year, which I was not. I lived eighty miles away. And I did almost the same for Swansea for five years, from 1974-9, although I didn't again pursue the idea of students having pictures in their private rooms. I was invited to buy for the College and I bought from artists I knew in Paris, this time adding Russian, Czechoslovak and Italian work.

Your aim was always to include work by Welsh artists amongst that of European masters.

Yes. When we had an exhibition of the Gulbenkian Aberystwyth collection in the College gallery in 1971 I wrote the following for the student magazine:

The collection was founded with two objects in view: to give students the opportunity

to have original works of art in their own rooms and so prompt them to buy original pictures in later life and, secondly, for the encouragement of contemporary Welsh painters.

I wanted to bring pictures from abroad to Wales. What has always angered me is the notion that Welsh art should be evaluated by London. Wales is a different kind of place altogether and has a foundation of culture which London knows nothing of – the great Celtic culture. I found in Wales there was coming into being an art which was related to this country now, and we founded 56 Group Wales on the very notion that Welsh art should be judged from within Wales or, say, from France or Italy. We had to rid ourselves of this domination of London. Certainly it's a great centre of art, a stimulus, but we needed to get away from its influence. When I bought, on purpose I bought little from London.

Did any of the students approach you, wanting to discuss the works of art?

When I was hawking them round, yes, they did. I'd talk about the pictures and why you should borrow this one rather than that. I was very much involved in it all: I loved to see, by chance, through a window one of the pictures in a student's room. That was exciting.

In our first conversation you mentioned that repeatedly in your life you've tended to become captain of something. As a lecturer you joined the Association of Tutors in Adult Education.

I was a member of the Association because of teaching with the WEA and because of being a tutor in the Extra-Mural Department at Aberystwyth. I was elected National Chairman from 1964-7, and this necessitated my travelling to Scotland, the north of England, Derby, all over the place for meetings concerning its proper running. I found it a rewarding experience, and it provided me with an opportunity to see art in those places I would otherwise never have visited. In Derby I was able to study the work of Joseph Wright and when we were up in the north, in the Lake District, I realised I had the chance to see the last work of Kurt Schwitters. I located a farm near Elterwater and as a man came over to me, asked if I might see the barn Mr Schwitters had worked on. He, it turned out, had known Schwitters quite well because Schwitters painted portraits of people in the village and before his death had begun transforming a wall of the barn. I was taken to see it: it was sheer fantasy on the scale of a live-in-able room – Schwitters, I gathered, almost lived there while at work on it. Previously he'd made two other constructions, *merzbau* he called them, one in Germany and the other in Norway; this one he named *merzbarn*. Soon afterwards it was removed to the Hatton Gallery at the University of Newcastle. I already knew the collages of Schwitters, those beautiful accumulations of unexpected objects making a magical impact. They are enchanting, assembled from stamps, bus tickets, bills and anything else to hand. I'm quite sure they were part of the inspiration which led me to make my own works, or perhaps were rather a confirmation, because I was, I think, already making such things and that's why I was interested in Schwitters.

As at Aberystwyth, you must have met interesting people in this Association.

Indeed. Tutors in adult education are unusual because they believe in the necessity of education over a lifetime; my own students stretched from the age of eighteen into the eighties. It's education in part through discussion so the tutors have a different kind of experience of teaching: one of them being that you are teaching, in the main, adults, who have lived a life. You get more back than you give because what you teach inevitably leads to debate, questions and comments, not only during the lecture but afterwards; you linger and talk about it and in doing so you prepare, as it were, for the next week.

How did you become involved with the Gulbenkian Foundation?

It was Rollo Charles, an excellent Keeper of Art at the National Museum of Wales, who recommended me to the Foundation in the late 50s. They wanted advice on how to help with the development of art in Wales so I suggested a grant be given to the newly founded 56 Group – we only added Wales to the title later – and another to the University College at

Aberystwyth which I've already spoken about. In 1977 Rollo again put my name forward for membership of a Gulbenkian Foundation enquiry into the economic situation of the visual artist. Meetings were held in London and Pierre Gimpel, by the way, was one of the people who appeared before the committee, to tell us about the gallery system. We eventually prepared and published the Report but I recall feeling that there were, from outside, objections to our research and findings... from the Arts Council and from the dealers. As you know, I believe that the artist is now on the periphery of our society, looked upon as an entertainer and so in Government terms linked with sport! What he or she does, it is imagined, can be done as a pastime.

Between your two bouts with the Gulbenkian Foundation you served as a member of another committee?

I sat on the art committee of the Welsh Arts Council from 1965-75, running the whole business of the Council, acquisitions, awarding grants, supervising exhibitions and so on. And I still belong to yet another organisation, the Contemporary Art Society of Wales, and have been a member of its executive committee for some considerable time. Our purpose is to promote interest in the visual arts and we also buy contemporary works, mostly from artists in Wales. We appoint a buyer annually, giving them about £10,000 to spend – I was buyer some years ago – and then we distribute our purchases, in the main to Welsh Art Galleries. When Bill Cleaver, a great rugby player, in previous times known as 'Billy the Kick', was secretary of the Society he had the brilliant idea, which he carried out – that's the point about an idea: if you've got it, it's you who must carry it out – of our going to visit the great art collections of the world. He organised tours for members which have taken us across Europe to Rome, Venice, Florence, Berlin, Vienna, Madrid, Oslo, Moscow, as well as to China and India. We always visit the principal galleries or museums and before we leave, in preparation for our visits, I give a lecture. They are usually attended by many more than those who are travelling because our aim is to encourage others to take one of these journeys subsequently. I also frequently write a short article to be included with the annual report.

So in an astounding number of different ways, you have tried – ever since 1940 when you were evacuated back to Wales – to foster greater understanding of the arts of the past, the historical culture from which we derive, and to spearhead the culture as it evolves, never more purposively than in your chairmanship of the 56 Group Wales. What is its story?

In 1956 three artists, Eric Malthouse, David Tinker and Michael Edwards, chatting about the situation in Wales, found themselves saying, "Welsh art is being judged from London but we think it should be assessed from within Wales." At that time, whenever an important exhibition was proposed, it was normal for someone to be sent from London to select the work, which would then tour Wales, organised by C.E.M.A. or some such body. The kind of painting normally shown was of the great mountains of the north or coal-miners going home on a wet evening – the type of subject which London presumed represented Wales. The three artists agreed it was unsatisfactory and decided, "We'll alter all that!" They then wrote to ten other artists asking, "Would you like to join a group showing Welsh artists in Wales?" All but one, Brenda Chamberlain, replied so a group of a dozen people sprang into being. The next question was, "Where can we have an exhibition?" Nobody in Wales would invite us to show, but I knew a man who was working in Worcester, a civil servant Jim Phelips, a good friend from Hertford College, and he offered to get us an exhibition in Worcester. The art gallery at the Public Library was willing to have us so the 56 Group Wales showed for the first time, in 1956, in England! Rollo Charles came to the opening, liked the exhibition and promised, "Your next exhibition will be at the National Museum of Wales." That was our second exhibition and from there, over the next forty years or so, as well as showing in Wales we've gone to Ireland, Scotland, Germany, Italy, France, Holland, Belgium and Czechoslovakia, but that is how we began. It was a great movement, although after three years we had various difficulties – understandable at the start – amongst them money. The

Gulbenkian Foundation granted us about £300 a year for three years to pay our expenses and after that we either floated or we didn't. That sum gave us some funding to proceed on. We managed to get a secretary to work for us and, as a result, the Arts Council began to take an interest, for many years giving us an annual grant to help with our organisation.

This was the Welsh Arts Council?

It was originally the Welsh Committee before becoming the Welsh Arts Council. Alas, eventually they came to the conclusion that such groupings of artists should not receive subsidies so we suddenly lost our grant, which was a wounding blow. They gave money instead to individuals and to the heads of art galleries. Admittedly, they have established some important galleries in Wales but I've never understood the sense of such a policy; they provide money for an orchestra or for a company of actors so why not for a group of artists? Artists need to join together in our time more than ever before because we are no longer incorporated into contemporary society as we were previously. The artist now is valued for the money the market can make from his work whereas we need the support of, and association with, those who understand painting or sculpture for its value as a work of art. I wonder what worth the man who bought van Gogh's *Sunflowers* for millions saw in it? 'The Ode to a Nightingale' is worth as much as van Gogh's painting but fortunately it cannot be made a victim of the market. He who loves it for itself can have it. I had a friend who valued his collection of pictures so highly that he left them in a vault in Switzerland! However, despite financial and other problems the 56 Group Wales has battled through and still exists.

Was it soon after its foundation that you were asked to become Chairman?

They appointed me Chairman in 1959 and I served for almost forty years, retiring in 1998.

How much time have you given it each year?

I've no idea.

Has it been time-consuming week by week or in stops and starts?

It has meant that I've travelled a great deal for the Group.

Would you see that as one of the bonuses of being Chairman?

I would.

Presumably you've had to reconnoitre possible venues?

Yes. When I was in Italy on one occasion I travelled from Florence to Bologna in order to try to arrange an exhibition there. Dr Solmi, a distinguished art historian and curator of what, I suppose, is the most famous modern art gallery in Italy, conversed with me for most of a morning and finally agreed to give us an exhibition. It was absolutely wonderful and, of course, once you've got one exhibition somewhere it's a tremendous encouragement for someone else to give you another. Our exhibition in Nantes arose from the fact that Cardiff is sister city to it so we were offered an exhibition and I went there for the opening, which always means making some sort of speech in the language of the place. I've spoken in German, Italian and French at these events and on television or radio in various countries. In Nantes there was at the exhibition by chance a painter, Olivier Debré, and as we chatted he said, "Tomorrow I've got an exhibition opening near here. Would you like to come?" Bim and I were delighted to be asked but discovered on the morrow that it was at least a hundred miles away at Les Sables d'Olonne. We travelled with him, saw the exhibition, which was magnificent, and became friends. As a result his brother Michel, who was formerly prime minister of France and later mayor of Amboise, suggested, "Come and have a show at Amboise". So the 56 Group Wales exhibited at Amboise and Michel Debré made the opening speech, saying, "Of course, we've had other distinguished artists here before, for example Leonardo da Vinci!" Olivier entertained us sumptuously in his château and all the members of the Group who attended the opening were invited. As you recall I'd lectured in Holland and I think it was because of that, and my friendship with Hans Polak Leiden, that I was able to arrange an exhibition for us in Amsterdam, at the Bols Taverne Art Gallery, which was opened by the British Ambassador.

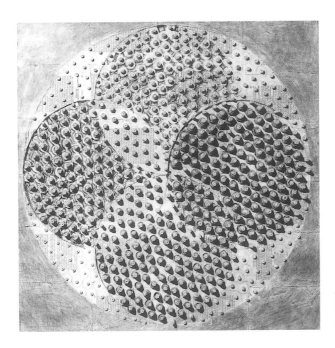

Orient and Immortal Wheat
79 x 79 paper, pigment on board
1981-82

You've done extremely well.
I was confident that the work of our artists would be well received.
Do people come and go as members?
Yes, they do. There have been a few artists who, having had the support of the Group, have felt that they didn't need us any longer and have moved on. Others have left for different reasons.
What are the conditions of membership?
The basic condition is that you must either live or work in Wales. If you're not in that state for more than two years, then you must resign. You have to be an artist in Wales but what 'Welsh artist' means I'm not sure – I'm not Welsh. We have always had more people wanting to be members than we could accommodate since our conviction is that such a group must be fairly small, otherwise any exhibition is a mishmash. Twenty-four is our maximum number; we started with twelve and we've had the whole range in between the two. We occasionally have a selection meeting when we examine photographs or slides and we then ask one of our members to visit the artist and see his or her studio. We take selection very seriously.
How did you arrange an exhibition in Czechoslovakia – was that again a probe of yours?
Bruce Griffiths, the husband of our secretary, Mary Griffiths, met a member of the Czech Embassy in London whose name was Zdenek Vanicek and, as a result, half a dozen friends went to Czechoslovakia. In Prague we talked of the possibility of an exhibition tour across the country and then an invitation was issued from the Government through Zdenek. Eric Estorick, my London dealer, also knew individuals in Prague so through him as well as through Zdenek we were able to meet influential people. Bim and I then travelled throughout Czechoslovakia, taken by Czechs to visit places where the exhibition might be held and to meet artists and art historians. In 1986 when the exhibition occurred, we went again this time as guests of the Government. Our exhibition was held, first of all, in the splendid Mirbachov Palace in Bratislava to a crowded opening, at Brno and then at Karlovy Vary, where the Minister of Art and our own Ambassador attended the opening and music was performed, and finally in Kosice beyond the Tatra mountains, south of Russia. We once more met artists, a few of whom would travel later to Wales, and we learned something of the rich history of their art. When the tour ended we visited the authorities in Prague and were invited to return. It was agreed that on the next occasion an exhibition should be held in Prague as well as elsewhere but in the intervening period the break-up of the country occurred so our second exhibition was only toured in the Czech Republic. The invitation was

honoured although it had been given by the previous Communist regime. Another factor was that a former curator at the National Museum of Wales, Peter Cannon-Brookes, knew Czechoslovakia well and he organised a magnificent exhibition of Czech sculpture at the Museum, which was a revelation to many of us. So there was a kind of balance. In conversation with the Czechs I mentioned that I had a collection of Czech art and suggested that they ought to buy Welsh art. They agreed to do so and from the first exhibition they bought work by Prendergast, myself and others; so there are works by Welsh artists in official collections in Czechoslovakia and Zdenek Vanicek, a poet and artist himself, was made an honorary member of 56 Group Wales.

This whole story demonstrates how remarkably the arts can bring about closer relationships between countries – a sort of cultural diplomacy.

The visual arts, like music, create no barrier of language. Every exhibition abroad gives us more confidence about being accepted internationally and we could not have travelled without the help of the Welsh Arts Council and the British Council. However, a matter of significance needs mentioning: I got to know a visiting Russian professor of art at University College, Swansea named Shestakov, who said he would like the Group to show in Moscow. He fixed this up with the Ministry and four artists were invited to spend a week in the city while the exhibition took place at the House of Artists. Slava Shestakov first travelled through Wales and selected the exhibition which was, in fact, shown at the Public Library in Cardiff. However, the British Council, partly because they hadn't enough money and partly because, as they said, the quality was mixed – I don't know what they expected; why shouldn't it be mixed? – didn't give us a grant. We needed that grant simply to take the work there and back because we had no money of our own. And so that wonderful opportunity was lost; this was, I think, absolutely tragic: negotiations for an exhibition of twenty-four artists of Wales to go to the House of Artists in Moscow breaks down because of lack of funding. How pathetic! Shestakov later made great efforts to re-invite us but, given the present circumstances in Russia, neither the British Council nor any other official body could possibly support us. We continue to hope that when things improve we may receive another invitation to Russia but the basic requirement of the Group is still for some sort of funding to keep us going. We have always lived from hand to mouth. Eric Estorick's son Michael did give us a sum of £5,000 towards making the journey but it wasn't sufficient to cover all our costs.

Are there other countries in Europe where the Group would like to exhibit?

Any country, but there remains the problem of money. We've had marvellous secretaries; the last one organised an exhibition in Belgium, for example, and the present one is devoted to the Group and receives very little payment, but it is not reasonable to expect a professional to work for next to nothing. We need official support.

And you've demonstrated your tenacity as a Group over almost fifty years. I wonder if similar societies of contemporary artists in Ireland or Scotland have exhibited so widely?

I doubt it. I've had two primary concerns as Chairman: one is to take Welsh art to Europe and, if possible, elsewhere, and the other is to take the art of professional Welsh painters and sculptors to any small place in Wales, which is willing to accept us. It is absolutely vital if you're going to stimulate a culture in gaining understanding of the practice of artists. Much support of official bodies is at present for amateur art. This is, no doubt, fine but amateur art is dependent upon the quality of professional art. If amateurs need teaching it is teaching by professionals. Just 'doing your own thing' won't help. It accustoms people to what is amateur, whereas what is needed is an understanding of professional work. In wishing to encourage the amateur you mustn't neglect the professional because one is fundamentally different from the other. Even a genius like Le Douanier Rousseau got to know professionals and did his best to emulate them. Incidentally, I say all this despite having a real interest in the amateur; I enjoy teaching them to paint, and watch them learn in the process.

Years ago, when teaching adult amateurs, I noticed that their paintings seemed to fall into four or

five different categories and I thought it would be fascinating to research this further to see if I could differentiate more accurately, and so help each person develop in the genre he or she worked in, i.e. genres the amateur naturally selects, but I could not convince other members of staff of the validity of the project. I would love to have attempted this research because over millennia art has divided into a series of genres. It's astonishing to see an artist like Le Douanier Rousseau flower in what is referred to as a 'naïve' style. He is, admittedly, the greatest – Picasso wanted to own his pictures.
And I love Alfred Wallis from Cornwall. Ben Nicholson admired his work but Wallis undoubtedly got a clue or two from Nicholson, didn't he?

And maybe from Christopher Wood. Critics have tended only to see the professionals as learning from the naïves. I appreciate your reversal of viewpoint. Tell me, how far have you succeeded in visiting every nook and cranny in Wales?
We have shown in many, many places – basically wherever anyone has a room.

And have commissions come the way of members?
Our biggest disappointment is the amount of sales, let alone commissions, that we've had; they're minimal.

Then how do you fund yourselves as a Group?
Each of us – and there are twenty-four of us at the moment – pays about £50 a year for membership. We need a secretary, to whom we pay a small amount, but some members are not employed by art schools so they don't earn sufficient money to pay more to the Group, nor can they afford to travel abroad. Artists have difficulty selling their work but either they or the dealer in the community must do it. Paintings or sculpture do not sell themselves any more than Rolls Royces do. You have to have a place in Mayfair to sell Rolls Royces, don't you?

We mustn't forget how many hundreds of years it took to establish an English School of painting. It really only began in the eighteenth century.
I accept that it will take a long time to reach the understanding of the visual arts in Wales such as we already have of music.

In 1998 you decided to end your Chairmanship of the 56 Group Wales.
I did it because I want the continuity of the Group to be assured: it's an essential group in Wales. The artist, I'm convinced, works very much against the present trend of society, which concerns itself with values, and by 'value' it always means money. But money means nothing when you're trying to evaluate the quality of a work of art. The people who can best evaluate a work of art are the artists. The greatest writing on artists is by artists: Leonardo, Michelangelo, Reynolds, Delacroix, Pissarro, Cézanne, van Gogh. This is where you get the most profound understanding of quality, which has nothing to do with money at all. I appreciate the work of great critics and art historians but it's a different kind of understanding that they've got. You must have groups of artists, fairly small groups, who show together and can make their judgement about who are the artists who are really of interest. Of course they will make mistakes. Everybody does. That's part of it. So I decided I would resign and let someone take my place. After all, I've been to many countries and our art has been warmly received in various cities, and, as a result, we've had people back, artists, critics, art historians, taking an interest in art in Wales. Now, this has not been an official institution at all. Essentially it's based upon selection of artists by artists without interference from outside. This is a tradition which must continue; you've got it in the Welsh Group, founded six years before us, and you've got it in 56 Group Wales.

There's a floating population in the 56 Group Wales, which seems to me a strength, because otherwise there could be the danger of a sort of academicism coming about, the same Group deciding year by year that "These are the artists, and if we don't acclaim them, then they have no worth."
Our intention has always been, "These are the artists I would like to work with and amongst whose works I would like to exhibit." I don't think we've ever thought that we were the artists of Wales. That isn't the idea. The idea is simply that we need to clan together, just as actors create their plays and musicians have orchestras which are supportive. Our divisions are

solely concerned with quality – as we see it. Regrettably, the people who nowadays normally decide who are the artists are dealers or administrators of galleries or museums.

Many of your members have gone on to be much admired across Britain, haven't they?

Indeed, that's true. And members have resigned over the years for one reason or another but now we have a very strong group of young artists in their late twenties and thirties.

It's important that they should mix with much older artists – surely that's healthy for both?

Well, it's certainly been healthy for us who are much older, that we've always got the pushing from behind of young members of the Group who have determined ideas of their own. The whole business is regulated by annual general meetings, which are usually fairly easy discussions, and we also have meetings to select new artists – these can be pretty tempestuous sometimes because it's a very vital institution, very much alive.

You all went back to Worcester for your fortieth anniversary exhibition.

They showed our work beautifully and were, I imagine, quite well satisfied that after forty years we were still vigorous.

What an excellent time for you now to pass the running of the Group on to others.

It's essential that the responsibility, which I must say is considerable, is passed on, primarily to the new Chairman – and Secretary. One of the finest secretaries of the past was Mary Griffiths, a barrister, a woman of great ability and utter determination as far as the Group was concerned. We have had other good secretaries but Mary was quite exceptional.

She saw herself as the fulcrum of the Group, she told me. All correspondence would apparently be sent to her and then, as she put it, she would 'frame questions' to put to you by letter.

Her letters were marvellously clear, written in beautiful English: simple, straightforward statements. And she had a natural wit.

You would think things over and then respond by letter.

Or she might write to me and soon afterwards telephone for my answer, if the matter were urgent.

Did she organise everything, packing, transport, insurance and the like – as well as taking the minutes?

It varied. Usually artists were put in charge of particular tasks or the gallery might shoulder part of the responsibility. Mary would always deal with the preparation of the catalogue and would tend to check up on details. The Arts Council was extremely helpful with transport, transferring our work to Holland, Italy and Germany in their vans but later they did away with the service.

Mary mentioned that she retired twice, coming back the first time because she was missing the Group and only leaving because of her husband's ill health.

She passed the job on to a friend who did it for a while and then gave up. Mary later confided to me that she had felt rather jealous seeing her friend with the Group's papers under her arm. Mary did actually find the job very interesting – and was rather envied by her friends for having it!

She speaks very highly of your abilities, not only as Chairman but in your making introductions, careful letter-writing, public relations and possible speech at the opening, often in the language of the country. What she admired was the assurance with which you could meet with artists or art administrators, academics or government officials. You won't be an easy man to follow.

ELEVEN

Once, when speaking to me about your dealer, Eric Estorick, you were suddenly reminded of your first encounter with another dealer, while still only a schoolboy.

During the time that Germaine, our French lodger, was staying with us in Streatham, two young cousins of hers came to London to study furniture and painting at the Victoria and Albert Museum and the Wallace Collection. Their father, Monsieur Fabus, was a famous antique dealer in Paris and when I visited Germaine I was taken to see him, more than once, at his house in the Boulevard Hausmann. In order to reach his office we had to climb up a staircase, each step of which was crowded with gorgeous objects stacked on either side. There was scarcely room to squeeze past. We would always find him bending over his books, pondering the day's concerns. He would turn round, look at Germaine and might say, "Give her a necklace," or some other small gift. Later on his two sons also became dealers, and one of them discovered a painting by Georges de la Tour of Mary Magdalene, which is now known as the 'Fabus de la Tour'. All this was part of the richness of being with Germaine.

How was it that you came to meet Eric Estorick?

I used to exhibit at the Howard Roberts Gallery in Cardiff, and in the early 60s an American, Kay Roper, saw examples of my work there and soon afterwards bought two reliefs from me. She knew Eric Estorick and told him about her purchases, so he suggested I go to see him at his Grosvenor Gallery in London. At our first meeting he commissioned a big relief construction, three by four feet, for his wife. "I want to give it to Sal as a birthday present," he said. She had just bought a wood above Llandovery with a cottage and outbuildings adjacent to it. I made the construction and called it *Coedwig Sal*, Sal's Wood; it was later put in the front window of the Grosvenor Gallery and was bought by the Arts Council of Great Britain. From then on Eric showed examples of my work continually at the Grosvenor and after three years, in 1965, gave me an exhibition. From my first one-man show he bought everything and after that, again and again, he commissioned me to make items as presents for Sal because she particularly liked my work. During the 60s I also showed at the gallery in two mixed exhibitions, but my work was always, as they say, 'available' there.

About a year after you joined the Grosvenor it moved to new premises in Davies Street, which were described as "the largest and most splendidly equipped private gallery in London, and perhaps in Europe."

And I cannot think of any which had so grand a window to look through from the street. You would almost be in the gallery by looking through the great window. Just compare that with the usual velvety cubby-hole!

Was it exciting to become part of such a gallery?

Indeed it was. I went up often to London to see the exhibitions.

Your association with Estorick was, first of all, as an artist but as time passed that seems to have altered. How was it that a friendship developed between you?

Well, from the first we had interests in common but I suppose it happened gradually. Some time before my first show at the Grosvenor he took me to his home in St John's Wood, which was filled with works of twentieth century art such as I'd seen at the galleries in Paris, and since Germaine was part of a large Jewish family that included dealers, this too made me feel readily at ease with Sal and Eric. When I got to know him well, Eric would ring me up whenever he came back from his journeys asking, "How are you, Arthur? And how's the work?" He and Sal came and stayed with us at Llethr and then with Bim and me at Warren on various occasions. He was quite different in spirit from the normal run of art dealers. I'd been round the galleries in London for about fifteen years trying to get exhibitions. I'd shown at the London Gallery, the Woodstock, Gimpel Fils, and the Redfern Gallery had often included me in mixed exhibitions; Rex Nan Kivell, was very friendly towards me, sold a few

watercolours and exhibited some of my first constructions, but it was Eric who, I felt, was a man of deep intelligence and wide experience. He had written a history of Marks and Spencer, a biography of Stafford Cripps and a series of biographical portraits.

He'd also edited and written introductions to volumes on the British Commonwealth and earlier in his life had contributed articles, essays and book reviews to magazines. It's very impressive – about twelve volumes in all, he said.

He owned a marvellous library, which Bim and I catalogued for him. The whole collection of books was brought down here in crates, put into our art gallery and we catalogued it. My God, what an immense undertaking! There were Jewish books, a wonderful selection of theological studies, art histories, series of art magazines, modern histories, books on economics – quite a bit about the oil magnet, Paul Getty – and ever so many novels because as a young man he'd known novelists in New York. We had everything out on the floor and it was hard work since the range was enormous, but exceedingly interesting to do.

His son has pointed out to me that this was a somewhat devious move on Estorick's part. He was by that time living outside the country and didn't know where to put his library so you were doing him a double favour: storing it as well as cataloguing it.

Later on he did take it all back. He was a man of culture, an only child, brought up in New York, but his family had come from Lithuania. As a student, and later as a lecturer in economics, he'd got to know about modern art because there was a private collection, the Gallery of Living Art, housed in the Library at Washington Square College, which was part of New York University. It included work by painters such as Braque, Picasso, Léger, Lissitzky and Moholy-Nagy. He was fascinated by all of this and as soon as he got any money began to buy such work as he could by some of these artists for himself. I can't recall his whole life here but I did help him by means of recorded conversation in the writing of his autobiography.

Was that his idea?

It was my idea; I persuaded him. By then I'd realised that he had become an important figure in the world of art. Over years he'd formed a collection of twentieth century Italian painting and sculpture, which included some of the most famous Futurist works, and had found and bought in Russia Constructivist and Suprematist paintings and drawings as well as quantities of contemporary graphic art. Sixteen times he travelled to Russia in the early sixties to make purchases. On one of his visits he had to meet Ilya Ehrenberg, who said to him, "I hear you're buying up all the shit in Moscow!" Well, all that shit included some great treasures of the early part of this century. After a short time Eric had been introduced to the famous Greek, George Costakis, who also collected Russian art. It was typical of Eric that he should get to meet the chap on the spot who knew where to find things, and it was partly through him that Eric was able to buy marvellously in Russia. Then, on one of his journeys back to London, he realised that he was flying over Czechoslovakia so he touched down there a number of times, once again befriending a key figure, Adolf Hoffmeister, who introduced him to the families of Alphonse Mucha and Otto Gutfreund from whom he bought work, and to many contemporary artists as well. Eric was exceptional. Whereas other London galleries concentrated largely on English and French art here was a dealer buying in Russia, Czechoslovakia or Italy, and eventually much further afield, to sell at the Grosvenor. In those days, for instance, Italian art was spoken of as though it were no longer of any interest – the great days were thought to be past – but these were the days of Sironi and Morandi! Eric got to know five of the Futurists, Severini, Carrà, Soffici, Sironi and Morandi, as well as de Chirico and also younger painters and sculptors. This is how he was able to assemble most of his own collection.

And seeing that helped you discover more about European art, first hand.

It helped me vastly. I used to go and stay with him and there on the walls were Picasso, Modigliani, Carrà, de Chirico, Utrillo and others. He also had, I remember, a complete collection of Morandi's graphic work – one of the finest etchers of our time.

Did Estorick have to part with much of this over the years?

He began as a collector and became a dealer, putting aside such works as he could not bear to part with. The inevitable clash sometimes distressed him. But he succeeded in both enterprises.

You had joined the most adventurous gallery in London, with a European perspective initially and then one which stretched beyond Europe to include Africa, America and even contemporary China. The range of exhibitions Estorick put on from 1960-71 was quite astonishing. When mentioning the conversations you recorded with Estorick weren't you being far too modest? You seem to have done all the writing of his supposed autobiography!

I proposed it and we got together at his homes in London, Wales and France to do it. I even went with Bim to Barbados to help the book along but, in fact, we did very little. It was always difficult to pin him down, actually to have him sit there and answer questions.

How did you set about it?

I made Eric – as far as anyone could have – tell his autobiography. My questions and his answers were taped and then I cut myself out – I assumed that that was how it would be. I wanted him to write his story and so I prompted him to tell me about matters, and very extensively he did. He was not reluctant to talk, although his son is particularly aware of what he left out. Of course there were sides of Eric that I hadn't the impudence to delve into. And I did not think it was for me to comment, only to get him to speak about what I thought would show whatever he was willing to reveal as an intelligent, adventurous, courageous, ambitious, passionate, angry, relentless man!

I'm intrigued by what you've just said: you make him sound admirable and somewhat sinister too.

I think he was jealous of the creative artist. If he could not be one, he would control them. I believe he admired and was envious of the man or woman who focused his or her mind on making works of art. He, himself, could not have made the necessary sacrifices or rather he could not look down just that *one* tunnel at the luminous radiance in the distance.

In the book he laments the fact that he is not a creative artist saying, "I always wanted to be related somehow to the creative process" and explains, "It is as if the creative artist was my artificial lung, as if I was a person who could breathe only when I was close to art".

He puts it better than I can.

Here's how he describes himself, "I don't think I'm a conventional dealer – much more a self-styled teacher and propagandist". Is this why some of his exhibitions were so compellingly complete?

Eric could not have done what he did without Sal. Together they became great dealers.

Eventually you became much more than an artist in the stable, not only a friend but occasional buyer, library cataloguer, Estorick's biographer and more than just a chronicler in collating a history of the gallery. I greatly enjoyed your witty, perspicacious remarks about contemporary art, artists and critics, including anecdotes or giving perspective where necessary.

Eric asked me to write the history of the gallery. I did so using mainly the press cuttings and my own memory of whatever exhibitions I'd seen. When I finished it, he and Sal said, "What about us?" so I wrote what I thought about them, but only because they wanted me to.

The biography and the history of Estorick's gallery must be your most extended pieces of writing. After all the work you did were you not upset that neither of these books was published? No attempt seems to have been made even to have one of them printed privately.

I have the original manuscript, but the decision to publish did not rest with me. I'm not a writer – I'm not concerned with that – Eric gave me the job and I did it and I'm quite certain it will be a source: all sorts of things emerged from our conversations, and someone at the Grosvenor Gallery has told me how useful the book has been already.

In the Introduction to The Estorick Collection of Modern Italian Art *I notice it is referred to frequently.*

Oh yes, I knew Eric well, and throughout his life Eric protected me. I was with him in the Grosvenor Gallery two days before he died, and he said, "Arthur, you must have a show. I

will give you another show", and so on and so forth. That was Eric. I became devoted, very much devoted to Eric, but I must say that he would make promises which he never fulfilled. Once when I was, I suppose, feeling gloomy about sales Eric said, "One day they will all go whoosh!" On the other hand, he would do things which he'd never promised and which were beyond my expectation.

I know he had promised an exhibition in New York since you wrote to Fairfield Porter about it. Did he suggest other possibilities?

Yes, he did. He mentioned arranging shows for me in Capetown and Johannesburg but they never happened.

And what did he do which went beyond your expectation – asking you to design a door for the Grosvenor Gallery, perhaps?

Eric astonished me by suggesting I make one. I was nonplussed but he insisted so, first of all, I commissioned a door in mahogany and then I cut up brass taps into sections and nailed them to part of its surface, facing the street – Bim had to go to evening school to find out how to rivet brass nails into bits of brass tap. I fitted a nail into each small segment and then, using an adhesive pigment, hammered them onto the door. It looked rather like a poem in Arabic writing with the street number and the words Grosvenor Gallery incorporated into the design. Unfortunately, however, a recent owner of the building has had everything removed from the door, but I have photographs of how it was.

Maybe another surprise was your persuading Eric to speak at a one-day conference in Wales?

Through the Extra-Mural Department at Aberystwyth, yes. How much preparation he'd done I'll never know but the day before the conference he came to stay and on arrival casually admitted he hadn't written his lecture yet. I was terrified because I take ages to write one but he was relaxed, "Yes, I've brought my typewriter. I'll do it this evening." And he did. And it was a fascinating lecture he gave, at Gregynog, about being a dealer.

Despite many happy surprises it sounds as if it could be in ways a very tough relationship.

It was a tough relationship, which went altogether beyond painting. We discussed quite other matters, which were of great importance to me and, I believe, to him.

What would they include?

Our conversations ranged much further than what is in the so-called autobiography: literature, the faith, the whole range of human endeavour was embraced in our discussions. An aspect of Eric that does not come out in the book is a kind of mysticism. I found that he had a belief in God; in a sense he really was deeply a Jew but so much of his ambition and life had centred upon making a fortune, really big business, that this aspect didn't normally appear. But theology is a profound interest of mine and I pressed him upon it and found not the usual kind of trite, atheistic, businessman's common-sense attitude at all but a genuine concern about such issues, which rarely appears uppermost in anyone's conception of Eric Estorick. What chiefly interested me about him was that he was his own man. He didn't follow the critics. He didn't care a damn for other dealers. He followed his own understanding. He knew he'd got to make a living, and he wanted to make a fortune, so there was that very strong side to him, but he loved the pictures and once, when I talked to him about Morandi, I remember him saying, "Oh, I had a wonderful oil painting by Morandi," and I could feel the grief in him, that he'd had to sell it because, after all, he had to keep in with his client and the client wanted it. It's part of Eric's Will that the Estorick Collection of Modern Italian Art should be given to London – where he was often ridiculed! It was a great experience knowing him and now, of course, his son Michael. I've known him since he was a little boy. He's very gifted and I believe will accomplish a good deal as a novelist.

What artists of note did you get to know through Estorick? What about the designer Erté?

His real name was Romain de Tirtoff. He was a member of an aristocratic Russian family, originally Tartar, from a long line of admirals but Erté himself, being homosexual, felt he would rather not embarrass his family by what he was doing as an artist in Paris and decided

to call himself R.T. instead and begin to write it phonetically E R T É. He had gone to Paris to work as a fashion designer and then for the stage at the Folies Bergères and Casino de Paris, getting to know well famous acting and dancing personalities of those times. He became one of the great designers of the period. Eric invited us to stay in Barbados for a fortnight, where we first met him. We stayed at the beautiful villa Eric had next door to one owned by the French movie star, Claudette Colbert. There was a wonderful garden in which stood splendid statues he'd bought in Africa, and in the house were pieces by Henry Moore, Picasso, Archipenko.

You were always surrounded by art wherever you visited the Estoricks.

Absolutely. And at the edge of the garden stretched the ocean. Erté was also a guest, and Eric asked Bim and me to make sure that Erté didn't drown because he bathed every day, although about eighty at the time. While intellectually and spiritually not in the least fragile he looked very fragile. He would wear an enormous, gorgeous hat, dark glasses and only just enough fabric to cover his nudity and would stride up and down the sands as though walking were something whose purpose was solely to keep him in good health. Then he would get into the water and we would swim out with him to make sure that he didn't come to any harm!

Erté was not only rediscovered but almost re-invented by Estorick.

Erté had been very nearly forgotten, that is true. In 1966 Eric put on an exhibition of Art Déco, an enchanting exhibition and well written up in the press. After the opening an elegant Parisian, when purchasing from Sal, asked, "Est-ce que vous connaissez Erté?" She inquired who Erté was, noted the name and asked for a catalogue to be sent. Soon afterwards Sal and Eric visited him in Paris and, typically, Eric at once bought what is now the famous alphabet and offered him an exhibition. Within a year Erté, Eric and Sal were closely bound by contract and when Eric put on a show by Erté in New York the entire exhibition was bought by the Museum of Modern Art. Suddenly Erté was brought back to life in his mid-seventies and over the years Eric built up a business world-wide concerned solely with his art. The large Grosvenor Gallery was closed in 1971 and he ran in South Molton Street a much smaller gallery, where dealers would buy but it was very rarely open to the general public.

So you lost him as your own dealer?

I still had his support: he still bought or commissioned reliefs periodically and my work was always available at the smaller gallery. I had a one-man show there in 1987.

Under the guidance of Estorick Erté began designing all over again.

He was, as it were, recreated and designed all sorts of things: jumpers, jewellery, sculpture, large editions of prints. It became an international enterprise which brought in a fortune both for Erté and for Eric. Erté ended as a man famous across the globe but absolutely unchanged. His chief concern was always for making his designs. We visited him in Boulogne sur Seine where he lived in an exquisite apartment; I vaguely remember there being pigeons and certainly cats but what struck me particularly was that his studio consisted of the amount of space occupied by a small table and chair, by the side of which he would put a box or case containing what he needed for designing. That little table and the small area around it was the whole of his studio.

What was the reason for your visit?

We visited him there because the Grosvenor Gallery had had the idea of a British art school acknowledging Erté's achievement, and so the College of Art in Cardiff agreed to offer him some sort of homage, electing him Honorary Fellow, and asked me to make the presentation at his home on its behalf. I took a document and a beautiful piece of craft made by a student – I can't remember precisely what but I think it was a teapot. There was a short ceremony in which the items were handed to Erté. He opened the present, was astonished by its beauty and commented flatteringly on it and, in return, he presented to the College a collection of his graphics. He was a very small man, most distinguished in his behaviour and intriguingly perceptive in his comments. He later visited us here and I recall that while we were having

lunch one day in the dining-room he happened to glance up at a picture, which was hung high near the ceiling. I mentioned that it was mine and with characteristic charm he said, "I'd like to see it more closely," and pulled over a chair to stand on in order to have a proper look at it. He was a very considerate man.

Were there other artists you met through Estorick?

It was Estorick who suggested that we meet Ota Janecek on our first visit to Czechoslovakia. He was employed, richly, by the Communist government; it was a feature of Communism that if they supported the arts they did so superbly. Janecek was overwhelmed with commissions. He was an excellent illustrator as well as making prints, drawings and paintings. He had lived and worked in Paris where he'd done a great deal of work in a Cubist idiom but his prints of the nude figure were based on Matisse. What amazed me was that he had two or three studios: two in Prague and he owned a little estate way out in the country, where we also visited him, with a third beautiful studio, superbly equipped, set in a garden. I though that the treatment of the artist in this Communist state was far better than we could expect in an art world dominated by dealers, administrators and critics. He was very well supported as I noticed were other artists in Czechoslovakia during that time. People have asked, "Could they paint what they liked?" or "Wasn't it a strict regime?" I didn't find it so; I found that artists were honoured and respected. They were given many commissions for public buildings: railway stations, waiting-rooms or hospitals were all decorated by artists. Because I was a guest of the government we always had an interpreter with us and one day travelling near Bratislava I said I would like to see the work of a dissident artist. The interpreter said, "Well, you can but I won't come because he is a dissident." My reply was, "If you won't come, I can't go", so then she relented, "Okay, I'll come!" So we went and visited Milan Laluha. His work had been shown at the Venice Biennale, where he'd been awarded a prize, and I knew of him through Eric because he'd bought his work. There he was practising his art as far as I could see in complete freedom in a well set up studio. I bought a drawing from him.

It is regrettable that we don't know the work of these artists. You were privileged to be able to meet them and study their painting.

Janecek was what everybody expects an artist to be: lively, vivid, sensuous, passionate. He spoke French and so we were able to converse easily; he later came to stay with us here on a couple of occasions. And he had an exhibition in Wales arranged by Peter Cannon-Brookes at the National Museum.

And there was another Czech artist you also got to know.

Jan Bauch, but it was Zdenek who introduced me to him. Eric knew nothing of Bauch. It was curious to me that the artist most highly regarded in Czechoslovakia at that time Eric hadn't been introduced to. Bauch is a painter and sculptor and I found him very generous. We visited him several times and always as we were leaving he would say, "Will you take a drawing?" or "Will you take a painting?" Absolutely typical. I had a great ambition to possess a major work by him and asked if he would sell me one. It was all arranged but somehow didn't happen. Well, after a great deal of difficulty it finally arrived in an enormous wooden crate all the way from Czechoslovakia. What a thought! The colour in his pictures reminds me of the sea-bed in rocky places seen through water.

Bauch is a mid-European artist whether drawing, painting or sculpting. At his finest, his work can be placed in an international context, don't you think?

He is highly regarded as an Expressionist painter. In 1988 an exhibition of his work was toured in England and Wales but he was already well known in Europe.

Again through Estorick you met one more important artist, Zoran Music, in this case from Italy although born in Dalmatia.

Eric had suggested, "When you're in Venice go and see Music." And indeed we did this: every time we went to Venice we used to visit him. But my initial acquaintance with Music's

work actually had nothing to do with Eric; I first saw his paintings in the Galerie de France in Paris where I admired them and talked with his wife, Ida Barbarigo, very probably a member of the famous Venetian family. She is a painter herself, like her father, and she and Music lived in Paris as well as Venice. Eric had been involved in the award of a prize to an artist in Paris and through his intervention it had gone to Music; Music was always grateful and full of admiration for Eric, and Eric bought many paintings from him. So I already knew his work when we went to see him in Venice, where with Ida he occupied one of the palaces overlooking the Grand Canal, with a splendid large salon such as you find in these palaces. He himself lived and practised his art in the very top rooms and there we used to see the paintings and drawings he was doing. I think his most remarkable, though not his greatest, achievement is probably the continuation of the *Disasters of War* of Goya. He was not a Jew but had been put in a concentration camp – why I don't know – at Dachau. He had made some drawings after the Germans left, before Dachau was liberated, showing the degradation and full horror of the camp, and then for many years afterwards he made further drawings as they occurred to him and these drawings, together with paintings, were collected and shown in an exhibition at the Accademia in Venice. The grim title of the exhibition was *We are not the last*, meaning this is going to happen again: it is inevitable unless people take a stand. This series of drawings and paintings is an enormous contribution to understanding the results of war. When we were at the exhibition with Music, Bim looked at one of the big paintings and said, That chap's got twelve fingers". The fingers were clutched at his neck in an expression of agony. Music, who doesn't speak English, understood and answered, "Oh, they are not enough!" Not enough fingers around the man's throat. They are stunning works, beautiful and horrifying. Goya had observed the disasters; Music was a victim who survived them.

He is an exceptional artist but somehow not well known in Britain.

His first one-man show in London sold nothing and the next very little but in Italy and Germany he is considered to be a great figure.

I have the impression that when you met Erté, Janecek or Bauch much of your conversation would be about art. Did they ask about your work?

They always did and that's one of the reasons why I loved to be with them. Janecek, for example, when he came here was always very much interested to see what I was doing and sometimes we exchanged works. Debré had a relief of mine in his home in Paris, just as I have a painting of his. And periodically he'd send me a lithograph or drawing that he'd done. With Music it was different. He never saw my work and, in any case, we didn't converse in that way. He always invited us to go up to his studio but would simply show us drawings and the paintings he was working on, without comment. We chatted about quite other things, often speaking of Estorick – "He had the nose," Music would say appreciatively of Eric's judgement of paintings. He was a very grand man, Music, tall and old with a splendid head, as you can see from his self portraits. And his wife Ida is an enchanting woman, whom he's often portrayed. She would bring something for us all to eat from the *trattoria* opposite.

A moment ago you spoke of Olivier Debré. He was another European artist you became friendly with, but in this instance not through Estorick. How did your friendship develop after the two 56 Group Wales exhibitions in France?

Olivier invited Bim and me to visit him in Paris where he lived in an apartment in the Rue de la Faisanderie. He had two studios in Paris – we saw both of them – which were absolutely packed with drawings and paintings; big drawings, some of them three or four feet long, of great beauty and he also did extremely small-scale work, as well as making lithographs. He owned a château near the Loire, which he brought us to, with cellars full of paintings, some being enormous, pictures as big as a stretch of wall. He took great interest in showing his pictures and we discussed them in detail. I believe I've discussed painting more with Olivier than with anyone else, particularly his paintings because I admire them very much – as I also do his drawing, which is marvellously spontaneous. When working it was as though he

became the wind or lightning: he stood there as if smitten by something, then the colour swept across his canvas or dashed across a piece of paper and very, very quickly, as though he were writing a letter under great stress, he created this vibrant image. Whenever I went to see him he was always in the process of making my portrait. Although it was quite small it was somehow never finished but he made a couple of portrait drawings of me, which I do have.

I find it astonishing that his work – like that of Music – is not yet known in England.

Because it's so different. Although he's of the same period as de Staël and their art shares similarities his work has developed independently.

I would see his way of working as being closer to that of American contemporaries who use large areas of flowing colour.

No, I don't think Olivier would accept that he was influenced by American painting. He became very famous in France; in fact one of the postage stamps of 1993 was designed by him. In 1988 he'd entered an international competition, along with various famous Americans, for a painting for the drop-curtain at the new opera house in Hong Kong, measuring 15 x 19 metres, and had won the commission. Part of the reason why he received it was because he'd already painted a curtain in Paris for the Opéra Comique. That was an enormous undertaking. I remember we went to visit him at Le Bourget aerodrome where he'd been lent a hangar in which to paint it. He erected a tower so that he could look down on the vast canvas, which he was helped to complete by assistants using brooms to drag the pigment across the surface. Another commission he carried out was for a gigantic mosaic in one of the Paris playgrounds. He became a world figure but it's quite true that his work is not yet known in England, and that is a shame.

However in Wales the story is surprisingly different.

It was, in a sense, in return for the wonderful hospitality that the 56 Group Wales had enjoyed at Amboise that Olivier was offered a grant by the Welsh Arts Council as a visiting foreign artist to spend three months travelling in Wales, to paint and to meet other artists. For some of the time he worked in conjunction with the Art Department at the University College in Aberystwyth, helped particularly by Shelagh Hourahane. He was highly articulate and cultivated and was, therefore, well able to converse with students and anybody else who was interested in painting.

The fact that he was painting motifs in Wales was, I think, equally exciting.

He found motifs near Aberystwyth and I recall him going to St David's to make a picture of the cathedral. He also painted the Stack Rocks in Pembrokeshire, needles or standing towers of rock at the cliff edge. And his method of making pictures was fascinating: he would put a big piece of stretched canvas, sometimes bigger than himself, on the ground and would have brooms to work with as well as large brushes, as I've explained to sweep the pigment onto the canvas – it was a physical feat painting these pictures. He had a special kind of intimacy with nature. The motif would inspire him: he would stand in the wind, he would feel the salt of the sea and the fury of the spray. His pictures are the expression of that whole experience.

And Wales scored one or two more firsts with Debré.

Olivier received the first International Artist Award offered by the Welsh Arts Council and was also awarded a silver medal by the Contemporary Art Society of Wales. The following year he held his first museum retrospective exhibition at the National Museum in Cardiff. He gave a lecture there – he was a fine lecturer and writer on art – and donated a painting to the Museum's Collection. This is the kind of exchange which interests me deeply: that foreign artists, whose work is unknown in our country, should come to Wales to work and exhibit. As I've said, artists here have long been concerned that Wales is so dominated by what is successful or admired in London. We need contact with other countries in Europe.

It was a wonderfully creative gesture on the part of the Welsh Arts Council.

Exactly, and an excellent precedent. I hope it will happen again.

It proved to be a fruitful connection for you personally as well as for Wales.

It's quite true. Olivier and I became close friends.

How do you feel when you return to Wales after meeting one of the European artists we've mentioned?

I find great pictures, as opposed to indifferent ones, enormously encouraging. I don't feel I can do the same as I've seen but I feel invited anew to take part in this particular activity. I'm thrilled by these excursions because to study such pictures or to visit a great artist is to have your mind altogether illuminated by possibility, and so new possibilities open for me. If you go to see a chap like de Kooning you suddenly find yourself thinking, "I could do that," or when Cedric Morris knelt down and made a picture there in the field while I watched I had a similar thought. That is an attribute of the great artist: he is willing for you to take part. The great artist, unlike the indifferent one, I have found is always vastly encouraging.

You feel renewed by visits to such artists; there is a cross-fertilisation between you.

Exactly. Living in Pembrokeshire I don't meet other artists – except with difficulty – but when I go abroad, if I visit someone of the calibre of Olivier I'm thrilled. I return full of the idea of getting on with more work.

What about your relation to artists of the 56 Group Wales?

I visit Peter Prendergast and William Wilkins especially, and sometimes others. Peter I got to know well before he was taken on by a London gallery; I have a great admiration for his painting and bought major works from him at that time. He's a man of considerable natural intelligence quite apart from his art, an astute mind, extremely interesting to talk with. In an altogether different way William has a brilliant mind, is a great organiser with wonderful vision, and in my opinion a very fine artist, although still largely underrated.

One of the most striking features of your life is your ability to make friendships and then maintain them over long periods of time. This, you've suggested to me, is due to your mother's instruction.

In the past we used to have autograph books in which family and friends would write something. What my mother wrote in mine were the words of Polonius to his son from *Hamlet*:

> The friends thou hast, and their adoption tried,
> Grapple them to thy soul with hoops of steel;

I've remembered her advice ever since and seen the wisdom of it. The rewards are enormous – that's the point.

TWELVE

In your radio interviews we gain some idea of your conversations with friends such as David Jones or Ceri Richards. When you talk about Olivier Debré we sense the excitement of your knowing an astonishingly productive and successful modern master, but since your relationship with Fairfield Porter, an American, was essentially one conducted by letter, we can, perhaps, discern more of the anatomy of a friendship between two painters, beginning when both of you were young and neither of you yet sure of what you would become. Amazingly, the whole relationship of over forty years grew from about a month spent in each other's company.

There were, in fact, three of us. I rolled up in Florence in my second year at Oxford and found at the Pensione Mariani the two other students I've already described, Violet Pfeuti from Switzerland and this chap Fairfield Porter from America. We three became close friends and maintained a long correspondence subsequently. It was an intimate relationship we all had: we got to know one another very well because – rather like being on a boat – there was nobody else we could get near to. My Italian wasn't good enough to become really friendly with Italians but Violet and I spoke Italian; hers was better than mine and Fairfield's less good.

Porter, we discover from his biography, wrote home saying that you really already knew Italian and insisted on his conversing in Italian with you.

I have no memory of this. It surprises me, though I did have some Italian. I'd studied it in my last year at school and had just done a year at Oxford.

Violet Pfeuti you met again when she visited Amroth to improve her English and after that you went to stay with her and her family in Switzerland, where you fell in love with her sister, Helen. In high spirits you describe the situation to Porter: "I have to write to her in French. I wooed her in German, with a spot of intermingled Italian..." and conclude "whether I win the damsel or no is on the knees of the Gods". The Gods evidently decided otherwise.

They did. She was far away and in time I fell in love with somebody else.

In 1967, thirty-four years later, you remark wryly on the increasing impact the story of your visit to Berenson has on others: "With the passing of each year the impression I make when I say I had lunch with Berenson becomes greater: I'm looked at as though I said I'd lunched with Plato."

Berenson had become more and more famous, seen as the foremost authority on the art of the Italian Renaissance.

Apart from drawing or painting in the landscape around Florence you and Porter also drew portraits of each other – with apparently very different purposes. You remind him: "You draw to express form, I draw to express my sympathetic relationship with another person." This subject arose because after your return to Oxford Fairfield Porter married and sent you two drawings of his wife. One of them you pinned to the wall of your room in College.

Two beautiful drawings, the first done before and the second after their marriage, but that is actually a heartbreak. They have been lost but may possibly come to light. This has to do with my having had to move out of Llethr. However, I still have the lithograph of which I spoke earlier, of myself as Korrilov from *The Possessed* on which there is a smudge made by his hand. He was interested in having it left there as part of the intimacy of the print. It was of a murder by night: as the victim I had to press myself against a wall and look terrified, and I still recognise myself, very much terrified, in that image.

You acted the part well.

I did get into the character. It's a piece of illustration, as close to terror as possible.

Untypically, it has a crude, Expressionist fervour.

Fairfield was incapable of working in an Expressionist manner. That's why I had to look *so* terrified!

Part of what is fascinating in reading this correspondence is that repeatedly letters provide further eluci-dation of events you've already touched on. A typical incidence is the thesis on Botticelli drawings you

submitted for publication, which was rejected. "My writing was too scholarly to be enthusiastic... For that magazine the main bias had to be on the literary side... I succeeded in proving my point, but did not show the importance of my discovery. It was a dry piece of stuff." Your next piece of information is far from dry, conveyed with an underlying sense of excitement. Will you read it?

> "The family has just begun renting a largish farm-house in Amroth... There we last summer held a summer school, the pupils being foreigners of various nations – German, French, Swiss. With them we have other visitors – schoolmaster and family, doctor and family etc; we mix them all up together. The foreigners thus learn English and the others are entertained. Teaching foreigners English is a most interesting occupation. I love it. We are gradually getting a technique. Most teaching is done individually on walks, while bathing or prawning. Every morning there is, however, a set lesson taken by one of the family. We are hoping and believing that this sideline will develop into an important business concern into which we can put all our energies."

The date is 1934. Your parents have just evolved a pattern which they will follow for the rest of their lives and which you and your wife will continue from the late 40s until the end of the 60s. The scheme was developed little by little. What was exciting about it was that it was a way in which I could make money in three months and work at my art for the rest of the year. *About teaching in a school you are less confident. Although you have by this time trained to be a teacher, and will soon begin working at Harvey Grammar School, the dilemma of whether to be a teacher or an artist will not leave you. You enjoy teaching but believe you were "built for something else", which you can do better. You explain: "I am haunted by the thought of becoming an artist" but of what kind you are not clear. You even lament: "I begin to believe that the Fates played a joke when I was born – they fashioned an artist and – curse them – left something out – heaven knows what."*
What they left out was money – my family was poverty-stricken.
But you're resolved; "I intend to teach for about two years, perhaps always, and... [then] to judge, if possible, whether it is worth my while giving up something I can do for something I may be able to do. I earnestly believe that I am an artist..." and you end with a query: "I don't know whether my prudence is my friend or my enemy." Yesterday, while chatting, you mentioned Prudentia.
Prudentia, yes, one of the virtues, not theological but cardinal. Under the heading of Prudentia come the arts in Mediaeval thinking. Prudentia has to do with how you live your life, and the purpose of painting, as with all the arts, is to tell us how to live. I knew I wanted to be an artist but I couldn't work out how it might be so because, as my father said, "You won't make a living as an artist." So he said, and I never have done.
Towards the end of 1937 you write in agitation. This much greater concentration of mood would, at first, seem to have been occasioned by your marriage to Judy, which had evoked in you the most turbulent emotions.

> "I am married too... Perhaps it was because I was living so intensely in those days that I found no time to write... My feelings were intense. I was putting all my energy into working out the main design of our living. Changes in relationship took place, suddenly, sometimes with delight and sometimes with pain. We drove relentlessly, it seemed almost as if we were driven into one another's beings. That is still going on. I think that the extremes of emotion are more rarely experienced by us. We are enjoying some of the peace of an existence strongly and well constructed. We have changed a lot, we are freer."

And you describe Judy for Porter.

"Judy is a pianist – she never received a normal education and consequently is womanly. She has very little second-hand knowledge and comparatively few derived opinions: she is very interesting to talk to and work with. She has facile skill at drawing and in music. This skill is not yet the vehicle of her being, so that sometimes she plays and yet remains unexpressed. I suppose her facility and muscular perfection are impatient of being burdened by personality. We work together. I believe she will know what it is to experience herself in a piece of music. We work together. I criticise and breathe into her my own inspiration. Sometimes she flies ahead of me. I try to do everything through an intense working of my mind. Things she does seem unexpected, but they are fresh and natural. Judy makes a good housekeeper and cares for me in a way I had not expected."

Your phrase "the main design of our living" and the repetition of the sentence "We work together" seem astonishingly prescient and, by implication, it is Judy's creativity which has more insistently provoked your own. You continue to probe – a "desperate introspection" you call it – and intimate the passion with which you pursue this quest.

"I still want to be an artist. It is a faith somehow I shall be one that makes me go on earnestly studying everything I can or get a chance to... I read and discuss Communism, Nazi politics and ways of living, painting, writing, music, flowers, German, printing, poetry. I enquire into everything that offers itself. When I realise that I am doing that, I am enquiring into myself."

And through your music-making you come to the same conclusion.

"I work very carefully and as hard as I know how... I work at the viola for its own sake, and also because it helps me discover myself."

As a result of your introspection you confess: "I see myself as different from other people, and in the same thought, grow ashamed of being proud."
At this point Polonius is comforting:

This above all; to thine own self be true:
And it must follow, as the night the day,
Thou canst not then be false to any man.

Porter has become your confidant and more, a point of reference, temporarily your double, mirroring a similar quest for meaning within society. In reassuring him that he is an artist and warning him not to allow his painting to "be conditioned or determined by a movement" because it "is likely to make it unsatisfactory as art" you are surely also addressing yourself? After briefly outlining what you've seen of recent German art you sum up: "I am reaching the conclusion that in his art a man must be himself his only dictator."
What only he can find he has to put down in some way, related to what other artists before him have done. Nobody can tell him what to do or how to do it. His reward is our delight.
In your state of heightened emotion you communicate vividly, without intending to, the general uncertainty of the late 30s: "social problems... the need for material changes" are thrown into relief against a background of Communism, Socialism and the Nazism which you've just experienced yourself contrasted, in your case, with what you've discovered in Christianity through studying the bible or through association with the Oxford Group. You state: "I believe Christianity is the only way of living which will bring permanent justice and happiness in the world" but add: "I believe less in the Church, in organised religion as it is in the world today, than I did. It merely is part of the chaos. The New Testament is still the most valuable book – perhaps I should say the four gospels."

So much has happened since I wrote these letters to Fairfield. They were just for him. My faith hasn't changed, but I am more sure than ever that I need faith.

In October 1934 you'd written: "...when I was in Italy you remember I believed that Christianity held the secret" and ended the letter: "I believe that there is a period of cultural and spiritual resurrection at our threshold – Christianity being the driving force as it has been before. Whether the period comes in depends on us." A renewed desire for belief seems to have been widespread at the start of the 30s: while you found it expressed in the ideals of Gandhi or the Oxford Group others, with a similar longing, were attracted to Communism or Fascism.

During the 30s Picasso painted *Guernica* and T.S. Eliot began to write *The Four Quartets*.

Then there is a gap in the correspondence of twenty years.

In 1957 I sent Fairfield a Christmas card and in answer to his letter soon afterwards wrote again in February 1958 to explain: "It was the war which made an appalling gulf... Only last year I began to take up the threads of a very close Oxford friendship – one of many which lapsed because of the war."

In that first letter from Porter he reminisces about how the relationship developed in Florence – you were apparently a new and very different sort of person for him to meet – and he suggests there was a degree of affection between you both which somewhat startles you.

I replied: "I have often thought of you but I have never analysed our relationship and was quite surprised to read your analysis of it... words seem to pin down an experience and yet the truth of the matter flutters off." Nevertheless, I assured him: "I was deeply interested to read your letter and altogether delighted to receive it."

In a reply you completed in February 1959 you suggest "...if I met you now I should be immediately on the same terms of rather shy intimacy which we enjoyed in Florence." From your point of view, would that be a more accurate description?

I was shy because of Fairfield's wealth and social self-confidence, his relaxed assurance in the company of Berenson and others at I Tatti. I had made myself at home in Oxford and with my friends in Paris but this was something I was not yet accustomed to. He was, at the same time, a warm-hearted, thoughtful and engaging companion with interests related to my own. We were friends, like friends at Oxford, but in quite a different place.

By 1958 you are "a freelance lecturer and a painter", exhibiting in Wales and London, and soon to become Chairman of 56 Group Wales. Judy and you have a daughter of eighteen and a son of sixteen and have been running a guest-house at Llethr for nearly a decade as well as giving lecture recitals together for the University of Wales. The situation is summed up succinctly: "Our life is very varied and interesting and pretty hard."

This gives an idea of our circumstances; we did have to work very hard.

In your next letter you mention having been a conscientious objector and again you are concise: "I gained a lot of experience of working against a torrent of opinion and feeling. Perhaps I was wrong; but I don't think so. I found a few friends and a deep gratitude for the movement of life itself."

There's nothing more I can say about the experience. Fairfield also had by this time a growing family. Initially he became celebrated in the States as an art critic before being recognised as a painter. Incidentally, he was one of the first to take an interest in the work of the Dutch emigré, Willem de Kooning and bought one of his pictures from him.

I notice that among the artists you've known several are gifted writers on art as well as being practitioners: Debré gave lectures and wrote, Porter, as you've mentioned, became a renowned critic as well as painter and Jones, apart from being a poet, was the author of two books of essays.

I believe that the artist is a man of unusual intelligence. This is always so whether he or she can put ideas into words or not.

You have said that artists' writings on art are the most insightful there are.

Every time in my opinion, and the list is long.

You speak with great passion about this so what place do you assign to writing in your own creative life? Do you see it as an extension of your lecturing or as a separate activity?

I think it's an extension of my lecturing. I've always been concerned with the great tradition of painting. It's something that leads us back to thirty thousand years ago. If you wish to appreciate and enjoy great works of art, you have to have an increasing awareness and knowledge of, for example, the European tradition starting at least as far back as Giotto. This tradition I put into practice in my own work but I also try to explain it to those who are interested to come and listen to what I have to say. Or I write it down. And it follows that I'm intrigued by the ideas of friends of mine who are artists like Richards, Jones, Debré or Porter. We've all exchanged ideas in terms of words but in the end you come to the conclusion that only the picture can explain itself. Nevertheless, we go as far as we can in words.

Porter, it was, who introduced you to the boxes of Joseph Cornell.

He did. He wrote an essay on Cornell, which is a penetrating study; he knew him and owned a beautiful box by him that he kept in his studio. The reason why Fairfield told me about him was because he thought my work resembled that of Cornell – imaginatively rather than figuratively – and when I saw the boxes I readily appreciated what he was saying. I also found Cornell's work enchanting. It's a kind of still drama you discover there: you experience a world you were formerly unaware of but once seen it is believable.

Do you see any likeness between Harry van Tussenbroek, the Dutch puppet-maker, and Joseph Cornell? I have a sense of each of them living in a similarly withdrawn, self-sufficient world.

It's interesting that you should compare Cornell with van Tussenbroek. They are of a kind, aren't they? Cornell, apparently, used to wander about expecting something out of the ordinary to happen. He recounts walking along a seashore and meeting a small girl, who, like himself, was picking things up just because she liked the look of them. That suggests a man who is aware that you will come across something extraordinary in a place where other people would expect to find what they knew was there, without being alerted to some strangeness or something marvellous in a commonplace situation. The little girl had this ability and so had Cornell. By chance they met and talked.

You say in a letter that you see the Cornell box as "a stage as much as a cabin"; you suggest theatre where Porter suggests journeys and continue "...he has helped me to go dreamier", ending with a remark I much like: "What is most fascinating is the tantalising lack of a complete understanding." I find myself reminded of your small reliefs of myriad objects nestling behind circles of glass, for instance A Shoal of Time. *They could be seen as mementoes preserved from voyages of discovery long ago, also somehow evading comprehension.*

That is the challenge of Cornell's work: the understanding of it is not complete. My reliefs are often concerned with the passage of time. We are haunted by it and so we cling to this idea of immortality – whatever that may mean!

You and Fairfield Porter frequently discuss writers as well as painters. In the late 30s you mention both D.H. and T.E. Lawrence but, to my surprise, it is the latter you are drawn to, noticing many similarities between you but you immediately add: "His brain was so much better than mine."

In T.E. Lawrence I recognised his genius – genius is always magnetic, isn't it? – and his courage to do things which were apparently impossible. I've devoured all his books and I have his collected letters. He knew what they call 'everybody': Bernard Shaw, C.M. Doughty, E.M. Forster, John Buchan, Lady Astor, Winston Churchill, Edward Elgar, Robert Graves... and was portrayed by Augustus John.

Much later Porter suggested books by very different writers.

Fairfield introduced me to Borges's *Labyrinths*, Robert Frost's poems, the poems and letters of Emily Dickinson, books I bought in New York when visiting him. We dropped into the nearest bookshop, where in turn I introduced him to David Jones's *In Parenthesis*.

Eventually you did meet again but before you visited him he came to stay with you at Llethr. He'd been excited for months about revisiting Europe, dreaming about it repeatedly, he wrote.

He made the journey in the summer of 1967 with his wife Anne and two of his daughters, Lizzie and Katie.

What was it like seeing him thirty-five years or more after you first met?

My memory of him was continuous. I was naturally delighted – and to meet his wife, a poet, whom we liked straight away. Anne's book of poems, *An Altogether Different Language*, shows her as through a mirror.

What he found remarkable was your whole way of life. He wrote to his close friend, another poet, Jimmy Schuyler: "In Wales the Giardellis have a heroic and entirely peculiar household of about twenty boys and girls from foreign countries there to learn English, old friends (four in a family) as well as four Porters. In the two months of summer Arthur does no painting at all, just the opposite of me..." Were you able to spend any time alone and discuss your work with him?

He was sorry about that because there was comparatively little time. As his letter makes clear I was busy earning my living. Maybe that's why I cannot recall what he said about my work.

In less than a year you met again, this time in America.

For years he'd invited me to come to New York so in 1968 we combined a visit with one to Canada to see my daughter Judith and her husband Robin Lewis, who were newly married and living in Montreal. First we travelled to Southampton where Anne and Fairfield lived in the 60s. We stayed with them and met a number of their friends. Until then I hadn't realised that he came from an eminent family; T.S. Eliot was a cousin.

Porter had sent you photographs of his work in 1958 and you'd written back commenting on the "inviting open quality of the forms", "the apparently casual arrangement of an actual scene", "an air of contentment". So you had some idea of how his art had developed.

In Southampton he took me into his studio in the garden where I was captivated by the paintings he'd made of New York. I had always taken delight in his art. There is a simplicity to his painting. He puts up an easel in front of his daughter Lizzie at the table having breakfast or Anne holding the baby in her arms, standing in the middle of the room dreaming. The colour is clear and the structure open and harmonious as a song.

As well as seeing his work he took you to meet other artists who were friends.

We went to see Al Held, I recall his big pictures and those of Alex Katz, but especially I recall our visit to de Kooning. He met us in the avenue leading through woods to his house and studio. He was planting a tree but immediately gave up his digging and took us into an enormous round building, rather like an airport structure it was, and we went up to the second storey. The first was concerned with some cinematic or photographic equipment to show films or slides, whereas the second storey was his studio. There were many easels standing in a circle, the room being circular, and on the easels were pictures in the process of being painted. Underneath some of the easels I noticed sheets of paper lying on the floor with an imprint of the picture above. While the painting was wet a kind of blotting-paper was used to remove the surface pigment and it was then placed on the floor. De Kooning explained, "If I like any of these sheets I will work on them as well, so they may become paintings too." There were also a number of chests in this circular area on which were stacked piles of small drawings. I asked to see them and as I fingered through he said, "I do these while I'm watching television." This is what so interested me: his art was about happening, not premeditated or pondered but the result of some kind of accident. He was very charming. Fairfield and he were long-standing friends.

Your thank-you letter expresses the immense exhilaration of those days. Will you quote from it?

> "You gave us a wonderful welcome: it was like coming to our American home. And you took us to your friends who also treated us like old friends. Then came the fabulous (don't criticise me for choosing the extreme word...) so fabulous stay in New York. It was so generous of you and so fascinating for us: the artists, the avenues, the Piranesi subways, the language, the people, black, yellow, white... tall, short, old, young... the pictures, great, small, old, new.. the park with the fear of thugs... the sea, the river, tiny distant Liberty, the Wall, the Battery... Greenwich and even

Babylon... arguments, discussions, concords, disagreements... buses, taxis... sirens, hooters... roads which trembled... amazement, delight."

One of the delights of the letters is that, as you grow older, each of you rejoices in the success of the other, whether in his case it's being given an honorary doctorate or exhibiting at the Venice Biennale or in your case carrying out public or private commissions or receiving an M.B.E. from the Queen. Your careers happen to keep pace with one another.

Yes, it was an affectionate relationship and as it was such a long one it was unconsciously a great encouragement. *And* it was hard work because Fairfield was well versed in intellectual matters. He lectured in universities so it was a challenge to receive a letter from him.

In almost every letter there is discussion about your own art or the philosophy of art, art in relation to society, art and reality, perfection in art – topics such as these recur again and again.

They were not matters of abstract concern but intimate matters between ourselves. The thinking I am concerned with is about my activity as an artist. We wrote to each other because we enjoyed exploring such questions. And it all started in Florence.

About English, or British, art Porter seems to have had the gravest reservations. In 1965 he writes about an exhibition of contemporary British art in Washington D.C. where he saw work by you: "I think your constructions I could identify with, much more than with any other paintings there. Some of [them] were a little too identifiably English for my taste... how can I describe that more concretely?"

Ah, that's quite different from Ceri. Ceri wouldn't want to tie it down to the concrete in that way. Ceri's response to a subject was the intuitive artist's response whereas Fairfield, from his boyhood and his studies at Harvard, submitted everything to the process of understanding through words. Ceri stumbled with words, was fascinating to listen to but extremely difficult to read.

Porter then develops his argument: "It is as though there were a feeling that one must not be direct, that out of good manners one should understate; there is a coyness, that in painting becomes almost schoolgirlish... or schoolboyish. It is as though subtlety were the result not of great sensitivity, but of its inhibition, as of something not manly enough. This quality was only in some of the more subtle painters. It is a paradoxical quality, because this attempt to be more manly makes the artist less so."

I can't improve on that description. There is a kind of Englishman, and he's not uncommon, who regards the artist as somewhat effeminate.

In that letter already quoted to Jimmy Schuyler from Europe Porter writes searingly: "English niceness has a broken heart."

Once again I can't put it better. I can see that as well. Fairfield had studied Italian art deeply and he knew French late nineteenth century and twentieth century art extremely well. He looks at English art as an American, a learned and brilliant American painter; therefore I value his remarks but I'm not saying that he's looked at it objectively, only that he's looked at it from a profound understanding of other European art.

I am reminded of a sentence written by the painter Paul Nash: "The artist comes to understand neglect as his birthright as an Englishman." You've talked to me about the effect of puritanism on English art. Is there a connection here?

Yes. Puritanism was a cultural disaster, regarding art as having to do with the pleasure of the senses and therefore potentially wicked. Now the Roman Catholic Church has never had that notion, so far as I can see. It commissioned great artists to tell the stories of the bible or to present to the community the truths of the faith. British puritanism, on the other hand, has had a deadening impact on the development of British art.

Which would give weight to Porter's comment.

Puritanism affirms that this human body in which we have our existence is in some way evil... the result of 'original sin'. It regards being alive and taking pleasure in life as something to

be distrusted whereas there is no privilege greater than that of being alive and having a body.

But I wonder if there's not a degree of puritanism in Porter too?

Why do you say that? Are you relating him to the Pilgrim Fathers?

Perhaps I am. Early in our conversations you made a simple remark, but maybe it's not so simple, that all your life you have been in love with someone. I have noticed hanging on your wall a drawing by Sironi called 'The Dream' which seems, on one level, to depict the artist with his muse. How do you, I wonder, relate to the concept of painter and muse? For some artists such as Picasso, who always needed a beautiful woman in his life, the concept of muse is essential whereas in the case of, say, Monet or Léger we don't really know what their attitude was.

I understand what you mean about Picasso; he was always in love. Sironi's drawing poses questions; is the woman there with the man or is she his dream? I believe we are incomplete and, it's true, I have always been in love. I think, first of all, it's a fundamental human need since without it the race won't continue, secondly, the notion of that which is other, but which is utterly necessary, is the basis for the muse and a third point is that love is divine. God is love, and in a painting by Poussin for instance, following Greek or Roman tradition, it is the muse who tells the poet what he must say. Without the muse he has nothing to express and so I feel this relationship with someone other than myself gives me the appetite, or need, to make things. The primary making is the making of a child but all other making stems from this gift we have from God, the gift of love. All experience there is is of the spirit. I don't know what the spirit may be but I'm aware that it exists – I speak of it as something I know but can't argue about – and we are all part of it.

Fairfield Porter concludes his essay on the art of Joseph Cornell with a disquieting quotation from Gérard de Nerval, which may just as aptly allude to the unease of his own, or indeed many another artist's, relationship to the muse: "I have carried my love like prey off into solitude."

THIRTEEN

In 1969 unfortunately my marriage to Judy ended and I left Llethr.

Because what followed happened more than thirty years ago we cannot do better than quote from letters sent at the time to Fairfield Porter. You write most movingly: "There is an upheaval in my life such that whenever I think, 'I must write to Fairfield,' I also think, 'Well, not just yet, not until I can tell him what has happened'." Will you continue?

"Judy and I are separating. It is a process, not an event. The time of our physical separation I still do not know. We have been coming apart spiritually and mentally for years. Perhaps you sensed this... I think Judy and I lived quite happily together for twenty years."

And you tell him your plan.

"I am going to live with [Bim] in a house we are now buying and trying to put in a habitable condition. Life seems to be either too long or too short. But is it not now too late for both of us, and for the woman I hope to marry who is 50, to start again? The answer in life, as in painting, can only be worked out in the doing."

Later, when you have actually moved house you write again.

"The emotional upheaval is even greater than the colossal physical problems involved. The confusion of legal and friendly advice and information reflects I suppose upon the impossibility of fitting rules to any, let alone this, human situation."

And The Golden Plover is described for Porter.

"We are in the middle of buying an old house which was once a school and then a pub: one schoolroom was converted into a bar and the other into a ballroom. We shall use the ballroom for hanging pictures so that people can come there and buy them if they want to. And the bar we are converting into studios."

You sound exceptionally busy.

"Part of every day I spend at the Plover painting (walls) or scraping them down or telling workmen what to do next. Most mornings I work in the cellar at Pendine on two panels I've recently been asked to make on commission. And I also have a lecture to prepare on 'Modern Art and Society.' "

That was in June. In August you are still hard pressed.

"My most recent job has been to hack down the plaster on one wall of the kitchen and a corridor. Yesterday I was burning out the dry rot and treating it with what I'm told is a lethal (to it) liquid, and at the same time I'm reading for my winter lectures: 'Italian and British Painting'."

One of the commissions, for a panel 3 x 4 feet, you have somehow managed to complete in spite of the upheaval.

For an American in London, working with Universal Pictures, who wanted a relief sculpture for his office. He seemed satisfied with it.

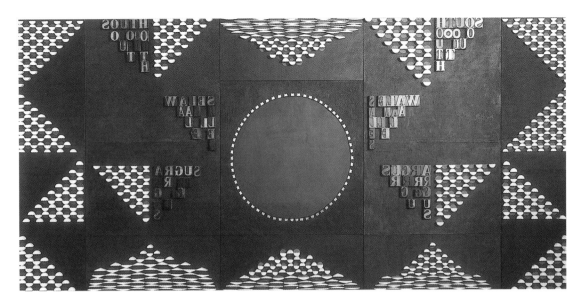

Mural for The South Wales Argus 1680 x 229 silk, burlap, brass, oak 1969

And now you explain what the house was actually like at the time of purchase and describe more of the considerable toil involved in making it habitable.

"We took this place which stands alone out in the country after it had been empty for a year. For some years before it had been neglected, so that it was nearly derelict. We have been fighting to stop wind and rain from beating in, round and under and through. We have had floors up to stop dry rot; we have painted and papered walls and ceilings. We haven't nearly enough furniture or anything else... I have just finished preparing tonight's lecture without the books I needed... I have no bookcase, but books scattered over floor and sills."

And you conclude laconically.

"I feel as though I'd been hit by a typhoon. Every night before we go to bed we read a chapter of *Moby Dick*. I'm beginning to see why we hit on that book."

Apart from making reliefs for individual buyers, you have over the years carried out three public commissions, one of which – the door for the Grosvenor Gallery – you've already described when speaking of Eric Estorick. The largest and most ambitious of them was for the reception area of a newspaper in Newport. You completed it not long before leaving your wife at Llethr. Measuring 15 feet 6 inches by 7 feet 6 inches it was as you wrote '...enormous for my kind of work' and you relate how you went about the making of it.

"I went to the site as the building was begun and discussed my design with the architect, who wanted my panel to be the heart and focus of the whole [concept]. The newspaper is called *The South Wales Argus*. So I did a panel about Argus, making the eye of Argus the camera lens. I broke the whole thing into nine sections like a mediaeval altar for practical reasons and took six months to make it. I made the mural partly of those beautiful printers' blocks of individual letters, which are of course reversed, and included brass by cutting up some brass taps; I was intrigued at that time by the shapes created when you section a brass tap. I also used blue silk in a large circle, which represented not only a lens but the pupil of Argus. In the myth, you may remember, the eyes of Argus were never to be closed."

You reserve judgement on the final result.

"We are glueing it to the wall on 27th June and it is then that I shall know whether or not I can design on the grand scale."

What did you feel about it when it was finally set in place?
I thought it succeeded very well.
The Brook Street Gallery, about a hundred yards you say from the Grosvenor Gallery, liked the door you had designed and "...commissioned one in the same materials [towards the end of 1971]. It is this that I'm making with my old watch parts. I want to convey the impression that my door opens onto an Aladdin's cave." Your maquette certainly does give that impression. Did you manage to achieve the same result on the door?
Yes, I did. The door is like the maquette but the design covers the whole surface: it's a cascade of brass. I made the design from the plates of watches into which the cog-wheels are fitted. These plates I cut in half and then set them into the mahogany with glue, up and down the door.
Did you oxidise them?
No, but the weather itself did. I like this weathering and I suppose it's possible that the door is looking more beautiful than when I first made it. As Velasquez said, "Il tiempo tambien pinta," Time also paints. Fortunately, when the Brook Street Gallery closed and moved away the owners took the door with them.
Have you found a difference between making your own reliefs and carrying out public or private commissions?
I welcome commissions. People talk about 'being free to do your own thing' but it doesn't matter a whit to me. When the Pope said to Michelangelo, "Paint my Sistine Chapel ceiling!" he was damned lucky and took advantage of the opportunity. I believe our function is to use our art in such a way that people can understand what we have in mind when we make it.
You would say that a public commission allows an artist greater, or wholly new, scope?
Indeed new scope and, not only that, it gives him a living. He, like everyone else, needs to earn. This notion of 'doing your own thing' as an artist – art schools sometimes say, 'We encourage students to do their own thing' – is rather like allowing a footballer, who's a member of a team, to do what he likes: he's a bloody nuisance if that's all he does. You've got to serve the community in which you live. That's your function as a human being.
Another work of yours you donated to St Woolos' Cathedral in Newport.
I made it, as I thought, a Star of David, out of wood and glass, actually broken mirror, about three feet square. It is a circle set within a square. I gave it to the cathedral in memory of my parents, and, as it's in a cathedral, there's a chance that it will remain there for a long time!
Bim and you married in 1976. How had you met one another?
We met as a result of an exhibition I held in Tenby with another painter, Robert Hunter. Bim bought a watercolour of mine, which I delivered to her. After that she began to come to weekend painting classes I took and then attended the lectures I gave on European art in Pembroke. I recognised her very deep interest in the visual arts. She had been a student at the Byam Shaw School of Art in London so she was already a trained, professional artist. In buying The Golden Plover we aimed at owning a home where we could also have the gallery I've mentioned, simply showing our work, because for an artist it is important to see his or her picture framed and study it objectively once it's finished. I don't know how many works the gallery holds but I imagine fifty or more quite easily so you can see work in a domestic setting, close enough to feel cosy with it, but also somewhat more formally as in an art gallery.
Here at The Golden Plover Bim and you have formed a quite exceptional relationship in pursuit of the same goals. Bim said to me yesterday "With Arthur I have become myself" – she wasn't fully a painter, nor a maker of fabric pictures, before she met you – and you have told me that without her you would not have travelled nearly as extensively.

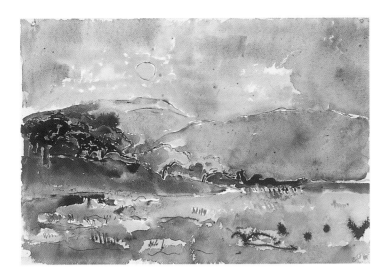

San Giorgio Maggiore, Venice
35.5 x 50 watercolour 1993

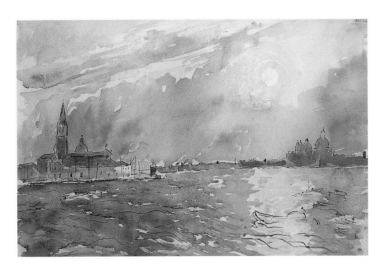

Glandyfi, near Machynlleth
39 x 57.7 watercolour 1968

That's true. Bim was a great traveller long before I knew her. She'd been to the Far East and sailed to various countries around the Mediterranean by yacht. She it was who explained to me that we could take a car abroad and, as a result, we've travelled to Germany, Austria, Italy, France, Spain, and when we travel we always paint, as Dürer did all that time ago. Also by train, ship or aeroplane we've been to the North Cape, right through Norway to Sweden, Lapland, to Russia, China, India, Nepal, Singapore, Malaya, Egypt and I've been to the United States and Canada. I remember in Lapland when they told us, "There are ninety different ways of describing snow", I thought that explained precisely why you cannot translate accurately from one language to another. Each is unique and utterly precious. Of the valuable things which the Welsh possess the most valuable of all is their language. They daren't lose that because if they do, they will lose their identity.

When you travel together you are not only drawing or painting.

When we're in Venice I can study the masterpieces of Bellini, Titian, Tintoretto and Veronese on the spot. In Madrid we draw but we also study in the Prado, which is the only museum in the world where you can really see Velasquez and Goya, or when we went to Peking we sought out the sculpture gallery in the Forbidden City and similarly in Kathmandu we studied the architecture and wood-carving in the great Durbar Square at the centre of the city. We travel to study the traditions of our art going back hundreds or thousands of years and we always draw. We're not holidaymakers. It's part of our profession to find out what the art of different civilisations is like in the various countries we visit.

And political considerations have not impinged – you have never been deterred from painting?

Only once, in China. As soon as I arrived in Peking I went into Tiananmen Square with my little notebook and began to draw. Before long I found myself surrounded by people to such an extent that I began to include in my drawing the head of one of them, who was so close to me that I couldn't see much else. Suddenly I realised there was a reaction against me and I got quite frightened, closed my book and walked away. I've never experienced that anywhere else. Later we drew a great deal in China, on the Great Wall or in the Forbidden City, with no trouble.

And in Russia?

Curiously, it didn't happen in Russia although Estorick had warned me to be careful about drawing in Moscow. But I did. I found my way to Red Square and began work; the police came up and had a look, soldiers had a look, schoolgirls looked. It was altogether different from what Eric feared might happen. In Kathmandu we were even more fortunate. Working in Durbar Square, on a bench by the wall of an army barracks, we were so crowded by those watching us that soldiers came out and cleared our view of the temples.

When you travel to somewhere you haven't been before how do you set about choosing a subject?

Frequently we travel with a group of people and usually these journeys include lectures. When the lecturer begins to speak I remain on the outskirts of the group, turn round, look at something and draw whatever is there in front of me. Very often it is just chance that has taken us to a certain place. In a way the decision is forced upon me and I don't mind a bit – in fact I like it because I might not have thought of drawing what I do. I have to make the drawing during the time he's talking so I must work fast – normally in Wales I work slowly – because when the group moves, I have to move soon afterwards or I may get lost. So my technique is governed by the need to stop at a particular moment. We both draw a great deal like that: little drawings, which we don't use in any other way. The people who travel with us, when we go as a group, are always very intrigued. They take out their cameras. We take out our drawing books and work as quickly as possible.

You never use a camera?

I used to carry a camera everywhere but now I leave it behind because if I take one, I don't draw. Bim and I earn our journey by making pictures which, when we come back, we are able to sell. And, besides, when I looked at my camera pictures after getting home there was a sense of disappointment; when I look at my drawings they're much more vivid.

These small drawings you do not consider to be sketches?

No, I don't sketch. By sketching I mean something casual or trivial whereas a drawing must be something that you have your mind on. The little drawings I make are valid in themselves.

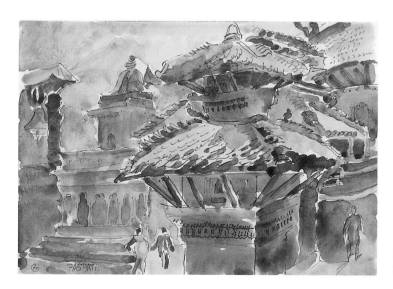

Paspati, Nepal
20 x 28 watercolour 1987

I concentrate hard on what I'm doing, trying to put down evidence of my experience. When I've done the drawing, if I can, I paint it on the spot but more often than not I can't, so what I do is look at the subject, shut my eyes and try to remember it and then as soon as I get back to the hotel or can do it on the boat I paint it. And I paint with very few pigments. I determine before I start what pigments I shall use, and as few as possible, in order to get the essence of a colour as I've seen it with my eyes closed, looking at it for the last time, as it were.

Occasionally I glimpse in some of your later watercolours a non-Western element. There was one I saw yesterday where the use of the brush seemed to have been almost Chinese.

I go to China or Nepal to find an inspiration I can't get in Europe. That's why I travel: partly to see what's been done in other places and at other times and partly in order to work there myself.

So when in China, you're slightly influenced by the Chinese way of doing things?

I hope so – but I bring that back home with me as well.

Due to the aeroplane you are able to extend your travel far further than any English topographical artist would have, excepting the artist who travelled as part of a ship's company.

Like William Hodges, whom Captain Cook took with him to the South Seas. Yes, I do travel to paint. Wherever I go I take my watercolours with me and my drawing book. I expect to paint wherever I am.

You've made much the same remark to me about your painting, when only fifteen or sixteen, in Amroth. Even at that age it was utterly natural for you to see something, draw it and then add watercolour.

It was. I always had my paints with me. I painted the ash trees, the sea, the cottages, Carew and Manorbier Castles.

How did you move on from this intuitive way of working when you realised you had become an artist?

I was always an artist. I took what I did for granted, seeing myself as following in the tradition of Cotman or Girtin.

So that when you became aware of what your contemporaries were doing...

I was already there, and supposed they had done what I had.

By then it was an inherent part of you so when you began to exhibit in London you were showing watercolours of places in Wales.

I was. Those were what I took to Rex Nan Kivell at the Redfern and he immediately said, "We'll show them and later we'll show some more." I also exhibited paintings of flowers, in emulation of Cedric.

Some years afterwards you moved from figurative subject matter for your one-man exhibition at the Woodstock Gallery, which was of wholly abstract work.

I never moved away from painting directly from nature in watercolour, although I did abandon oil painting for the reasons I've mentioned earlier. My painting stems from my love as a little boy of the Surrey countryside. When I was a child I climbed trees. I knew them intimately. I loved being in trees, making them sway, jumping from bough to bough. I love being in the sea, I love bathing. The sea for me represents the sheer joy of being lifted up and played about with by water. It's as a result of these excitements derived from nature that I'm a painter: they are the source of my art.

In another aspect of your painting you are concerned with certain types of architecture: castles, churches or the palaces of Venice – ancient buildings.

That I get from the English tradition but I've also painted frequently in cities such as London, Paris, Berlin or New York.

So you select urban as well as country themes. And what about your paintings of flowers?

I adore wild flowers especially. Both my parents were ardent gardeners; they loved their flowers, planted their flowers. However, I suspect again it goes back to my early boyhood when we picked wild flowers, buttercups, daisies, and violets we used to bring to my mother when her birthday came. We'd find primroses, we went searching for cowslips along the railway

Cà da Mosto
56 x 38 watercolour 2000

embankment. My mother taught me their names and my father collected those beautiful early nineteenth century books. There was in them a whole tradition of painting flowers, in the botanical sense: they were painted with the eye of the botanist but keeping in mind the needs of the doctor. I paint whatever I like the look of which is customarily seen at a certain season where I live.

In our time it has become much more unusual for a painter to go out and work directly from what Cézanne would call 'le motif'.

In that respect I've followed Cézanne.

You want to have the actual landscape or building in front of you.

Most definitely. I'm also aware that my own watercolours are now closer to those of Cézanne; I don't mean they are comparable to his in any way but they are no longer typical of the English tradition because my whole attitude towards colour is much closer to Turner and to the French tradition. Cézanne spoke of '*une petite sensation*'. Well, that is precisely my point of departure. I look at the complications of my subject and according to the sensation I receive from the very beginning, the first few lines, the relation of one form to another, I move from detail to detail and find that my sensations vary in relation to the growing understanding I have of the forms I'm observing. These sensations alter all the time so that towards the end what I'm seeing is something quite different, because of all the study I've made and because of the impact of my own representation, in terms of colour, ink and paper, on what I'm looking at. I can see things that I would never have been aware of when beginning. I only become aware of certain, to me fundamental, qualities in what I'm looking at after days of working.

Giacometti would, I feel sure, agree with you. He spoke repeatedly of his anguish when faced by his subject. Nothing remained constant for him and to get nearer to his sensations was a task of unceasing effort, hour after hour.

I notice a similar anxiety to discover what is there in drawings by Peter Prendergast. He almost puts his pencil through the piece of paper. That's why his drawings are so emotional. Constable summarises the problem thus: "The art of seeing nature is a thing almost as much to be acquired as the art of reading Egyptian hieroglyphics", and elsewhere he writes, "We see nothing until we understand it".

Thorn Trees at Dusk
49.5 x 68.5 ink and watercolour 1981

Thorn Trees in March
50 x 70.5 ink 1980

You consider one of your most important achievements in watercolour to be your thorn trees. Did you start drawing them because they were already there on the bank at the back of your house?
I'm sure I started drawing them because they are so easy to get to. The three trees stand on the edge of my garden and beyond, across the fields lies the sea. I've drawn them for twenty years because they've obsessed me. I shall never see enough of them.

Do you always paint them without leaves?
I prefer them without leaves because I like the skeleton of the tree. I think part of the reason why I'm so intrigued is because I only gradually become aware of the shapes which by the end I find are the vital ones. I always have to go through the whole process of discovering what the vital shapes are and this usually depends on the play of light or the degree to which they've lost their leaves. The pictures look, perhaps, as though I start big and gradually get small. It's not true. I start by drawing very intimate detail; my first strokes are about an inch long. I move very slowly to begin with and only at the end do I see the big, formally important strokes. They come right at the end after three or four days of work.

And will these first exploratory strokes be in pencil or watercolour?
They are always in pen. I didn't want to draw in such a way that I have to rub out. I make my stroke with confidence. I say. "This is it;" and it can't be altered because it's in Indian ink. I always draw in Indian ink, sometimes using water. I don't believe in sketching but in the utmost concentration throughout.

So you have never felt the need to turn a watercolour into a gouache because there were details you wanted to obliterate?

I've never done that. What I have done sometimes is put the whole drawing into the bath halfway through. That won't wash all of it out anyway because it's in Indian ink but occasionally it can create an interesting texture. A point worth mentioning is that the colour comes almost at the end after I've worked on the drawing for three or four days. Then it becomes a morning, afternoon or evening picture.

Will you return at the same time each day?

I will and just before the end there is an effect of light and I say, "This is the effect of light that I'm going to use." Then the painting, the use of colour, takes about an hour or two.

During those first days there is no colour at all?

Not until the last two hours. The colour is very simple and is dependent upon my immediate sense of it. This is thrilling to me because the labour has been intense. It's a meticulous study of these factors in relation to one another and at last I have seen the big, dramatic lines and made them. Very often in ending I fill my brush with water and ink, make the strong lines and then dry it absolutely. Finally, on the dry drawing I add the colour.

There is no merging of this black into the watercolour?

No, no. It mustn't.

These paintings vary considerably in mood: I've been reminded of Rembrandt's etching, The Three Trees *or, on the other hand, of van Gogh's tortuous olive trees.*

While my primary inspiration is the sea the thorn trees are equally a part of nature, part of the tradition of thorn trees growing in Pembrokeshire over thousands of years and an essential part of human experience in Europe because the thorn tree is associated with Christ on the cross. We speak of trees having 'limbs' or a 'trunk' but the thorn tree, in addition, has a sound. In winter it howls and whistles and sighs.

You would not use the term Expressionist, which some people say of your work?

I don't consciously seek it, in fact I react against that notion of self-expression. If it happens, and almost invariably it does, it is because every person's vision is different. Each of us is unique and that's why there can be no absolute, objective representation of what the world looks like.

As watercolourists Bim and you have been associated with the Tisch Beere Gallery in Cardiff over a number of years.

About fifteen I would say. Tisch Beere, first of all, invited us to put on an exhibition in a gallery in Somerset of the paintings we'd been doing in Venice. After that she suggested we have a two-person exhibition in her gallery every second year and also periodically show in

Thorn Trees
49 x 69 ink and watercolour 2000

mixed exhibitions. She comes here from Cardiff to look through the work we've done abroad and makes her choice of what she feels will appeal to her clientele. She's been a great support to us because she invites professional people, lawyers, dentists, academics, to her Private Views, which are always packed. She has charm and authority and people respect her judgement. She is a genuine dealer.

And for years you would also share an exhibition at St David's, speaking to whoever came in.

For seventeen successive years we showed our work in one of the buildings of St David's Cathedral, St Mary's Chapel, which was a fine place for seeing pictures as the big windows are high up and shed light from each side onto the opposite wall. A friend of ours, Wendy Gillett, a good draughtswoman trained at the Slade, made portraits of those who visited the exhibition and wanted their portraits drawn while her husband James displayed his pots in the centre of the chapel. Our pictures hung on the walls on either side, largely watercolours and usually of Pembrokeshire but including other places we'd travelled to. Those who visited might be from anywhere – people come to St David's from across the world. If it was raining it could be absolutely packed or there could be hardly anyone if it was a beautiful day. We prepared a small catalogue with details about ourselves and a list of galleries where our work could be seen. Other artists came to speak to us or we made a point of going up to people, asking them where they came from or for a response to our work. It was very valuable to have their reactions.

Some of the conversations were serious and not merely chit-chat?

Oh no. Especially with an informed person, who would look at the pictures with the degree of interest you'd expect, possibly an artist themselves. And sometimes they would buy something. We found it well worth our while, an extension of what we do in our own gallery but with a far wider audience. I love to talk to people about what I'm doing.

In your own gallery you do likewise?

When people visit our gallery quite naturally they want to hear what we have to say about the pictures on the wall. We expect to talk about our pictures and take great pleasure in discussing them with whoever comes to the gallery. And we have made a certain amount of money in this way, selling from it. It *is* a gallery in the sense that we advertise in the local press and a number of people, including holidaymakers, visit it. Bim makes fabric pictures as well as watercolours and I show my relief sculpture and watercolours. We've painted a great deal of what surrounds us, our garden, the beach, the local fields. The farmer finds us in his field painting the sunset or sunrise, the corn or the reaping of his harvest of potatoes.

And he's not unhappy to come across you?

At least he's not surprised to see us. One of the farmers in whose fields I've worked was a member of my art history class.

And has he bought any of your paintings?

He has as has the doctor, who also attended the lectures. We know our environment well from our viewpoint as painters who paint it. And the villagers and our friends in the district recognise us primarily as artists because we practise our art here. What is of paramount importance is to re-establish the artist's role in society: to be in the community as relevant to it as the doctor, the butcher, the farmer, the priest. Too often we're considered to be on the periphery of society – if we are thought of at all.

FOURTEEN

Let us celebrate the muse in what is for you one of her principal guises – the sea.

It interests me that you call the sea my muse because great Venus was born of the sea!

And shells continually figure in your reliefs. How did the sea become so much a part of your life?

One of my first memories is of travelling with my parents by train to Eastbourne to spend summer holidays. I remember paddling in the breakers and making sandcastles; once there was a competition for building a sandcastle in which I won a prize. Those visits, I imagine, caused me to fall in love with the sea. I already knew about paddling in the river Tillingbourne at Abinger but the sea was quite different. Then, when the family began visiting Amroth, I encountered another sort of sea altogether. I recall that immense storm, which washed away a whole line of houses at the top of the beach: the sea leapt across the gardens and swept eight houses out into the ocean. That was because of a tremendous gale from over the Atlantic and this has to be part of my absorption with the sea: it is the most direct experience you can have in this country which makes you aware of what man cannot dominate. When I'm on the beach at Freshwater West I participate in that experience, or a range of experiences, derived from contact with the sea. Take the sea at low tide on a very calm day: what I do is go down to the beach carrying my materials, a milk-crate to put my board on and a small stool. I get as close to the water as possible. I begin to draw, enjoying that wonderful sense of the vast expanse of the sea and, as the tide goes out, I follow it. I move my crate forward or if the tide's on the turn I move it back. I follow the sea, respond to its serenity, listen to its extraordinary noises. On the calmest days it ripples as it flows in, then as the wave turns it makes a sucking sound in pulling the pebbles out again or in one of those gigantic seas it roars as the whole Atlantic comes pounding towards me. The sea thunders, its foam brushes over me and perhaps I have to rescue my paper from the water. I love being there confronting the problems the sea presents me with. I will work for three or four hours making a picture in watercolours. I've discovered a method of doing it, using a few pigments, for example, so that I don't overwhelm myself with difficulties in tackling my subject.

Would you say that you've painted the sea in all its moods?

I would say so. How to represent what the sea is doing is the issue: I make a number of drawings in a book down on the beach, holding it in my hand, and some of these drawings I've used in making my relief sculptures.

Are they simple indications of rhythms?

I never use shading when I draw. I draw in lines, simple lines, so it's an abstraction even as I put it down. I suppose that a photograph, which is concerned with what happens in a split second, is also an abstraction but it cannot express movement in the way the artist should seek to because another attribute of the sea is that it's always in movement. It never stops, nor do the trees, nor anything else. The condition of life is perpetual, everlasting movement. The light always changes, the air is always shifting, but the sea most evidently and that movement has to be part of what I aim at expressing. One of the fascinations of the beach here is the impact of the sea upon the rocks, the way it has shaped them through aeons of time. They've become so smooth you can detect the rhythm of the waves on them, and the cliffs roll back because of the play of the weather over centuries. They too have taken on something of the rhythm of the sea.

So this shoreline, miraculous boundary between land and sea, where the encounter with the goddess is made, has become...

My principal inspiration.

You mention you might start a relief from one of those drawings you make in your book.

An absolutely spontaneous drawing of the sea; it cannot be captured because of its constant undulation but I discover forms and I may realise that a group of them in an improvisatory

Tide Coming In, Evening
40 x 58 watercolour 1963

The Sea
39 x 58 watercolour 1975

Morning Sea
40 x 59 ink 1976

142

drawing of perhaps three minutes can be the beginning of a large-scale construction. If so, I copy the drawing onto my board in charcoal and then allow the design to grow, modifying it according to the requirements of a relief sculpture.

Your watercolours in direct response to nature and reliefs abstracted from it are then obviously interconnected?

If I start with a piece of board and begin to draw forms which gradually develop, these, I'm certain, come to me as a result of the intensive study of nature I make in the watercolours. The difference is that in a relief I begin with a big shape or form and finish with tiny details, whereas in a watercolour the process is exactly the reverse. Another way I've begun many reliefs is to use a geometrical plan as my point of departure. I take a circle and relate that to another, or I take a square and subdivide it into smaller squares or introduce into the composition a second square. I will try and relate those two squares by the subsectioning of smaller squares and then move from one corner to another to another linking all the squares together. I find in working from primary forms, what Plato calls "forms which are beautiful in themselves", that I move towards what resembles nature. I first called one of my paper constructions *Looks like* because it began to look like ivy falling from a wall. When I realised what it was, I increased that likeness, making it fall in a cascade. Then I saw that underneath was a big form while over the top was this cascade of smaller circles. Finally, it became an image of a woman wearing a veil so I renamed it *The Veil*.

You are not interested in a completely abstract work, stressing one colour against another or form against form?

When it is abstract I want to imply more than form to form or colour to colour. I find I can't just do that.

So you may begin a relief with a drawing from nature or with a geometric form...

Or I may choose a piece of music; I'm sure I've been stimulated by Debussy's *La Mer*. Or I may try a musical structure such as an *allemande*, which has a characteristic rhythm. I'll set it down in terms of lines and once I have them on my board I can begin to move. It's as though I need a bit of grit and from it try to produce what I hope will be a pearl.

How did you begin using the innards of a watch?

Watches were available. I was given them since they were no longer of use to the shopkeeper, except for the gold or silver case, which he removed. The rest he regarded as rubbish.

You've made exceptional assemblages with them.

When I use watches, or parts of watches, it isn't only because of their shape or colour. A watch is symbolic in that it arouses our perception of time or, if a face has no hands, of eternity. And I have also sought to celebrate the ancient art of the watchmaker, which is disappearing. When I include watches in my reliefs of the sea it's sometimes to evoke the whiteness of foam on the water but also because the sea is, to my mind, apart from the sky, the closest approach I have to timelessness.

What made you then choose paper as a basic medium?

I came to see that paper is something from which you can construct with considerable precision and intricacy. Besides, it has a quality of its own and with the mere touch of a pencil you can get a slight differentiation of colour. I never cut paper, I only tear it. If you tear paper the line is beautiful and you can make it any thickness you like. The paper constructions led on from the sectioning of brass taps because I found I could make similar kinds of sections from circles of many layers of turned paper, which is far easier to manipulate than brass. I had in mind at one time those paper structures folded into Victorian books, which when the book was opened out, stood up and became three-dimensional.

These paper constructions seem to me technically some of your greatest feats.

They are complex and they've been made over hours and hours of time. The pieces are each torn to a precise thickness in strips of ten inches to very much longer. Then I roll them to exactly the size that I need.

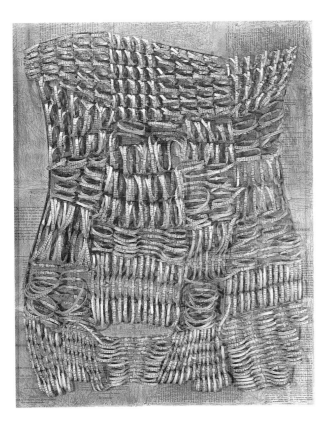

The Vessel
73.5 x 59.5 paper on board
1980

And then glue them in certain ways?

I glue them down as I want them to be. This all takes a considerable while but it's no good hurrying. You have to hurry if you're trying to draw the sea: because it keeps on changing you have to get it down. You're chased by it. However, once you're in the studio it's probably more like being a musician or poet. You forget the passage of time.

To use a musical analogy, there are very different time-signatures involved in the making of your watercolours of the sea and your more processed works, which may also relate to the sea but will be in wood, paper or include shells.

They take months and maybe years because I alter some of them after quite a time.

For me your flatter paper constructions, closer to collages, and sometimes the assemblages including watch parts, have an antiquarian feel to them – a very honourable aspect of Surrealism. I see it, for instance, in Max Ernst's use of nineteenth century engravings, which gives to his collages a curiously 'antique' quality, although what he worked with may have been less than a hundred years old. You make use of discarded books – how old might they be?

Perhaps a hundred years or less. The reason why they're old is because the paper has to be rag paper, free of acid so it won't rot, very often from books that nobody wants to read any more. I also tear into thin shreds watercolours that I no longer like. That paper is excellent, even stronger, so in a way better to construct with.

How do you react to my use of the word antiquarian? I have more the sense of a scholar, a philosopher, of someone in his cabinet.

They are more tranquil: there isn't the same degree of effort involved in making them. They're put together from old books so they could suggest nostalgia. They relate to the collector in me.

You've mentioned the value of a musical structure. Has the structure of a piece of writing ever proved similarly useful?

No, but some reliefs have incorporated entire pages from books.

How much are the words to be taken into account?

Words have an immediate impact upon the mind. I'm extremely interested in chance so if, in

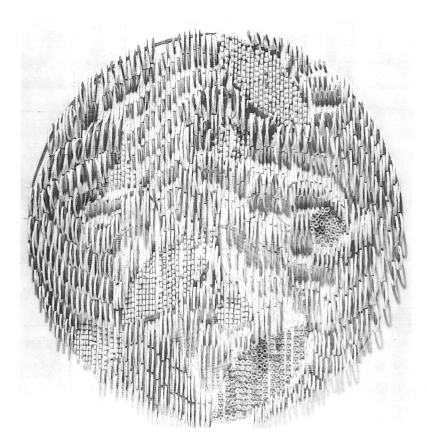

The Sea is All About Us
81 x 81 paper on board
1992

looking at one of my reliefs, you suddenly come across a word which unexpectedly fixes your attention I'm glad. I'm not concerned why but a word strikes in a way which nothing else does. The words are there by chance. They may be upside down; they may be halfway round. The onlooker's attention is caught, "Why ever is that word there?" he or she asks. I can't answer the question but it has for a moment or more rivetted their attention before they move on.

You've made an arena in which that word has a place. Where you've used a whole poem are you concerned with its content?

It is pure accident. I merely wanted a poem or I wanted a piece of music. What is there matters but is, to some extent, put there by chance. Sometimes I've found that a bit of paper I've torn out has a poem on it and I've thought, "Why not some bars of music as well?" so I've included scraps of music in my construction. Maybe the music is included because of its texture. There's a relationship of marks of certain shapes in a piece of music, semi-quavers, quavers, a minim. They have shapes as well as significance in musical terms, as have letters or numbers. These I've used often for their shape and for the reason that they spark some other part of the mind because they evoke literature, writing or printing but not speech.

In the context of multi-media, if one of your reliefs in which there are musical notes were on exhibition and there was a tape-recording of an instrument playing them, would you like that?

It would be wonderful.

In fact, there is a scrap of music in one of your collage constructions I'd like to hear you play on the piano. This is part of its enchantment, bringing forth what is embedded in its surface.

Those notes make an impact on me which is due to my working as a musician. To me they aren't just shapes but bring illumination to my mind as music.

Has the human figure played a part in your work, either in paintings or in making reliefs?

I would love to have drawn the human figure more, but it hasn't been practical. I didn't have the money for a model, nor to set up a studio appropriate for painting in oils, nor to buy canvases. I've become a landscape painter and a maker of sculpture of a kind through necessity.

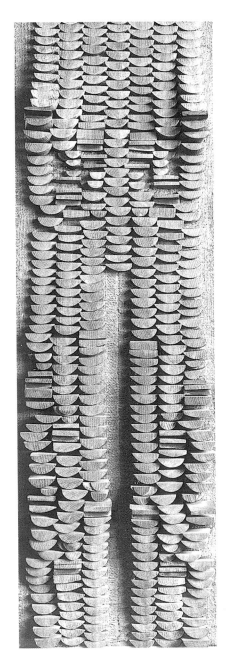

Venus Anadyomene
88 x 32 wood, sacking, pigment on board 1959

You sound like Cézanne, who equally regretted that he couldn't use a model.
I couldn't afford to and, I suppose, it has been partly because of the social situation in which I've found myself.
Were you in a town you could join a drawing-class.
Easily. I did as soon as I got to Folkestone and on arrival in Laugharne I went to the Art School in Carmarthen to draw from the model.
There is one relief of yours in wood of hips and a pair of long legs. I wonder why you've not done more work from the female figure?
I've made two sculptures of Venus. The point about Venus, or any woman, is that she divides in order to release the next life.
For me it would be inconceivable not to draw or paint nudes.
But I haven't got a nude to paint. My wife is cooking the lunch!
I have to do it whether I have a model available or not. You don't feel that same compulsion?
I'm not at all sure that I don't. I love drawing people who are willing to sit for me. I grieve

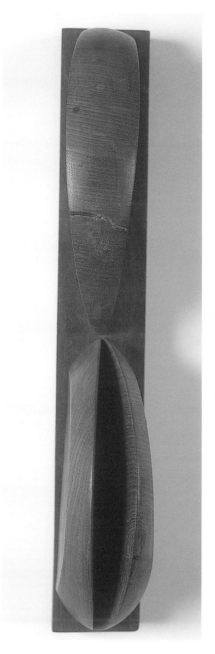

Two Related Forms
34.5 x 5 x 5 wood 1968

to think how little I've worked from the human figure and that I haven't been employed as a portrait painter.

Your references to the figure are usually oblique, although you have created one powerful, almost Tantric, image of the female genitals.

It isn't surprising that if you work intuitively as I do you are bound sometimes to come across sexuality as the meaning underlying what you're making. I planned and started to work on a mandorla, an almond-shaped form often used in Mediaeval art. I wasn't looking for a religious theme but found I was making a symbol of the human condition. My friend the painter Ota Janecek suggested I call it *The Treasury.*

The sexual imagery arises naturally. You don't set out...

No, but I'm glad if I discover it because sex is one of the joys of life, and a profoundly important one, a most serious growing of our responsibilities. Taboos are cruel and often pretentious but, at the same time, I feel that treating sex as a sort of game is desperately wasteful and trivial.

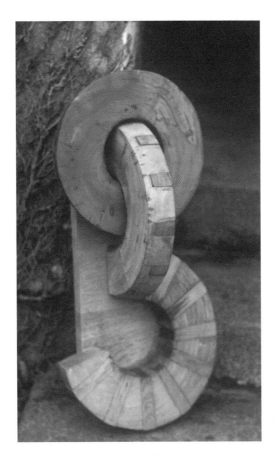

Interlocking Circles
60 x 30 x 20 wood 1963

Although using the phrase 'sculptor of a kind' you are actually quite clear about what sort of sculptor you are. When speaking about the head you'd modelled of Judy in one of our conversations some years ago I asked if you'd thought of becoming a sculptor and your answer then was no, but two pieces you've done seem to me to be sculpture rather than reliefs.

One small piece now owned by Michael Estorick, *Two Related Forms*, and another of half circles. Whereas the sculptor, for the most part, uses a chisel to fashion his wood or marble, I use a knife, a saw or chisel. I tear my paper. In the strict sense of the word I do regard myself as a sculptor as well as a painter.

A photograph taken at Llethr shows a vertical relief of yours from the 50s placed against the shaft of a pump. If the viewer did not know this, it would seem as if the shaft had been carved by a craftsman carpenter, as you decorated your leaping poles when a boy. You never thought of embellishing everyday objects around the home: an end baluster or a door-frame?

No, I've never done that.

I was thinking of the Romanian folk art lying behind the sculpture of Brancusi. I do know that one piece of sculpture standing locally has made a lasting impression on you.

Yes. The Celtic cross near Carew Castle. It's of radical importance to my work. I first saw it when I came to Wales at fifteen. And it is, after all, a relief sculpture.

Your work I see as having developed from the interest various artists of the 40s and 50s took in 'matter' or physicality such as Dubuffet or Burri, but moving towards a way of working which connects you with a much more recent development in the artist's response to landscape. People like Richard Long or Andy Goldsworthy work with natural materials, as you do, but out in the landscape selecting a site in which they photograph their compositions. These photographs, or compositions of objects, may then be placed in a gallery as installations although for you your shells continue to find a place on or embedded into sacking or board. How do you respond to their work?

I admire both of them. Long has opened our eyes to aspects of the grandeur of nature. In his work he takes us for a walk, and so we wander out into the countryside and try to see it

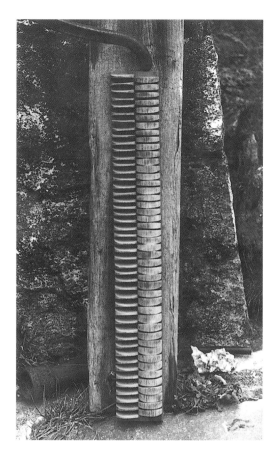

Untitled
dimensions unknown, wood 1959

through the inspiration we've received from him but the point I'd make about the photograph is this: if it's all I've got, I find there's an emptiness about it because of its extreme abstraction – even if it persuades most viewers that it *is* reality. A photograph represents what something looks like in a split second not to a mind but a mechanical contrivance. When we actually look at something we change focus again and again with our eyes – and we have two eyes, not one lens. I differentiate sharply between the discovery possible to a photographer and that of an artist. They are quite opposite in kind. The artist may sit before his landscape for hours, days or weeks. The account that he gives has to do with his craft, his intelligence, his vision, his experience of what changes as he sits observing it.

You saw a circle by Long a few days ago in Bristol.

It was very beautiful, an arrangement of roughly cut segments of rock laid upon the floor of the gallery and I saw it immediately as a work of art. Similarly a carving by David Nash; out of a tree he'd shaped a wonderful throne. These two works moved me deeply but I could never have that experience except in the presence of Nash's piece of sculpture or those rocks by Long on the floor. I've got to be there, absorb them through my mind, and experience the character of my seeing as a physical activity. I respect the work of Long or Goldsworthy but it isn't what I do. I try to bring the outside world, first of all, into my studio.

Are you speaking of the objects you collect?

Yes. I pick up common things like shells and incorporate them into my reliefs because they are related to the sea but I also honour them in themselves as evidence of the power that is within a living creature to construct objects of such intricacy necessary for its being. A shell has been a dwelling, which a little creature has constructed as a refuge, to protect it from the ferocities of the sea – and I want it on the wall.

In studying these reliefs I find some shells are already in a state of decomposition: they've got a hole in them or are chipped, so the journey from creation to destruction is discernible, the cycle of nature that Ceri Richards stressed in your radio interview.

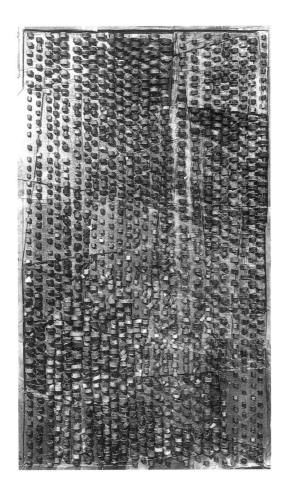

By Night
80 x 60 paper on board 1976

They are in process of returning to the sand.

Once when discussing how the world is perceived you quoted from Anthony and Cleopatra. *"Thou hast seen these signs, / They are black vesper's pageants." and you've occasionally mentioned in passing that you are subject to nightmares.*

Oh yes, very much so.

Do these, I begin to wonder, account for another dimension in your work? I'm struck by certain grey or black compositions, which are quite opposed to the optimism of most of your constructions.

There is one, *By Night*, which Olivier Debré had from me – we made an exchange – a black paper picture. "J'aime beaucoup vos noirs," he said. I don't think consciously about these terrors but my wife tells me that I groan and shout before suddenly waking up, absolutely terrified.

Subconsciously they inform your work?

I'm sure they do and perhaps that's part of the way in which I make contact with them: I get them outside of myself by means of my work. It's a release for that side of my mind.

The results can be disturbingly evocative.

One of my recurring nightmares is about being lost in a shattered city and I haven't an idea of where to find anybody.

Maybe those days spent fire-fighting in the ruins of Swansea have never been erased from your memory. I'm reminded of a small construction where the inner framework appears to be charred. On closer inspection it is in fact covered with fragments of black lace, recalling the trimming of a widow's garb. Others seem smoke-stained or crinkled or, if surfaces are scored with graphite, they take on the dull glint of coal.

What you're saying seems to me valid. I love the character of graphite and in the scribbling there is an energy akin to that of the coiled paper.

"Black vesper's pageants" for me conjures up the more sinister element within Surrealism.
It acknowledges that aspect of what we are because we carry darkness, or distress, within us. Life *is* terrifying as well as being utterly mysterious.

A photograph of one of your abstract reliefs tilted on its side could suggest a model for an installation. As you regularly visit the Venice Biennale have you considered developing any of your own work into something as large and all-encompassing as an installation?
I don't think I have. Primarily, I want it on the wall in a home and have to bear in mind when I'm making something that it has to have a certain size, shape and frame appropriate for the home.

On the other hand, there are a number of your reliefs you firmly believe should be unframed.
The relief, *Jetsam*, based on a very beautiful piece of wood picked up on the beach that has been worked on by the sea mustn't be imprisoned. I can't fit that into a frame. I far prefer it still to have the sea about it. In that instance the room is frame enough.

The small reliefs, where many discrete items are cut into cavities behind circles of glass, I've noticed propped against a book on a table on leaning casually against a wall. As I've said, I find this disconcerting.
I like them to be moved about, taken off the table and held on your knees or turned round and held up to be studied in a different light. They will have, say, twenty individual images in them and I really make them to be read. What I expect you to derive from looking at them is the sense of a relationship, which otherwise you wouldn't recognise if these objects were looked at in isolation from one another.

Do you mind if in handling them they are shaken a little and shells move around or sand shifts?
According to David Fraser Jenkins the clicking and the knocking they make is relevant to their quality. He almost hears my works, he tells me, when he looks at them. That has to do with the fact that I'm so much concerned with the sounds of the sea.

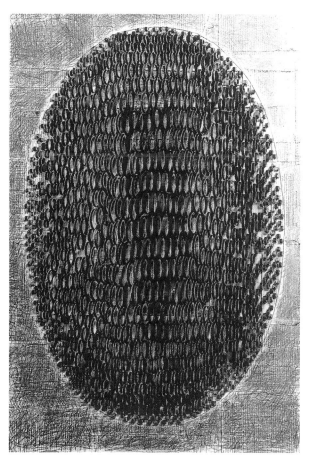

A Field
82 x 68 paper, graphite on board 1977

This conversation began with celebration. Let us in ending return to it. In 1973 you were honoured for your work in art and education with an M.B.E. for 'Services to Art in Wales'.

I was astounded to receive a letter asking if I would be willing to accept it and I answered "Yes". The climax was going to Buckingham Palace with my son. First of all, the recipients had to be taught how to approach and leave the Queen. A Guards' officer – he was very handsome, very tall – showed us what to do; he was so upright that he seemed almost to be tilting back as he went forward. He explained that we mustn't turn around in returning to our places. We had to walk backwards to a certain point and then could move off at a right angle. There were quite a number of us – plenty of people receive these honours – and we had to wait in the Queen's private art gallery, where they hold the Royal banquets, among the Rubens, van Dycks, and Rembrandts. I made the most of the opportunity and enjoyed myself vastly. And then, of course, the moment came when it was my turn to bow and walk five steps up to the Queen. Before pinning on my order she asked, "And what do you do?" I replied, "I'm a painter." "A painter?" She looked at me questioningly. Only afterwards did I realise that I ought to have said I was an artist. It was a great occasion. We were in the grand ballroom under the chandeliers facing the scarlet, canopied throne with Beefeaters holding spears and surrounded by soldiers in armour with drawn swords. Behind, arranged as in the choir of a cathedral, were our families or friends who had come to watch. Music was softly played by military bandsmen in the musicians' gallery. I'm a believer in ceremony. It was a sumptuous occasion; I loved it as I love the sumptuousness and grandeur of high mass in St Mark's in Venice.

Such occasions have almost vanished, haven't they?

High mass has by no means vanished. It's as grand, I imagine, as ever it was. Sung mass each Sunday; there are others but I prefer sung mass, when everyone goes up and receives the host from the priest. I'm not a Roman Catholic so perhaps I'm wrong to accept the host but I do. Music is played on the organ, there is a choir and that ancient place reverberates with sound. Then the moment comes when there's the ringing of bells from the floor of the basilica, followed by the chiming of more bells above in the great domes, pealing out across Venice. It's magnificent.

Quite recently you've had another honour bestowed on you. After a most distinguished period of service as Chairman of the 56 Group Wales you retired but they have not let you go.

I was Chairman for almost forty years. Some may think that was outrageous but, at the end they made me President for Life. And I am still very much interested in the contemporary art we have in Wales. Like other artists we in the Group are anxious to have a gallery of modern art but, it seems to me, what we need here is a gallery in which most of the works will be Welsh, but we must, at the same time, collect work by artists from abroad so that the work of our artists is related to the art from which it is derived and that is, of course, international.

You've been honoured for your many years of service on behalf of the arts in Wales – well over half a century – but you remain an Englishman.

I'm an Englishman in Wales, a foreigner but by no means a stranger. I love Wales and would rather live here than anywhere else in the world. That's why I've made my home in Warren. I think foreigners have certain privileges and I'm grateful for them.

What privileges?

You aren't a victim of scandal. You're separate, remote.

And what about your children? Do they see themselves as more Welsh than you?

Judith has lived in Wales since she was six. She was head girl at Whitland Grammar School and, after attending art school in London, completed her studies in Newport before teaching art at a school in Ystradgynlais. She then married into a family which is half Welsh. Lawrence was brought up in Wales, went to Llandovery College where he became head boy and captain of rugby. He can speak some Welsh and understands it. He first married a Welshwoman and then an Englishwoman. Both of my children now live in Pembrokeshire with their spouses, each embedded in the culture of the country and extremely proud of Wales.

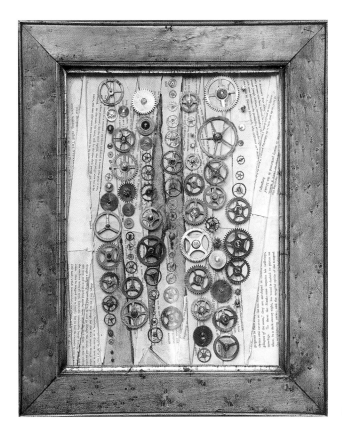

Pachebel's Canon in D Major
36 x 29 paper, brass,
silk on board 1973

Presumably your grandchildren feel themselves to be Welsh?
Judith's see themselves as half Welsh, half English, whereas Lawrence's would consider themselves to be Welsh and have learnt the language. Now almost all of my family, children, grandchildren, great-grandchildren, live and work in Wales, many here in Pembrokeshire.
You still exhibit frequently in Wales and continue to give occasional lectures at the age of ninety.
I give lectures and I'm about to have a major retrospective exhibition in London at the gallery of England and Co, followed by a tour in Wales.
And you make a point of travelling abroad each year, not only to Venice, to paint.
Every year we go to Venice. Why? Because I have a very red Italian blood.
One last question: what next, Arthur?
What next? That is the virtue of being a painter. My great fear is that if I don't paint for a week, it will be even more difficult. If I don't paint for a month, I may give up for ever. So the constant challenge is that you must keep on working. You must paint. You must draw. It's like speaking. I met a chap once who was recently out of prison; he found it difficult to talk at all. So you've got to carry on doing this job. Picasso was right about it, "Je ne cherche pas, je trouve." I do not seek, I find. You are finding out, you are on a journey. Rather like Dante's journey:

> Nel mezzo del cammin de nostra vita
> mi ritrovai in una selva oscura,
> chè la diritta via era smarrita.

> In the middle of the journey of our life
> I came to myself in a dark wood,
> Because the strait way was lost.

Now that was the very start. He never stopped travelling. He reached the presence of God finally in his hundredth canto. You have got to keep going.

Acknowledgements

For their help in initiating the project: Susan Behrens, Ken and Diana Bloomfield, Vera Chedburn, Howell Davies, Hugh Elliot, Michael Estorick, David Fraser Jenkins, Adrian and Annalese Giardelli, Bim Giardelli, Ceri and Alison Giardelli, Lawrence and Marcia Giardelli, Wilfrid Giardelli, James and Wendy Gillett, Malcolm and Donna Jenkins, Katharine Lewis Robin and Judith Lewis, Jean Claude and Denise Léon, Amine Mamode, Anne Morris, Peggy Mowat, Charlotte Skuratovicz, 56 Group Wales, David Tinker, William Wilkins

For their support during the project: Jennifer Booth, Kate Campbell, England & Co, Mary Griffiths, Brinley Jones, Jan van der Knaap, Christopher Leith, Christopher Lewis, Auriol Mayo, John McCormick, Judith McDonald, Jonathan Miles, Jill Piercy, Peter Prendergast, Anne Price-Owen, The Society of St John the Evangelist, Nicholas Tresilian, Robert Weir, Peter Wells

For assembling the final draft: Ruth Green

Photography copyright as follows:

Arts Council of Wales: *A Field*. Susan Behrens: *The Wave, Telpyn Panel*. George Butcher: *The Serenade*. Gallerie Convergence, Nantes: *Old Worlds*. Lawrence Giardelli: *Dwellings, Reflections*. Graham P. Matthews: *A la Recherche du Temps Perdu, Beach Rhythms II, Between the Violet and the Violet, Between Tides, Black and White Foliage, Black Fugue, Ca da Mosto, Carmarthen Bay I, Carmarthen Bay II, Dowlais, Evening Sea, Five Part Invention, Flowers, The Giardelli Family, Jetsam, Judy, Laugharne Panel, Lawrence, Morfa Bychan, Morning Sea, Once Upon a Time, Paspati, Nepal, Pendine, Pendine Panel, The Possessed, The Rape of the Sabines, Red and Black, The Sea, Sea Forest, The Sea's Drift, Semicircles, A Shoal of Time, Thorn Tree, Three Hellebores, Tide Coming In, Time Pieces, Winter in Wedmore, Winter Sea, Work Table*. Richard Griffiths: *The Hub*. Raymond Moore: *Frontispiece (Arthur Giardelli at The Golden Plover)*. Musée des Beaux Arts, Nantes: *Pachebel's Canon in D Major*. National Museum of Wales: *Towers, Glandyfi, near Machynlleth*. National Gallery, Bratislava: *Orient and Immortal Wheat*. David Perkins: *Mural for South Wales Argus*. Miki Slingsby: *Eternity the Other Night, Two Related Forms*. Tate Gallery: *The Sea is All About Us*.

Chronology

1911	Born at 27 St Stephen's Terrace, Stockwell, London, son of Vincent Ausonio Elvezio Giardelli and Annie Alice Sophia, née Lutman.
1912	Family moves to Bradmere, Scarle Road, Wembley, London.
1913	Birth of brother Wilfrid.
1915	Father leaves for the War.
1916-7	Moves with mother and brother to lodge in Gomshall, Surrey, and then to 26 The Dene, Abinger, Surrey. Attends the village school where mother has become assistant mistress.
1919	Father returns from France. Family moves to 1 Ellix Wood Cottages, Abinger, Surrey.
1921-23	Attends Guildford Grammar School.
1923	Family moves to 71 Hopton Road, Streatham, London.
1924-30	Attends Alleyn's School, Dulwich.
1925	Family moves to 4 Stanthorpe Road, Streatham, and begins to take in foreign students.
1928	Family leases The Retreat and later The Mead, Amroth, Carmarthenshire, taking in students and visitors.
1930-34	Studies at Hertford College, Oxford, and attends the Ruskin School of Art. Writes research paper on Botticelli's illustrations for *The Divine Comedy*. Becomes Captain of Soccer and is elected President of Oxford Musical Club and Union.
1933	Receives B.A. Hons in French and Italian Languages and Literature.
1934	Receives Diploma in Education from Oxford.
1934-40	Joins Harvey Grammar School, Folkestone, as a teacher of French and English. Teaches evening classes in Italian and French. Attends life-drawing classes at Folkestone School of Art and visits London fortnightly to study viola with Ernest Tomlinson. Visits Germany three times.
1937	Marries Phillis Evelyn Berry (Judy).
1938	Parents give up lease on The Mead, leave London and move to Wedmore Hall, Wedmore, Somerset.
1939-45	Part-time member of the Fire Service.
1940	Birth of daughter Judith Ann. School evacuated to Merthyr Tydfil; registers as conscientious objector and as a result loses job. Invited to live at Quaker Settlement, Trewern House, Dowlais, and to sit on Conscientious Objectors' Advisory Board. Becomes music teacher at Cyfarthfa Castle Grammar School. Gives concerts for the Quaker Settlement in The Armoury, Dowlais, and in Cardiff.
1941-6	Lectures on the History of European Art for the Workers' Educational Association and Extra-Mural students at University Colleges, Swansea and Cardiff; lectures with wife on History of Music, illustrated by viola and piano, at The Armoury, Dowlais; lectures on History of European Art at Pontypridd; Guide Lecturer for the Council for the Encouragement of Music and the Arts.
1941-50	Meets Cedric Morris in Dowlais and over the next few years occasionally studies painting with him and Arthur Lett-Haines at their art school at Benton End, Suffolk.
1942	Birth of son Vincent John Lawrence
1945-6	Moves with wife and children to join parents and brother at Wedmore Hall, Somerset, to teach foreign students English and take in holiday visitors.
1947	Both families move to Broadway Mansion, Laugharne, Carmarthenshire, to continue the same business. Attends life-drawing classes at Carmarthen School of Art.

1948	Moves with wife and children to Lethr, Pendine, Carmarthenshire. Meets Hans Polak Leiden.
1949-50	Two lecture tours in Holland.
1949-63	Occasional lecture tours for Welsh Arts Council, W.E.A. lectures, schools lectures, radio broadcasts.
1953	Death of father.
1958-78	Tutor, then Senior Tutor at University College, Aberystwyth.
1959-98	Chairman, 56 Group Wales.
1960	Joins Committee of the Contemporary Art Society of Wales.
1961-3	Forms art collection for University College, Aberystwyth.
1962-98	Artist attached to the Grosvenor Gallery, London.
1964-7	National Chairman, Association of Tutors in Adult Education.
1965-6	Radio interviews with David Jones, Josef Herman, Raymond Moore, Ceri Richards, John Selway, *Spectrum*, BBC Wales.
1965-75	Member of Art Committee, Welsh Arts Council.
1966	Television documentary, *See What the Next Tide Brings*, BBC Wales.
1968	With Judy, visits Fairfield and Anne Porter in Southampton and New York
1969	Moves to The Golden Plover, Warren, Pembrokeshire.
1972	Death of mother.
1973	Awarded MBE.
1974-9	Forms art collection for University College, Swansea.
1975	Television documentary, *The Art of Arthur Giardelli*, BBC Wales.
1976	Marries Beryl Mary Butler.
1977-80	Member Calouste Gulbenkian Enquiry into the economic situation of visual artists.
1979	British Council Award.
1979-85	Honorary Fellow, University College, Aberystwyth.
1980	Death of first wife, Phillis Evelyn Giardelli.
1983	Television documentary, *Where the Tide Turns*, on 56 Group Wales, HTV.
1984-2001	Artist Attached to the Tisch Beere Gallery, Cardiff.

Exhibitions

Selected One, Two and Three Man Exhibitions

1959 Woodstock Gallery, London.

1960 Country Clothes, Haverfordwest.

1962 Bear Lane Gallery, Oxford; Howard Roberts Gallery, Cardiff.

1963 Dillwyn Gallery, Swansea; National Library of Wales, Aberystwyth; Greenhill House, Tenby.

1964 Manchester College of Art; Stourbridge College of Art; Trinity College, Carmarthen.

1965 Grosvenor Gallery, London.

1966 Oriel Fach, St David's.

1967 Greenhill House, Tenby.

1972 University College, Swansea.

1975 Oriel Gallery, Cardiff; Welsh Arts Council Touring Exhibition.

1977 Arts Centre, Aberystwyth.

1978 University College, Bangor; International Trade Fair, Hanover.

1980 Galerie Convergence, Nantes; University College, Cardiff.

1983 *The Giardellis in Venice*, Thornbury Arts Festival; *At the Sea's Edge*, Arts Centre, Aberystwyth.

1984 *Expanding Horizons*, Tisch Beere Gallery, Cardiff.

1986 *Giardellis' Jewel in the Crown*, Tisch Beere Gallery, Cardiff.

1987 Grosvenor Gallery, London.

1988 Tisch Beere Gallery, Cardiff.

1994 *Travellers' Tales*, Tisch Beere Gallery, Cardiff; Grosvenor Gallery, London.

1996 Arts Centre, Aberystwyth; Queen's Hall, Narberth.

2001 England & Co., London.

Selected Mixed Exhibitions

1940s-50s Quantas Gallery, London; Clare College, Cambridge; Redfern Gallery, London; Gimpel Fils, London; 56 Group Wales, Worcester City Art Gallery; 56 Group Wales, National Museum of Wales; Tenby Civic Centre.

1960 56 Group Wales, Glynn Vivian Gallery, Swansea; *Expressionists de Londres*, Galerie Creuse, Paris; Victoria Street Gallery, Nottingham; City Art Gallery, Wakefield; Arts Council of Wales Exhibition.

1961 Woodstock Gallery, London

1962 56 Group Wales, Dillwyn Gallery, Swansea; Hereford Art Gallery; Victoria Gallery, Bath; 56 Group Wales, Howard Roberts Gallery, Cardiff; 56 Group Wales, Victoria Street Gallery, Nottingham; 56 Group Wales, City Art Gallery, Wakefield.

1963 56 Group Wales, Arts Council Gallery, Cardiff.

1964 56 Group Wales, Arnolfini Gallery, Bristol; 56 Group Wales, Newport Museum; 56 Group Wales, University College, Aberystwyth; South Wales Group, Turner House, Penarth; 56 Group Wales, Dillwyn Gallery, Swansea; International Exhibition, Grosvenor Gallery.

1965 Jefferson Place Gallery, Washington D.C.; Chicago University; National Eisteddfod,

Newtown; 56 Group Wales, Bear Lane Gallery, Oxford; 56 Group Wales, Carmarthen Art Gallery; 56 Group Wales, Bangor Art Gallery.

1966 Temple Gallery, Llandrindod Wells; 56 Group Wales, Dillwyn Gallery, Swansea; *Open Painting Exhibition*, Ulster Museum, Belfast; 56 Group Wales, Bangor; Grosvenor Gallery, London.

1967 University College Swansea; 56 Group Wales, Bols Taverne Gallery, Amsterdam; 56 Group Wales, Whitworth Gallery, Manchester; 56 Group Wales,City Art Gallery, Leeds; Grosvenor Gallery, London.

1968 56 Group Wales, Municipal Gallery of Modern Art, Dublin; 56 Group Wales, Municipal Gallery, Limerick; *Art in Wales 1900-56*, Welsh Arts Council; 56 Group Wales, Little Theatre and Arts Centre, Newport.

1969 56 Group Wales, Richard Demarco Gallery, Edinburgh; 56 Group Wales, Arts Council Gallery, Belfast; 56 Group Wales, Grosvenor Gallery, London; Howard Roberts Gallery, Cardiff.

1970 56 Group Wales, Ikon Gallery, Birmingham; 56 Group Wales, Bluecoat Gallery, Liverpool; 56 Group Wales, Cyfarthfa Castle, Merthyr Tydfil; National Eisteddfod.

1971 56 Group Wales, Arnolfini Gallery, Bristol; 56 Group Wales, National Museum of Wales, Cardiff; 56 Group Wales, Glynn Vivian Gallery, Swansea.

1972 56 Group Wales, Ludwig-Reichert House, Ludwigshafen-am-Rhein; 56 Group Wales, Midland Group Gallery, Nottingham; 56 Group Wales, Newport Museum and Art Gallery.

1973 56 Group Wales, McLellan Galleries, Glasgow; 56 Group Wales, University College Bangor; 56 Group Wales, National Museum of Wales, Cardiff; *Wales and the Modern Movement*, Arts Centre, Aberystwyth.

1974 56 Group Wales Musée des Beaux Arts, Nantes; 56 Group Wales, Cardiff University; *What's New?* Welsh Arts Council; 56 Group Wales, Oriel Gallery, Cardiff; 56 Group Wales, University College, Swansea; 56 Group Wales, Oriel, Bangor.

1975 Galerie St Germain, Paris; *Works on Paper*, International Trade Fair, Hanover; 56 Group Wales, University College, Leeds; 56 Group Wales, University College, Cardiff; National Museum of Wales, Cardiff.

1976 56 Group Wales, Exhibition Hall, Bank of Ireland, Dublin; 56 Group Wales, Crawford Art Gallery, Cork; 56 Group Wales, Sherman Theatre, Cardiff.

1977 56 Group Wales, The Arts Centre, Aberystwyth; 56 Group Wales, University College, Cardiff.

1978 56 Group Wales, Royal West of England Academy, Bristol; 56 Group Wales, Wyeside Arts Centre, Builth Wells; 56 Group Wales, Wrexham Library.

1979 56 Group Wales, Musée de la Poste, Amboise; 56 Group Wales, Museum and Art Gallery, Newport; 56 Group Wales, Glynn Vivian Gallery, Swansea.

1980 *Art and the Sea*, ICA, London; Mostyn Gallery, Llandudno; 56 Group Wales, Llantarnam Grange, Cwmbran; 56 Group Wales, University College, Cardiff.

1981 56 Group Wales, Sherman Theatre, Cardiff; National Museum of Wales, Cardiff; 56 Group Wales, National Library of Wales, Aberystwyth; 56 Group Wales, Oriel Mostyn, Llandudno; 56 Group Wales, Perth Festival of Art, Scotland; St David's Festival.

1982 56 Group Wales, St Paul's Gallery, Leeds; 56 Group Wales, Edinburgh Civic Art Centre; 56 Group Wales, Forebank Gallery, Dundee; 56 Group Wales, Artspace Gallery, Aberdeen; 56 Group Wales, John Owen Gallery, Cardiff.

1983 *Recent Acquisitions*, National Museum of Wales, Cardiff; 56 Group Wales, Howard Gardens Gallery, Cardiff; 56 Group Wales, Gallery of Modern Art, Bologna; 56 Group Wales, St David's Hall, Cardiff.

1984 Tisch Beere Gallery, Cardiff, and annually until 2001; 56 Group Wales, Haverfordwest Library; 56 Group Wales, Oriel Gallery, Cardiff; 56 Group Wales, Vale of Glamorgan Festival.

1985 *Recent Acquisitions*, Tate Gallery, London; 56 Group Wales, Newport Museum and Art Gallery.

1986 University College, Cardiff; 56 Group Wales, Bratislava, Brno, Karlovy Vary, Kosice.

1987	The Old Library, Cardiff; Swiss Cottage Library, London; 56 Group Wales, City Museum and Art Gallery, Worcester.
1988	56 Group Wales, Oriel Mostyn, Llandudno; 56 Group Wales, Pembroke Dock Library.
1989	Hove Museum and Art Gallery; Glynn Vivian Gallery, Swansea; Cyril Gerber Fine Art, Glasgow; 56 Group Wales, Old Library, Cardiff; 56 Group Wales, Swiss Cottage Library, London; 56 Group Wales, St Michael's, Derby; 56 Group Wales, Glasgow Group, Glasgow.
1990	56 Group Wales, Glynn Vivian Gallery, Swansea; 56 Group Wales, Chepstow.
1991	Gillian Jason Gallery, London; 56 Group Wales, Haverfordwest Library; 56 Group Wales, Prague and tour, Czech Republic.
1992	*Art in Boxes*, England & Co., London; 56 Group Wales, Theatr Clwyd, Mold; 56 Group Wales, Rhondda Heritage Park.
1993	56 Group Wales, Royal West of England Academy, Bristol; 56 Group Wales, Rhondda Heritage Park.
1994	Prova d'Artista, Venice; *Images from Wales*, The Old Library, Cardiff; 56 Group Wales, Newport Museum and Art Gallery; 56 Group Wales, Libramont, Belgium.
1995	Prova d'Artista, Venice; 56 Group Wales, National Museum of Wales; Y Tabernacl , Machynlleth; The Golden Plover Gallery, Warren, Pembroke; Abulafia Gallery, Llandeilo; 56 Group Wales, The Old Library, Cardiff.
1996	Prova d'Artista, Venice; Queen's Hall, Narbeth; 56 Group Wales, Turner House, Penarth; 56 Group Wales, University College, Cardiff; 56 Group Wales, Pembroke Dock Library; 56 Group Wales, Taliesin Arts Centre, Swansea.
1997	Prova d'Artista, Venice; 56 Group Wales, City Museum and Arts Centre, Worcester; 56 Group Wales, Tenby Arts Festival; 56 Group Wales, St David's Hall, Cardiff; 56 Group Wales, Oriel Bangor.
1998	Prova d'Artista, Venice.
1999	56 Group Wales, Henry Thomas Gallery, Carmarthen; 56 Group Wales, Yale College Memorial Gallery, Wrexham; 56 Group Wales, Oriel Plasnewydd, Maesteg.
2000	*Painting the Dragon*, National Museum of Wales, Cardiff.

Commissions

1969	Mural, *The South Wales Argus*, Newport, Wales.
1971	Street Door, Grosvenor Gallery, London.
1972	Street Door, Brook Street Gallery, London.
1974	Painting, British Petroleum, Wales.
1980	Paintings, Texaco, Wales.

Works in Collections

Arts Council of England; British Petroleum, Wales; Contemporary Art Society of Wales; County of Clwyd; Glynn Vivian Art Gallery, Swansea; Keble College, Oxford; Municipal Gallery of Modern Art, Dublin; Musée des Beaux Arts, Nantes; National Gallery, Bratislava; National Gallery, Prague; National Library of Wales, Aberystwyth; National Museum of Wales, Cardiff; Newport Museum and Art Gallery; Saidenberg Gallery, New York; St Woolos' Cathedral, Newport; Tate Britain; Texaco, Wales; University of Kent; University of Leicester; Welsh Arts Council.

Estate of Olivier Debré; Michael Estorick; Carl Foreman; Peter Prendergast, Anthony Quinn.

Publications

1939	*Up With the Lark*, with Phillis Giardelli, OUP
1943	'Cedric Morris', *Wales* No.2
1971	Autobiographical chapter, *Artists in Wales*, ed. Meic Stephens, Gomer
1972	'Three Related Works by David Jones', *Poetry Wales* 8/3
1973-4	'*Trystan ac Essyllt* by David Jones', *Agenda*, David Jones Special Issue
1976	*The Delight of Painting*, W.D. Thomas Memorial Lecture, University of Wales, Swansea; 'Four Related Works by David Jones', *David Jones; Eight Essays on his Work*, ed. Roland Mathias, Gomer; 'Eisteddfod Art', *Planet* 33
1977	'Zurbaran at Guadalupe', *Guadalupe* ANOLXI No. 632, Nov/Dec
1979	Review of *Nella Coscia del Giganto Bianco* by Roberto Sanesi, *The Anglo-Welsh Review* 64
1982	'Another Meeting with David Jones', *The Anglo-Welsh Review* 71
1983	*At the Sea's Edge*, Arts Centre, Aberystwyth
1984	'An Artist in the European Tradition', *Ceri Richards*, University College, Swansea
1987	'Four Related Works by David Jones', *David Jones: Man and Poet*, ed. John Matthias, National Poetry Foundation Inc, University of Maine
1991	Introduction, *Pembrokeshire Painters*, Rosedale Publications
1995	An introductory essay, *David Jones, A Map of the Artist's Mind*, Lund Humphries/National Museums and Galleries of Wales
2000	Introduction, *William Wilkins*, Martin Tinney Gallery, Cardiff

Television and Radio

1964	*The Welshness of Welsh Painting*, BBC Radio Wales
1965-6	Radio interviews with David Jones, Josef Herman, Raymond Moore, Ceri Richards, John Selway, *Spectrum*, BBC Wales.
1966	*See What the Next Tide Brings*, BBC TV Wales
1975	*The Art of Arthur Giardelli*, BBC TV Wales
1983	*Where the Tide Turns*, on 56 Group Wales, HTV

Awards

1958-98	Chairman of 56 Group Wales
1964-67	National Chairman of the Association of Tutors in Adult Education
1970	Prize at National Eisteddfod
1973	Awarded MBE
1979	Winner of the British Council Award
1979-85	Honorary Fellow, University College, Aberystwyth, Wales
1986	Silver Medal, Czechoslovak Society for International Relations.
1998	President for Life, 56 Group Wales

Index

Indexing under Arthur Giardelli's name is selective and the whole index should be consulted for information concerning him. Works are listed in italics; if accompanied by an italicised number this refers to an illustration.